Soul *of the* Rockies

Praise for *Soul of the Heights: 50 Years Going to the Mountains,*
the first in the author's Soul of the Heights series

"Many of us will know Ed Cooper for his brilliant photography. With his large format cameras, he captures the beauty and mystique of the mountain world. Among his thousands of outstanding images, surely his *Moon over the Titan* in Utah's Fisher Towers will be celebrated in the annals of nature photography."

—Climbing guidebook author Eric Bjornstad, Moab, Utah

"As an original 'climbing bum' during the legendary (and supremely competitive) early days of the sport in the 1950s, Ed Cooper made a name for himself through his pioneering routes up volcanoes, crags, and cyclopean rock faces ranging from Alaska to Yosemite to the Rocky Mountains and beyond. *Soul of the Heights: 50 Years Going to the Mountains*—gorgeously illustrated throughout with his own accomplished photographs of North America's most spectacular peaks—collects Cooper's recollections of harrowing first ascents, as well as firsthand accounts from other climbing luminaries of the 'golden age' of mountaineering. It is a must-have for any climber, backpacker, or armchair mountaineer."

—Online in "The Significant 7: Editor Favorites in Books" by Amazon.com for December 2007

"It is a stunning book, just beautiful in every way."

—Peter Potterfield, journalist, climber, and guidebook author

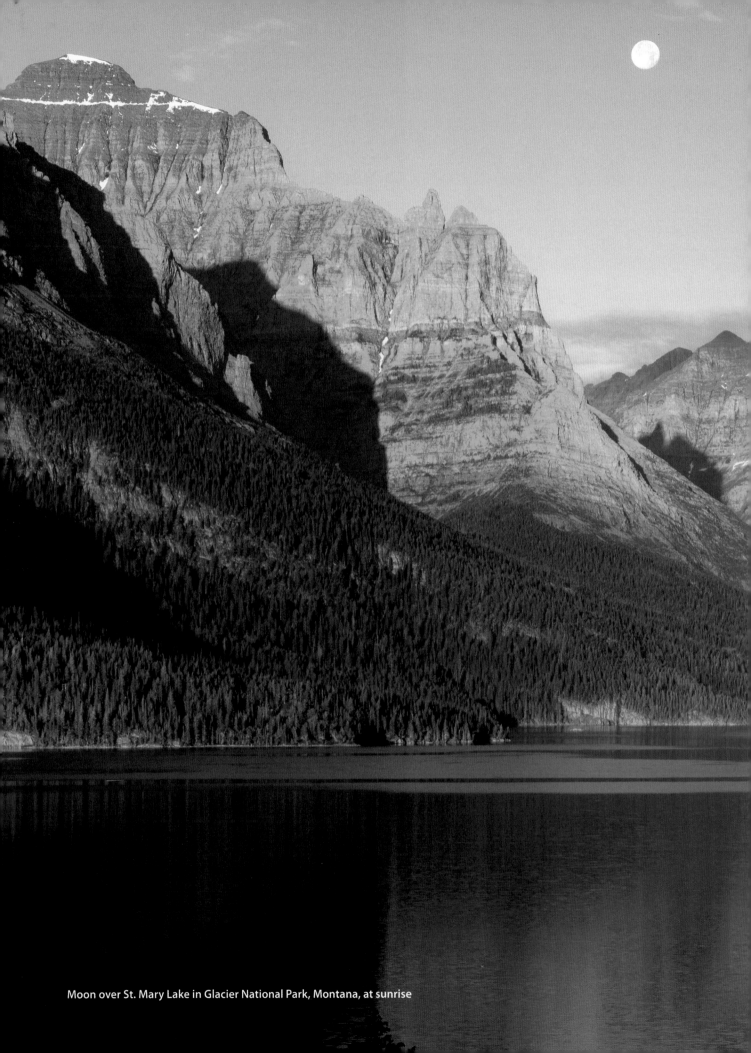

Moon over St. Mary Lake in Glacier National Park, Montana, at sunrise

Soul *of the* Rockies

PORTRAITS OF AMERICA'S LARGEST MOUNTAIN RANGE

Ed Cooper

FALCONGUIDES®

GUILFORD, CONNECTICUT
HELENA, MONTANA

AN IMPRINT OF THE GLOBE PEQUOT PRESS

To buy books in quantity for corporate use
or incentives, call **(800) 962–0973**
or e-mail **premiums@GlobePequot.com**.

FALCONGUIDES®

All interior photos by Ed Cooper

Text design by Claire Zoghb

Maps by Melissa Baker © Morris Book Publishing, LLC

Library of Congress Cataloging-in-Publication Data is available on file.

ISBN 978-0-7627-4941-6

Printed in China

10 9 8 7 6 5 4 3 2 1

DEDICATION

▲▲▲

As in the first book in the Soul of the Heights series—
Soul of the Heights–50 Years Going to the Mountains—
this book is dedicated to the mountains, a continuing
source of inspiration since I first discovered them. The
mountains are the real stars of this book.

"Going to the mountains is going home."

JOHN MUIR

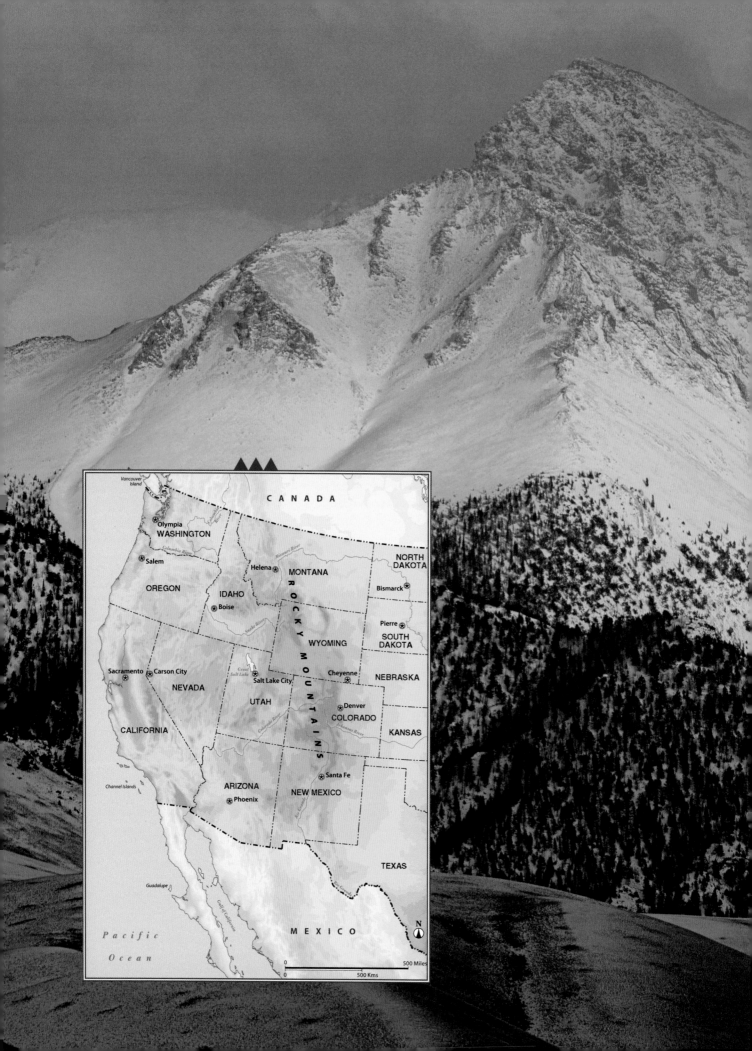

C O N T E N T S

▲▲▲

**Sunset on Borah Peak, highest peak in the
state of Idaho**

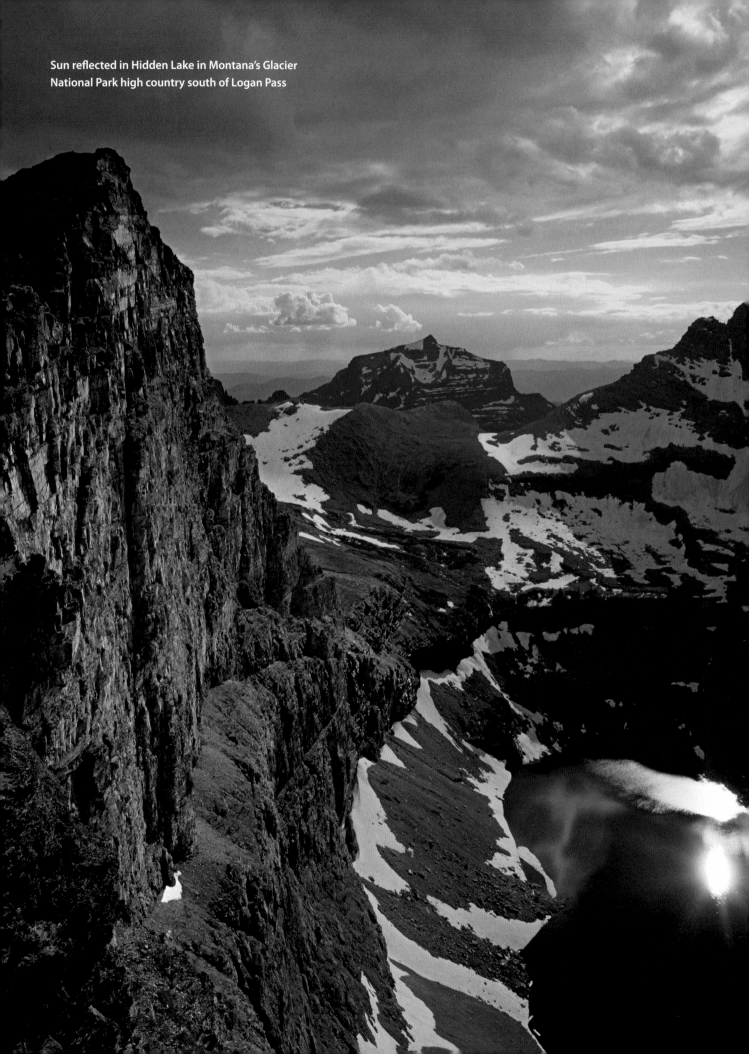

Sun reflected in Hidden Lake in Montana's Glacier National Park high country south of Logan Pass

ACKNOWLEDGMENT

▲▲▲

I would like to thank my wife, Debby, whose help was invaluable, although she gives much of the credit to Hazel Bullis, her English teacher for all three years of junior high school. Debby swears that if Miss Bullis had paid her students hard cash for every sentence she made them diagram, all her students would have been millionaires by the age of fifteen.

Besides correcting my errors of grammar, punctuation, sentence structure, and occasionally word choice (lack of this kind of knowledge is apparently typical of engineers like me), Debby also made a number of helpful suggestions to clarify what I was trying to say. She always assumed that if the text was unclear to her, it would probably be unclear to other readers as well. Having, she claims, forgotten more about English than most people ever learn, she calls herself a "recovering grammarian."

A rampart of Mount Timpanogos
in the Wasatch Range, Utah

INTRODUCTION

When I first started to work on *Soul of the Rockies*, book two in my Soul of the Heights series, the magnitude of the project seemed overwhelming. Providing all the images was one thing. Writing the text to go with the images added a whole new dimension to the project.

As for the former, I have roamed the mountains of the West for over fifty years, searching for mountain images and recording on film what I felt to be significant. It would be a matter of going through thousands of photos and choosing the ones to work with. The large selection I had to choose from was due to the fact that I had never thrown away any photos (color transparencies or black-and-white negatives) no matter how bad they appeared.

Among the color photos, there were faded, discolored, underexposed, and overexposed transparencies. The black-and-whites included some negatives that had huge light streaks due to a faulty 4x5 film pack holder that I had used for several years. Some of these images, after the magic of digital photography had been applied, helped complete the selection of photography for this book. In the process of putting this photo collection together, I made high-resolution scans of 139 of 154 photographs appearing in this book (photographs that were originally color transparencies or black-and-white negatives). I made high-resolution prints of all the scans as a guide for the publisher. An additional 20 images were shot in digital format to begin with, making a total of 174 images.

Regarding the text, I let the photographs be a guide for the text. The strength of the text is the exact identification of all the views appearing in this book. In some cases, supplying this information required considerable research. This is not a comprehensive book on the Rocky Mountains, containing all the pertinent information on geology, human history, flora, and fauna. Rather, what I have tried to do is give a large number of cameo descriptions, tied to the photos, that will give a good sense of what the high peaks of the Rocky Mountains are all about.

Further, the mountains are the stars of this book. I have gone out of my way to show what I feel are the

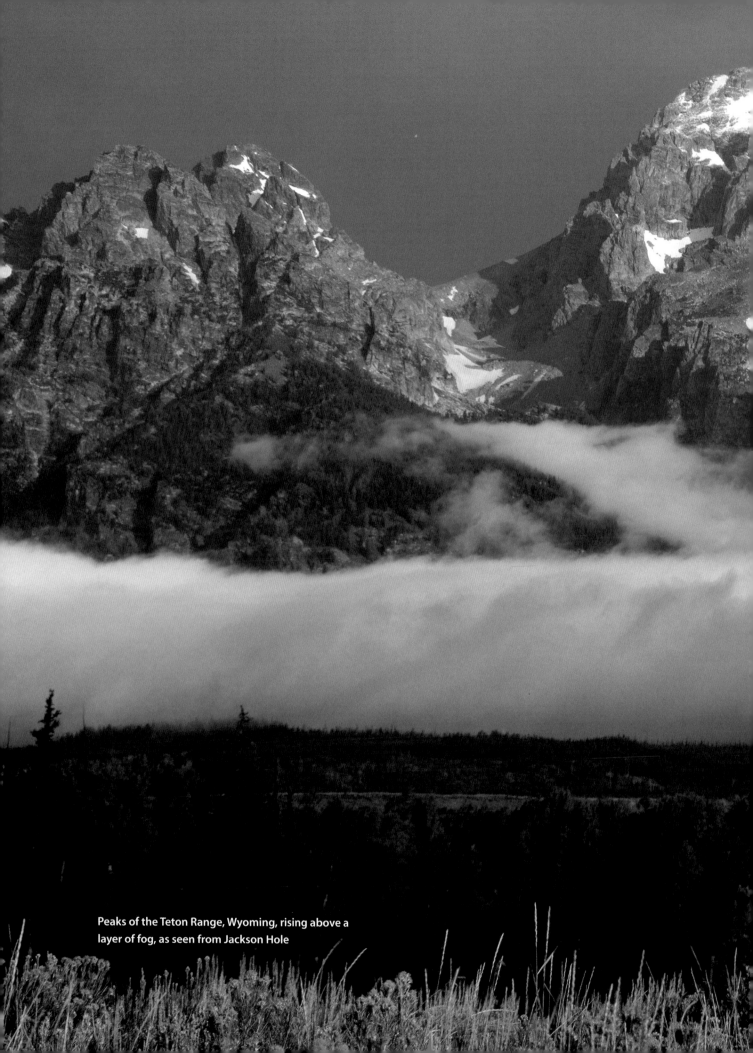

Peaks of the Teton Range, Wyoming, rising above a layer of fog, as seen from Jackson Hole

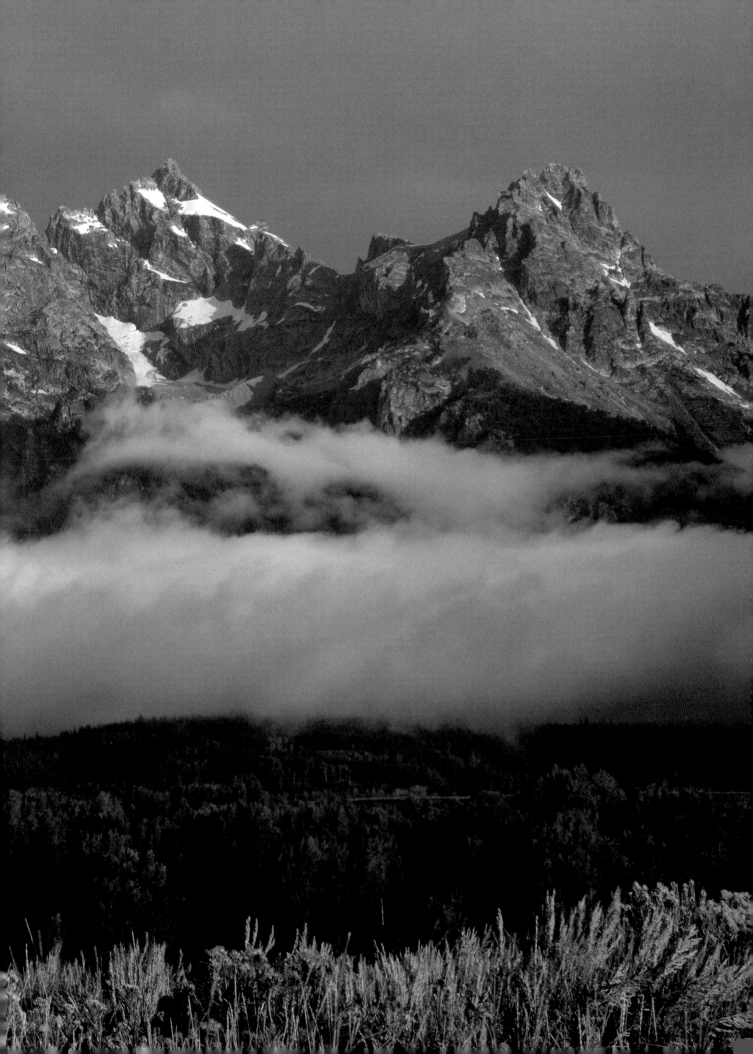

most spectacular mountain scenes to be found in the Rockies. While there are some photos featuring the Rocky Mountains' more gentle side, the emphasis is on the mountain peaks themselves. As in the first book in the Soul of the Heights series—*Soul of the Heights: 50 Years Going to the Mountains*—a large number of images are included that I would term "mountain portraits." I have tried to capture what I feel is the soul of the Rocky Mountains.

The Rocky Mountains are part of the great American cordillera, running from Alaska through Canada, the United States, and Mexico, through Central America, and down through the Andes Mountains ending at the Tierra del Fuego in Peru and Argentina at the southern tip of South America. In terms of coverage, this book is limited to the Rocky Mountains in the United States. The Rockies, of course, continue northward into Alberta and British Columbia in Canada, where they are commonly referred to as the Canadian Rockies. I have spent considerable time in these mountains as well, but this range will be the subject of a future book in the Soul of the Heights series.

The Rocky Mountains in the United States are considered to begin at the Canadian border in Idaho and Montana, continuing southward into Wyoming, then descending into Colorado and part of Utah, ending in north-central to central New Mexico. This southern boundary of the U.S. Rockies is somewhat arbitrary, more or less coinciding with the southern end of the Sangre de Cristo Mountains. But, in fact, isolated mountain ranges keep going south, including the peak Sierra Blanca in southern New Mexico. This peak—at 11,981c feet (3,652m)—is the highest most southerly peak in the contiguous United States, and it

supported glaciers during the Ice Age. (See the section on **Elevations** below for the meaning of "c" appearing after the elevation in feet.) The "highest most southerly peak" means that there is no peak farther south that is higher (until you go into Mexico). I have included a few of these mountain ranges in New Mexico as well as their continuation into Texas.

Also included are mountains in portions of the Colorado Plateau and the Great Basin, in recognition of the fact that parts of these regions are considered, by those who live in the Rocky Mountain West, as a part of the Rocky Mountains. This area includes parts of Arizona, Utah, and Nevada.

ORGANIZATION OF THIS BOOK

The photographs are organized according to state, starting in the north and ending in the south, and follow this order: Idaho, Montana, Wyoming, Colorado, Nevada, Utah, Arizona, New Mexico, and Texas. There is one case where the photograph was actually taken from Idaho, but the mountains shown are in Wyoming. In this particular case, I placed the image in Idaho.

GEODETIC DATA

Geographical coordinates are given in decimal degrees in WGS84/NAD83 data. Consumer GPS receivers default to this data. USGS topographic maps created before 1983 use the NAD27 data. The two figures are usually similar, but are rarely the same.

At the end of each state chapter is a table that provides the data for peaks and locations featured in that state, so that those who wish to look them up on topographic maps, or on an Internet feature such as Google Earth, can quickly find them.

Wheeler Peak, the highest peak in the state of New Mexico

ELEVATIONS

The reader will notice that in many cases, the letter "c" is added after the altitude in feet. This is a newer, corrected altitude, determined by the National Geodetic Survey. The very latest maps from the USGS set official heights of many Rocky Mountain peaks as much as 10 feet higher than before. These new altitudes reflect more accuracy in measuring, rather than geological uplifting. Even these new elevations may be subject to small changes through global positioning satellite technology. In most cases I have used the new corrected altitudes only for those peaks (or nearby peaks) that have benchmark stations on top of them. The Web page where you can go to determine recalibrated elevations for benchmark stations is at www.ngs. noaa.gov/cgi-bin/ds_radius.prl. It is necessary to have the geographic coordinates for the benchmark station.

And, of course, the symbol "~" when used with elevations indicates approximate measurements.

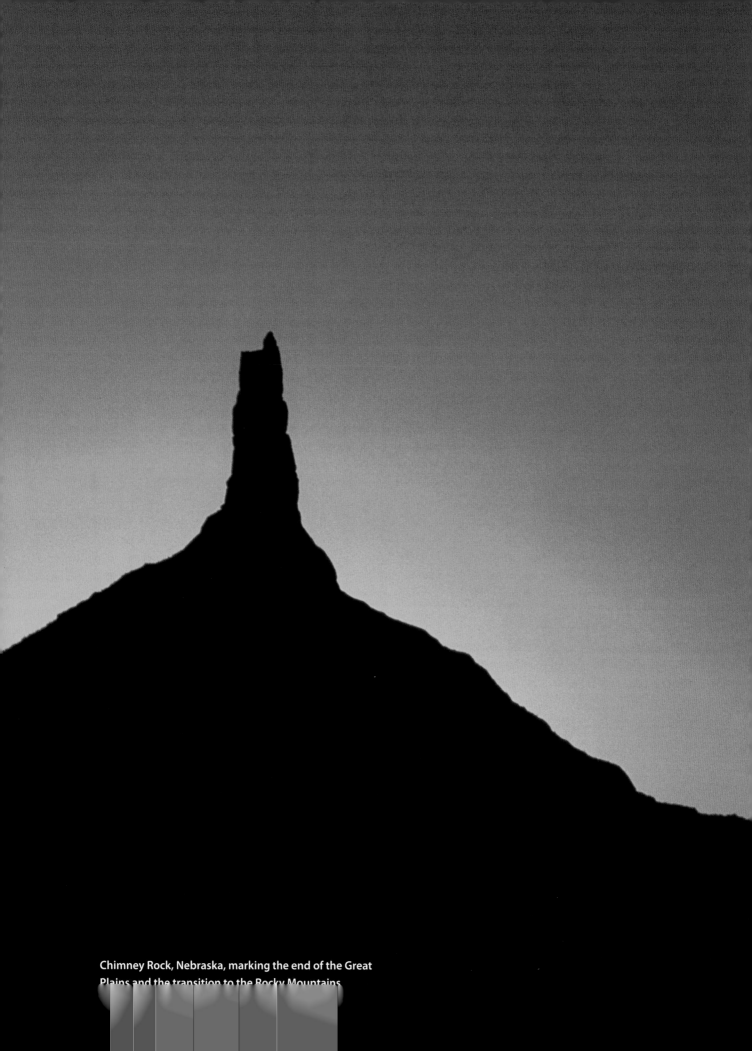

Chimney Rock, Nebraska, marking the end of the Great
Plains and the transition to the Rocky Mountains.

GATEWAY TO THE ROCKY MOUNTAINS

For over half a million westward-bound emigrants on the Oregon, California, and Mormon Trails, from 1841 to 1869 Chimney Rock was the most famous landmark along the way. When the early pioneers saw it in the distance, they knew they were nearing the end of the long trek across the Great Plains and were about to take on the hardships of crossing the Rocky Mountains. Many pioneers no doubt camped near here along the North Platte River, watching the sun set behind Chimney Rock, with the promise of a new day when they would cover 10 to 25 miles on their westward march. Today travelers on nearby U.S. Highway 26 and State Route 92 cover the same distance in a time span measured in minutes.

Chimney Rock is now contained within Chimney Rock National Historic Site, managed by the Nebraska State Historical Society. The most recent elevation determination for Chimney Rock is 4,226 feet (1,288m), with the rock itself rising 325 feet (99m) above its base. The final spire is about 120 feet (37m) of that rise. The rock has changed in historic times and lost some of its elevation.

One of the earliest depictions of Chimney Rock from a sketch in 1853 shows the spire as a tall and rectangular column. Fragments of the upper part of the rock have been found at the base in recent years, and at least one witness reported seeing a lightning strike on the rock that blew some of the top off. The weakness of the spire on Chimney Rock is attributed to its composition—Brule clay with layers of Arickaree sandstone, and volcanic ash interlaced within the sandstone.

The Native Americans had a name for the rock that means "elk penis," which it resembled to them, but the prim and proper pioneers preferred the more delicate name of Chimney Rock, which name remains to this day. For those wishing to locate Chimney Rock exactly, its coordinates in decimal degrees are 41.7039N/103.3482W.

You won't be disappointed when viewing Chimney Rock. So much of the history of the Rocky Mountains and the western United States can be traced to this starting location. And now we too will begin our journey through the Rocky Mountains at Chimney Rock, only this Chimney Rock is found near the Canadian border in northern Idaho and is very different indeed.

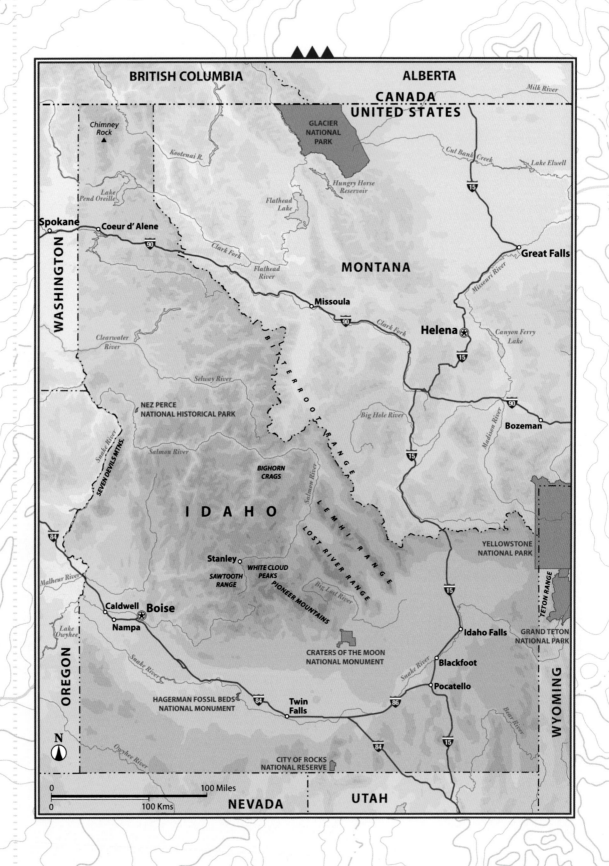

IDAHO

Chimney Rock

▲▲▲

One glance at Chimney Rock, 7,124 feet (2,171m), will tell the viewer why this peak is often referred to as the "Lightning Rod of Northern Idaho." It is visible from Priest Lake in the northern part of the Idaho panhandle, close to the Canadian border. It is, in fact, at the southern end of the Selkirk Mountains, most of which lie in British Columbia. In this view climbers may be seen rappelling on the 350-foot (~107m) west face, the easiest and most commonly used route to climb Chimney Rock. The firm granite makes this rock a climber's delight. A second view shows a climber on the smooth granite of the 450-foot (~137m) east face of Chimney Rock.

Seven Devils Mountains

▲▲▲

The Seven Devils Mountains take their name from a Nez Perce Indian legend about a young brave who, while lost in the area, had a vision of seven dancing devils. Nez Perce is French for "pierced nose," an attribute of this tribe. In French, the word *percé* has an accent on the last e. The official Nez Perce Indian Web site does not use the accent mark, but it is found frequently in some reference sources.

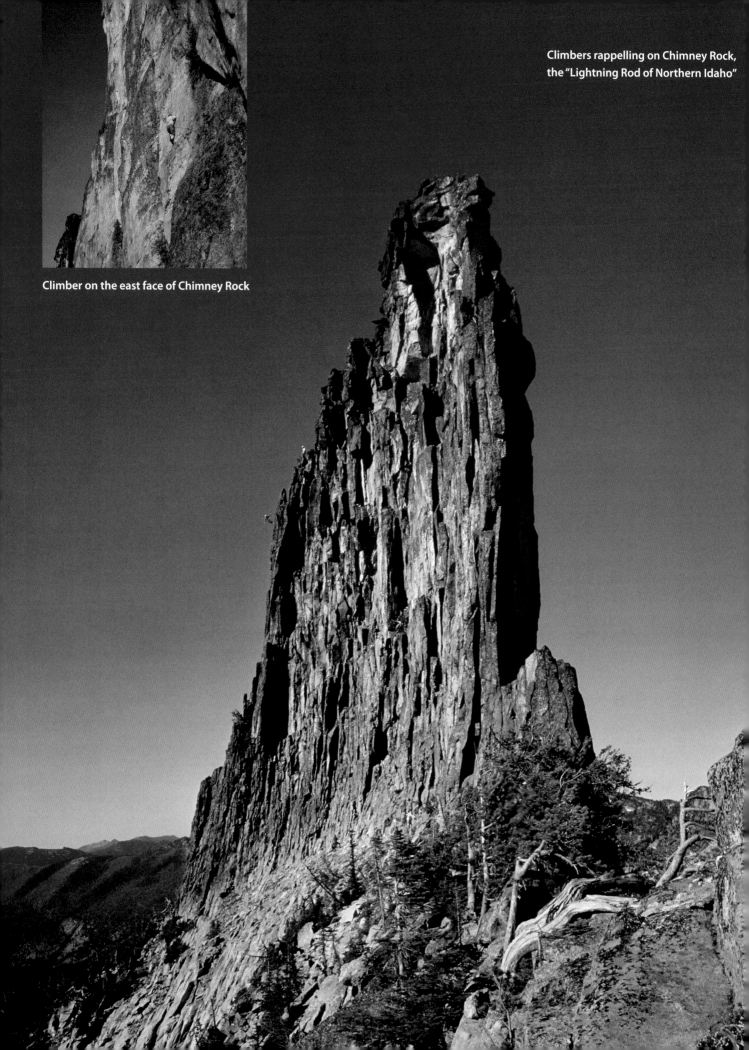

Climbers rappelling on Chimney Rock, the "Lightning Rod of Northern Idaho"

Climber on the east face of Chimney Rock

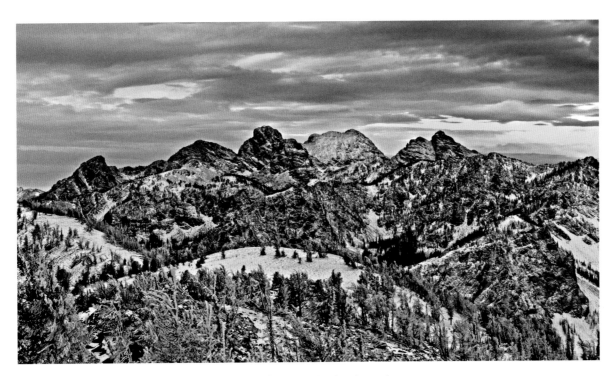

Seven Devils Mountains in winter dress

These mountains, located on the western border of central Idaho, have the highest relief of any mountain range in the state. From the summit of He Devil at 9,400+ feet (2,865+m) to the Snake River on the west, at 1,350 feet (411m), there is a drop of more than 8,050 feet (2,454m). The range itself, approximately 40 miles (64km) in length in a north–south orientation, is located in the Hells Canyon Wilderness, part of the Hells Canyon National Recreation Area. Hells Canyon itself is the deepest gorge in North America (including the Grand Canyon in Arizona). The Seven Devils Mountains are only some 15 miles (24km) wide, and the eastern face drops to about 1,800 feet (550m) at Riggins on the eastern side, at the junction of the Salmon and the Little Salmon Rivers. This range, raised up by block faulting mainly in the last six million years, is composed of very complicated rock layers, which contain a little of everything from oceanic sedimentary rocks to intrusive igneous rocks. This range rises up through the massive lava flows of the greater Columbia River basin.

In one view, we see five of the Seven Devils in winter dress, with leaden skies overhead, which promise more snow. Left to right: the Goblin, 8,985 feet (2,739m); the Ogre, 9,256 feet (2,821m); the Tower of Babel, 9,200+ feet (2,804+m); She Devil, 9,400+ feet (2,865+m); and He Devil, 9,400+ feet (2,865+m). At the current time, it is not known whether He Devil or She Devil is the higher of the two peaks (current opinion favors the He Devil), but this question won't be settled until there is an official triangulation of the peaks. The other peaks of the Seven Devils Mountains, Mount Belial and The Devils Throne, are farther south and cannot be seen in this picture. This view was taken from Heavens Gate Peak, 8,435c feet (2,571m), where there is a lookout.

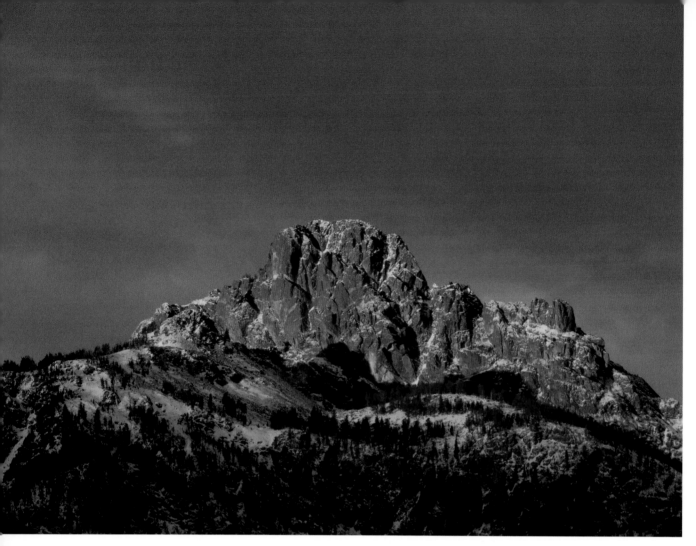

Sunrise on the Tower of Babel

A second view shows the Tower of Babel at sunrise, as seen from Windy Saddle. This was one of those views that you had to be in the right place at the right time to capture. This sunrise lighting lasted less than ten minutes as the sun shone under a thick overcast. All too soon, this view was gone as the clouds obscured the sun.

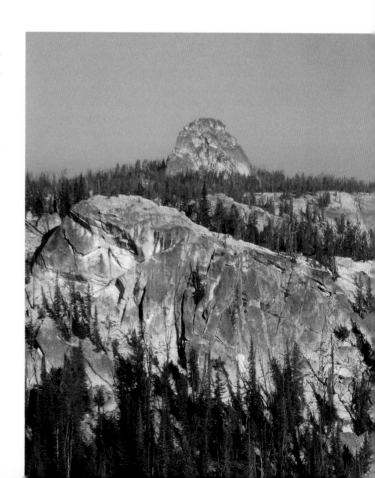

Bighorn Crags in Salmon River Mountains

▲▲▲

Located in central Idaho is the largest tract of back-country terrain to be found in the contiguous United States. In fact, drawing a line on the map straight north from Stanley, at the base of the Sawtooth Range, one could travel 155 miles (248 km) before encountering another paved road. Further, one would encounter only one dirt road. In the heart of this area, in the Salmon River Mountains, lie the Bighorn Crags, in the Frank Church "River of No Return" Wilderness Area. The River of No Return refers to the Salmon River.

Just approaching the trails into this area requires about 55 miles (88km) of driving on various dirt roads. The last several miles are pretty challenging. The Crags Campground, at an elevation of about 8,500 feet (~2,590m), lies at the road end and is probably the most remote auto-accessible Forest Service campground in the contiguous United States.

The Bighorn Crags area is a land of granite domes and spires, and the view seen here is vaguely reminiscent of Yosemite's high country. Cathedral Rock, 9,400+ feet (2865+m), on the right, is the only named peak in the nearby ridges. The highest peak in the Bighorn Crags (and the Salmon River Mountains) is Mount McGuire, at 10,087c feet (3,075m). This peak is just barely visible in this view as a shaded peak in the distance that rises slightly above the ridgeline, to the left of Cathedral Rock.

The Bighorn Crags in the Frank Church River of No Return Wilderness

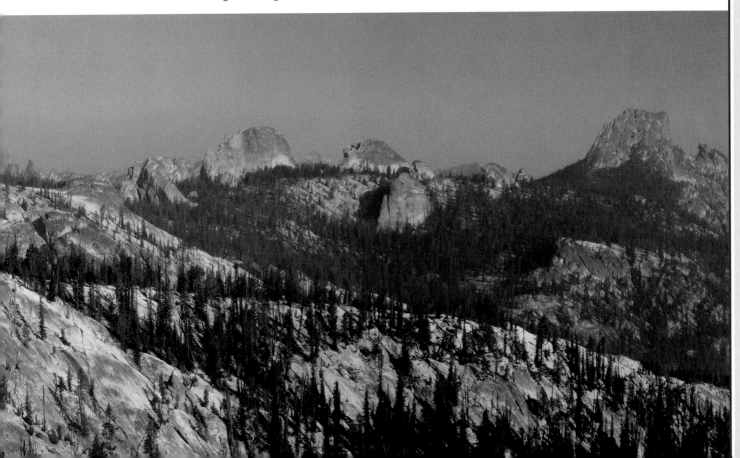

Ranges of Southern Idaho

▲▲▲

In south-central Idaho, five separate mountain ranges, running in a more or less northwest–southeast direction, march eastward. The third, fourth, and fifth have peaks exceeding 12,000 feet (3,658m) and include Idaho's highest summit. The second has a summit only 185 feet (56m) short of 12,000 feet, while the first's highest summit is only 10,751 feet (3,277m). Yet, it is this first range that is the best known of Idaho's mountain ranges. They are, in order from west to east: the Sawtooth Range, the White Cloud Peaks, the Pioneer Mountains, the Lost River Range, and the Lemhi Range. We will look at peaks in all of these ranges.

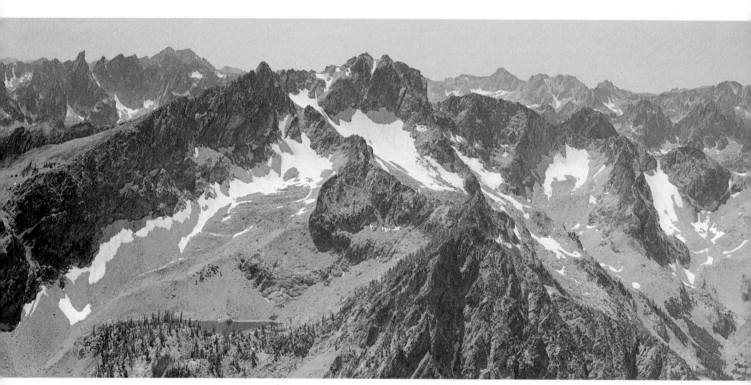

The Sawtooth Range as seen from the top of Mount Regan

Sawtooth Range

The Sawtooth Range is the most popular mountain recreation area in Idaho. This is not surprising in view of the fact that these mountains are not only accessible via State Route 75 and State Route 21, but there are terrific views of the peaks from the highways. Further adding to the popularity of these peaks as hiking and climbing destinations is the fact that there are numerous glacially formed lakes, and the rock in the region is

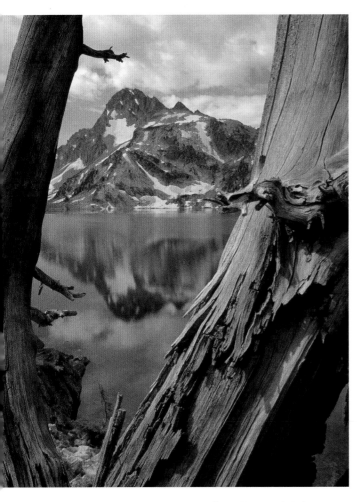

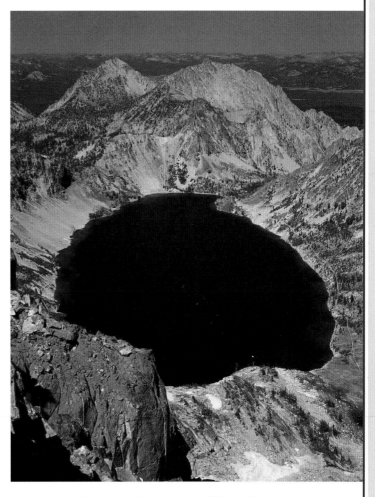

Mount Regan as seen from Sawtooth Lake

Sawtooth Lake as seen from the top of Mount Regan

primarily granite, good rock for climbing. Much of the land in this area is within Sawtooth National Recreation Area, with much of the high country of the Sawtooth Range itself being within the designated Sawtooth Wilderness. Being the westernmost of the five ranges listed above, it receives the heaviest precipitation, and snow and ice will be found in the Sawtooths (despite their lower elevation) when it has all but disappeared from the other ranges.

Two of the many jewels in the Sawtooth Wilderness are Mount Regan and Sawtooth Lake. Stunted trees at Sawtooth Lake, at 8,430 feet (2,569m) near timberline,

make for great photographic possibilities with Mount Regan in the background. Similarly, the view from the top of Mount Regan, 10,190 feet (3,106m), of Sawtooth Lake is just as stunning, showing exactly what you expect a glacially formed lake basin to look like. The trail may be clearly seen along the right side of the lake.

This panoramic view of the Sawtooth Range, on the opposite page, from the summit of Mount Regan shows the high peaks in the Sawtooth Wilderness. In the center is Baron Peak, 10,297 feet (3,139m). The sharp pointy peaks to the left form the granite crags of Monte Verita Ridge, a popular area with rock climbers.

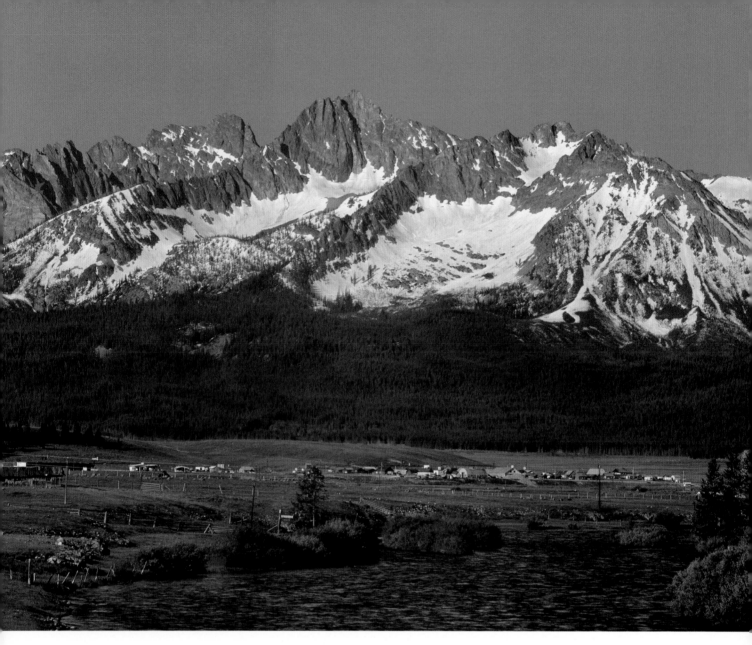

The Sawtooth Range rising above the town of Stanley and the Salmon River

After traveling in a deep canyon alongside the Salmon River, the traveler sees this dramatic view during the approach to Stanley from the east, via SR 75 from Challis. The peak that appears highest is Williams Peak, 10,635 feet (3,242m). But Thompson Peak, 10,756c feet (3,278m), which appears over the left shoulder of Williams Peak, is higher and is in fact the highest peak in the Sawtooth Range. *Note*: The corrected altitude, 5 feet higher than the old elevation, is stated in the National Geodetic Survey data sheet to be 5 feet lower than the actual summit.

Horstmann Peak, at 10,470 feet (3,191m), is possibly the single most spectacular of the Sawtooth Range peaks that are visible from the highway. Seen here is sunset on the great north face, with ranch lands near Lower Stanley in the foreground. The well-named Sickle Couloir, which holds snow and ice almost all year-round, may be seen to the left of the summit.

One of the absolute delights of the Sawtooth Range is all the lakes to be found both below and above timberline. Early mornings, when the wind is still and the lighting is excellent on the peaks, offer some

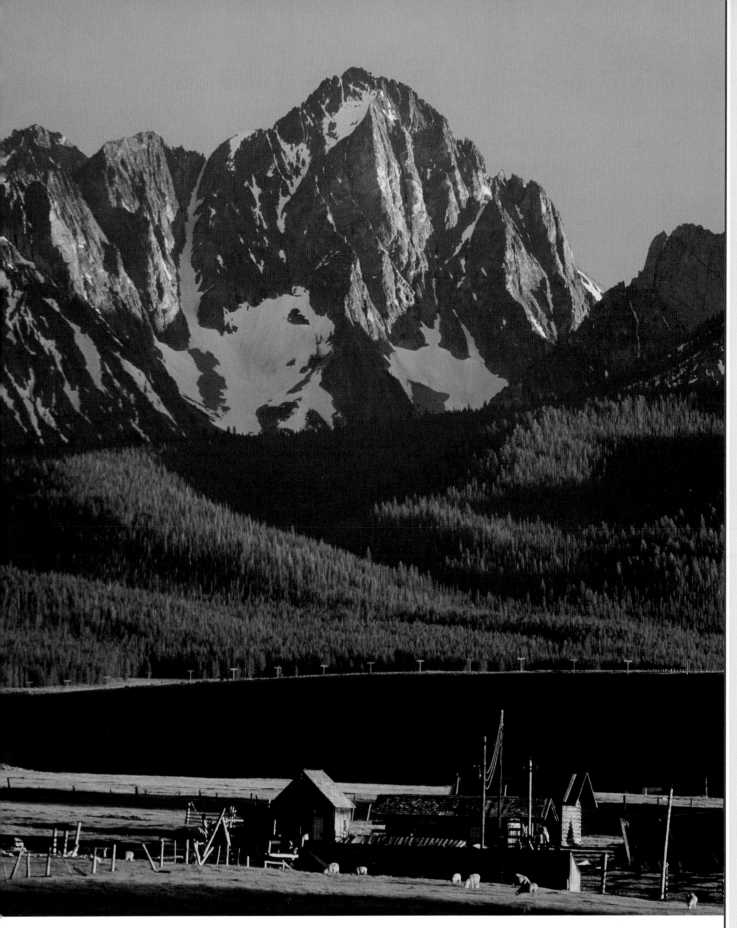
Horstmann Peak soaring above ranching country in Stanley Basin

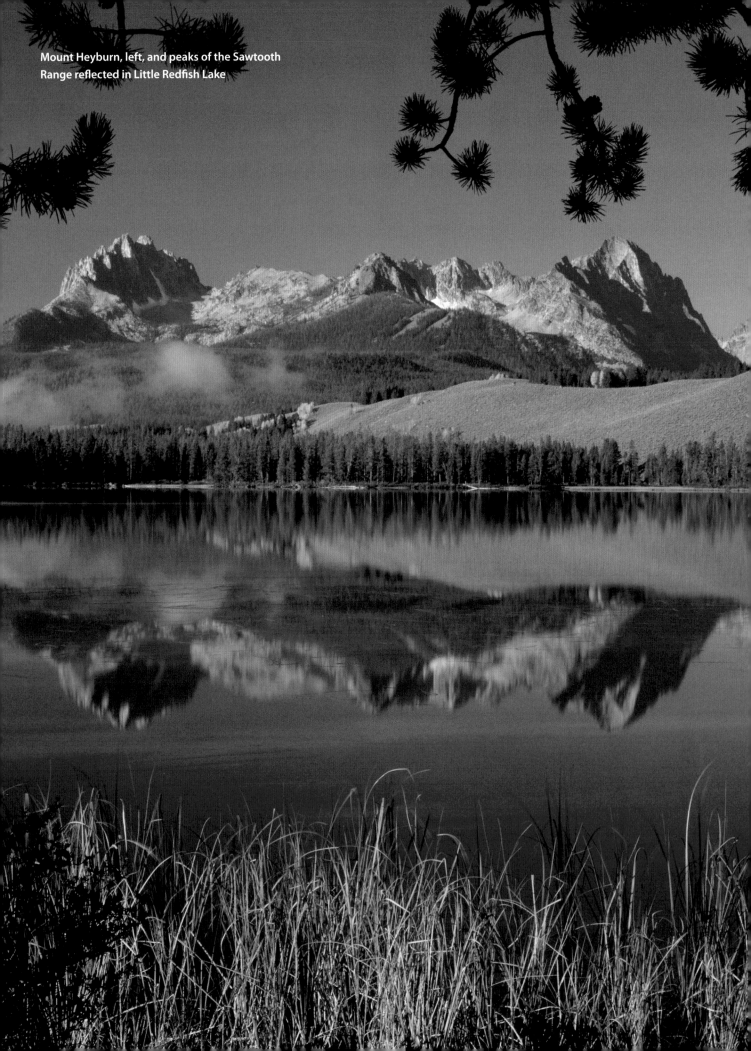

Mount Heyburn, left, and peaks of the Sawtooth
Range reflected in Little Redfish Lake

of the best opportunities to capture reflection views such as this. And you have to get there early, before the fishermen, boats, small boys throwing stones into the water, and the wind picking up to rile the water, in order to get the great views reflected into still water.

Seen at the left is Mount Heyburn, 10,229 feet (3,118m), one of the signature peaks of the Sawtooth Range. Mount Heyburn has two summits of almost equal height; the west summit is higher by a foot or two. On the right is Horstmann Peak, described above. On the USGS topographic map, Mount Heyburn is labeled Heyburn Mountain, but every other reference source I have seen refers to it as Mount Heyburn, hence I use the latter here.

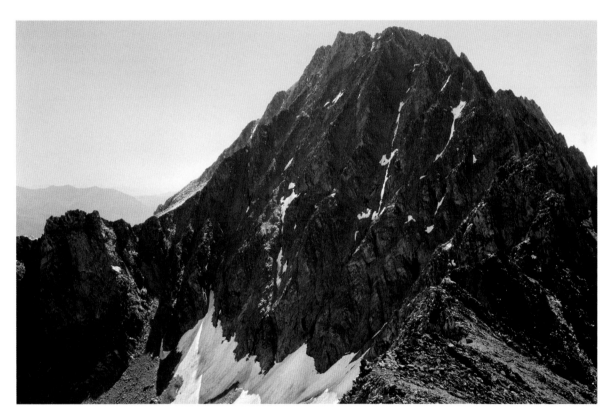

Castle Peak, the highest peak in the White Cloud Peaks

White Cloud Peaks

The White Cloud Peaks group is one range east of the Sawtooth Range (located between Ketchum and Stanley) and is within the Sawtooth National Recreation Area. Despite the group's location between two popular tourist destinations, the peaks in this group receive infrequent visitation. At 11,812c feet (3,600m), Castle Peak is the highest peak in the group. This view is from the west, an aspect of the peak seldom seen, but the appearance of multiple battlements leading to the summit confirms that the name Castle Peak is indeed appropriate.

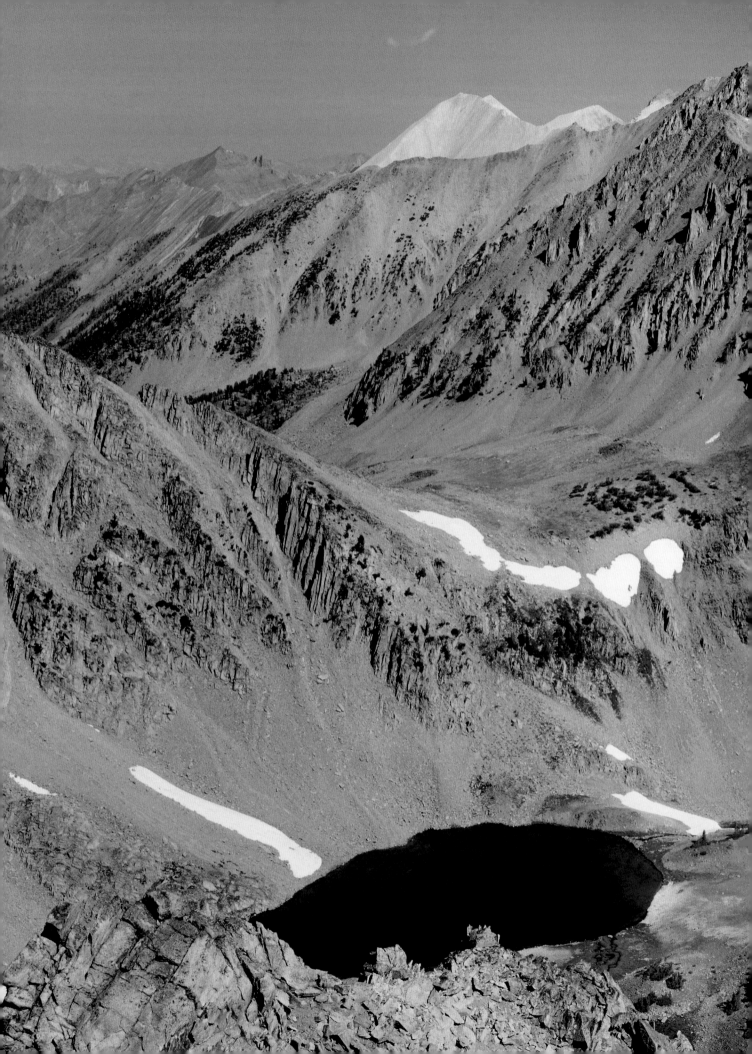

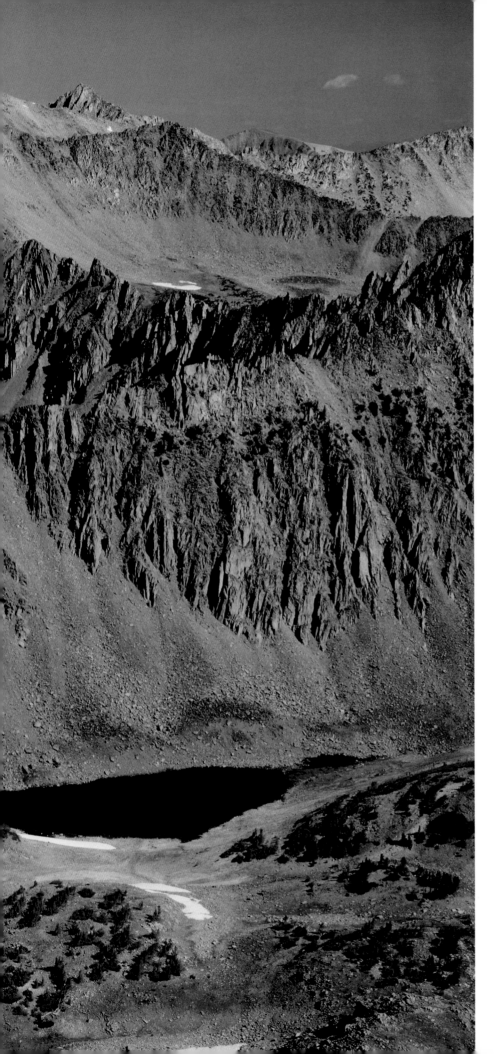

In the view looking north from near the same location as in the above image, the white peak in the distance is D. O. Lee Peak, 11,342 feet (3,457m). This peak is composed of white limestone, hence the derivation of the name White Cloud Peaks.

D. O. Lee was a longtime Forest Service employee in the region. Seen below are Emerald Lake (left) and Cornice Lake (right) in Four Lakes Basin.

The White Cloud Peaks, with the white D.O. Lee Peak in the distance

Old Hyndman Peak (left) and Hyndman Peak (right) in the Pioneer Mountains

Hyndman Peaks in Pioneer Mountains

The Pioneer Mountains are the next range to the east of the White Cloud Peaks. These mountains are composed of hard igneous and metamorphic rock. The two peaks seen in this view from timberline are Hyndman Peak, 12,012c feet (3,661m), on the right, and Old Hyndman Peak, 11,778c feet (3,590m), on the left. Hyndman Peak is one of nine peaks in the state rising to 12,000 feet (3,658m) or more, and it's the highest peak in the Pioneer Mountains. We are looking at the northeast faces of the peaks seen from Hyndman Basin.

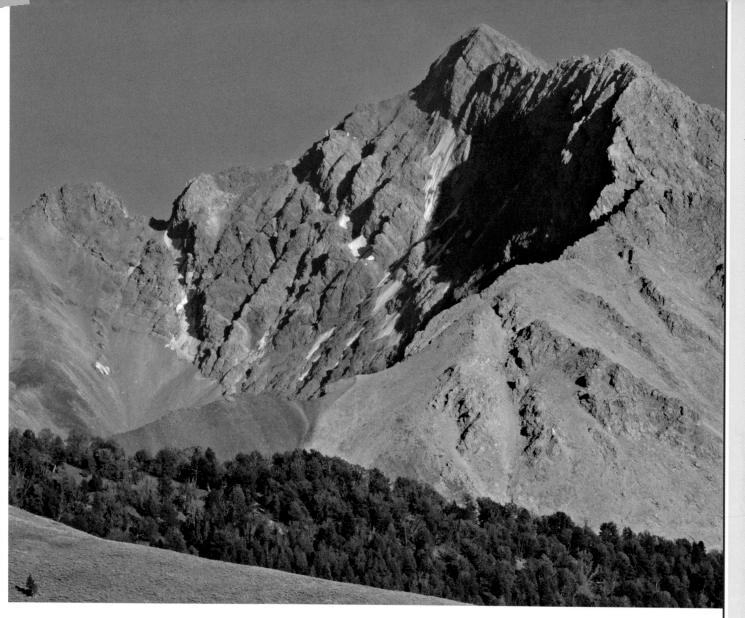

The north face of Borah Peak, the highest peak in Idaho

Lost River Range

The Lost River Range is the next range to the east of the Pioneer Mountains. It is home to seven of the nine peaks in the state reaching an elevation of 12,000 feet or more. The Lost River Range is a fault block mountain range composed of sedimentary rock, with a vertical relief on the western side (where the Lost River Fault is located) of over 6,000 feet (1,829m). An earthquake of magnitude 7.3 occurred along this fault on October 28, 1983, and left a fault scarp of up to 14 feet (~5m) along the base of the Lost River Range. This scarp is still vis-ible. Damage in nearby communities was considerable, and two children died as the result of collapsing walls. Fortunately, however, the area is sparsely settled, so the damage was much less than it might have been.

At 12,668c feet (3,861m), Borah Peak (named after a prominent U.S. senator from the state) is the highest peak in the Lost River Range and also the state of Idaho. The view seen here is of the north face of Borah Peak, seen from Doublespring Pass, itself at an elevation of 8,318 feet (2,535m).

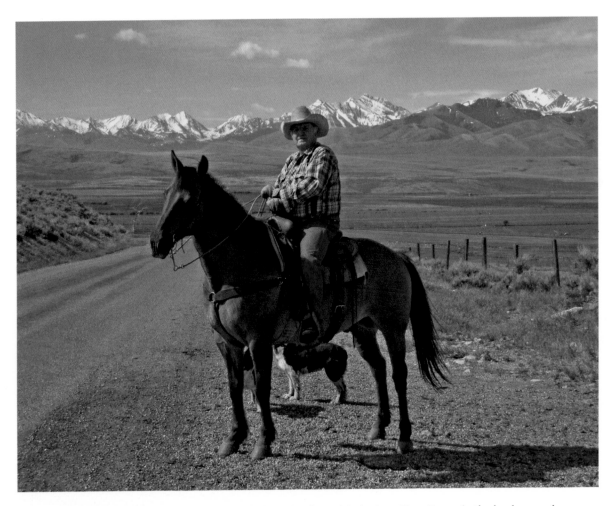

Rancher Leon Ziegler in the remote Pahsimeroi Valley, with the Lost River Range in the background

In the remote Pahsimeroi Valley, we see rancher Leon Ziegler with the Lost River Range spread out in the background. Borah Peak appears just to the right of Leon's head. This valley, located on the eastern side of the Lost River Range, sees almost no travelers, since it is out of the way of almost all major travel routes. To me, this is quintessential Marlboro Country. (One could imagine seeing a scene like this in the days when TV ran Marlboro cigarette commercials.) This was a situation that happened when I was exploring. I saw the rancher and asked him if he would mind if I took a picture of him with the mountains as a backdrop, and he was happy to oblige.

In another view we see a lenticular cloud cap hovering over the summit of Leatherman Peak, 12,233c feet (3,729m), the second-highest peak in the Lost River Range and in the state of Idaho. These cloud caps are most often accompanied by very strong winds at the upper elevations and are often a precursor to storms moving into the mountains. They serve as excellent signs for would-be climbers to abort their climbs and return to the safety of lower elevations.

Another peak of interest in the Lost River Range is Mount Breitenbach, named after John "Jake" Breitenbach, a climber killed on March 23, 1963, on the American Mount Everest Expedition, when an ice wall

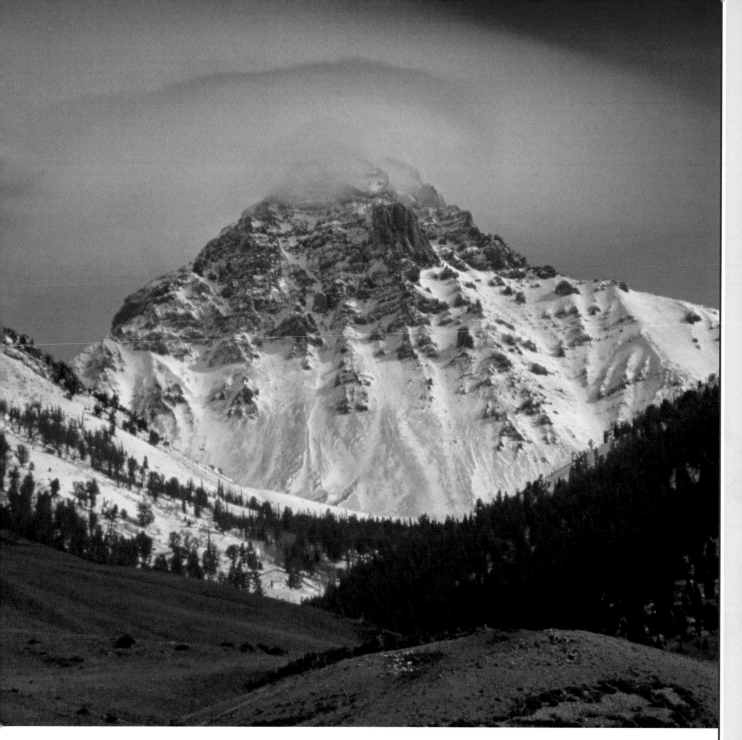

Lenticular cloud cap over Leatherman Peak

collapsed on him. There are no good views of Mount Breitenbach from any road because of intervening ridges, and I don't have a view of this peak, although from the pictures I have seen of it from upper elevations, it is quite a handsome mountain. At 12,145c feet (3,702m), it is the fourth-highest peak in the Lost River Range and the fifth-highest peak in Idaho.

After I completed assembling all the photography for this book and had written the text for the Rocky Mountains in the state of Idaho, I recalled that I had, in my photo collection, a picture of Jake Breitenbach taken after a successful 1958 climb of Mount McKinley in Alaska. After some searching, I found this picture, which had been lying undisturbed for almost fifty

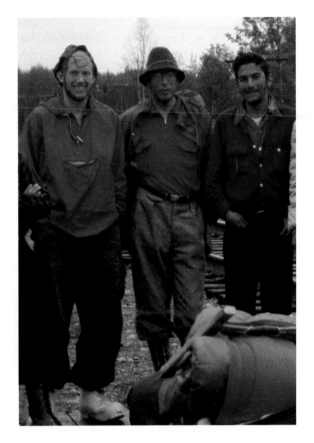

years. I scanned the 2¼ color transparency and enlarged a small portion of the image from a much larger group picture. (I had given my camera to somebody else to take this picture.)

The result is reproduced here, showing Jake (on the left) much the way he was in real life: easygoing and with a good sense of humor. He was an ideal companion for trips into the mountains. He was a mountain guide in the Teton Range for six years before his death, introducing others to the joy of the mountains. I feel privileged to have known him and feel that he would have approved of the peak named for him. In the center is David Dornan, another member of the Mount McKinley expedition, and that's me on the right.

John "Jake" Breitenbach (left), for whom Mount Breitenbach is named, in 1958. Photographer and author of this book (right).

Lemhi Range

At 12,202c feet (3,719m), Diamond Peak has been rated as the fourth-highest peak in Idaho and is the highest peak in the Lemhi Range. The correction adds 5 feet, which makes it 2 feet higher than the uncorrected altitude of Mount Church in the Lost River Range, currently ranked as the third-highest peak in Idaho, at 12,200 feet (3,719m). This controversy won't be resolved until a corrected altitude is determined for Mount Church. Adding to the confusion, the topographic map for Mount Church doesn't give an exact altitude, but shows a very tiny area with the 12,200-foot contour line, so presumably it could be listed as 12,200+ feet.

It's easy to see how Diamond Peak got its name—you only have to look at the profile to see that it looks like the upper half of a diamond. This view, from the northeast, was taken near State Route 28. At this point the summit is approximately 5,900 feet (~1,800m) above the viewer. This is the driest of Idaho's major mountain ranges, being the farthest east. By the time moisture-laden clouds have passed over the four mountain ranges to the west, there is not much rain or snow left over for this range.

Diamond Peak

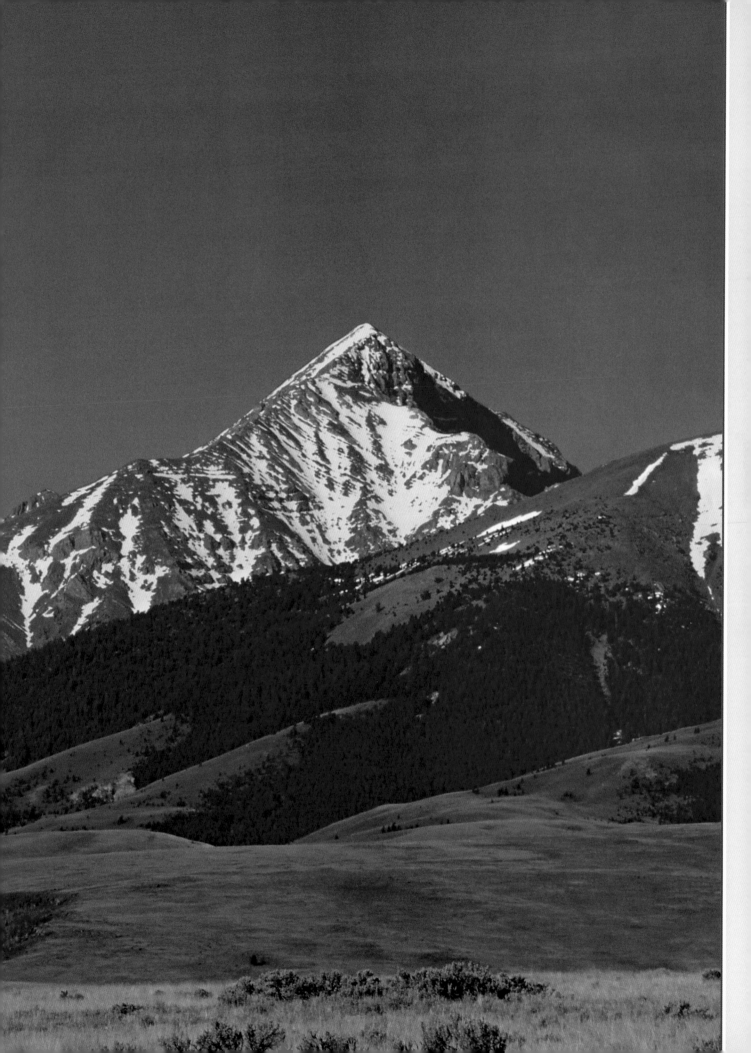

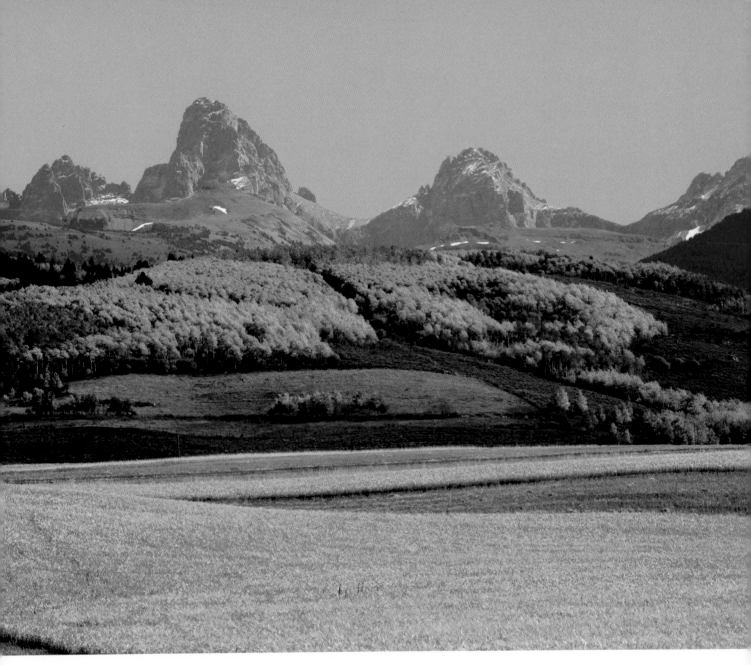

The Teton Range as seen from near Driggs

Teton Range from the Back Side

▲▲▲

Almost all the tourists who see the Teton Range see these peaks from the other side, from Jackson Hole in Grand Teton National Park. This view was taken near Driggs, located at the extreme eastern end of the agriculturally productive Snake River Plain (which crosses the lower third of the state). Above the grain fields and aspen trees in autumn, we see (from left to right): Mount Owen, 12,933c feet (3,942m); Grand Teton, 13,775c feet (4,199m); Middle Teton, 12,809c feet (3,904m); and South Teton, 12,519c feet (3,816m). While Driggs is in Idaho, the Teton Range itself is in Wyoming.

City of Rocks

▲▲▲

Located at the southern end of the Albion Mountains, only a few miles from the northern border of Utah, lies City of Rocks National Reserve, an area with great historical importance as well as being a current international destination for rock climbers.

This area was an important stop along the California Trail, which saw the heaviest emigration from 1843 to 1869, at which time wagon traffic declined with the completion of the first transcontinental railroad. One can still see traces of the passage of the early pioneers, with markings on some of the rocks, as well as remnants of the wagon trail still visible over nearby Granite Pass. A description written by James Wilkins in 1849 is still one of the best: "We encamped at the city of the rocks, a noted place from the granite rocks rising abruptly out of the ground. They are in a romantic valley clustered together, which gives them an appearance of a city."

With its many hundreds of routes, the area is now so popular with rock climbers that it is virtually impossible to find a camp spot on weekends. Reservations must be made weeks or even months in advance. For those new to the area, campground registration and climber sign-out materials are found across the street from Bath Rock, several miles into the reserve. Slightly farther along the road, there is a pullout where it is possible to take pictures of climbers on the rock formation known as the Incisor, as seen on the next page.

City of Rocks

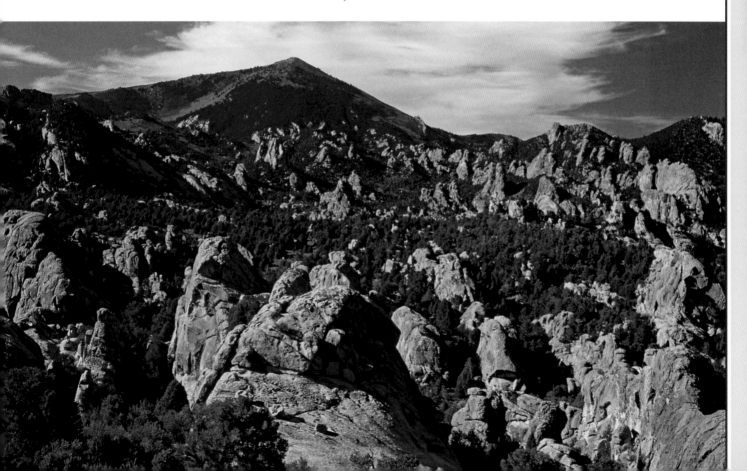

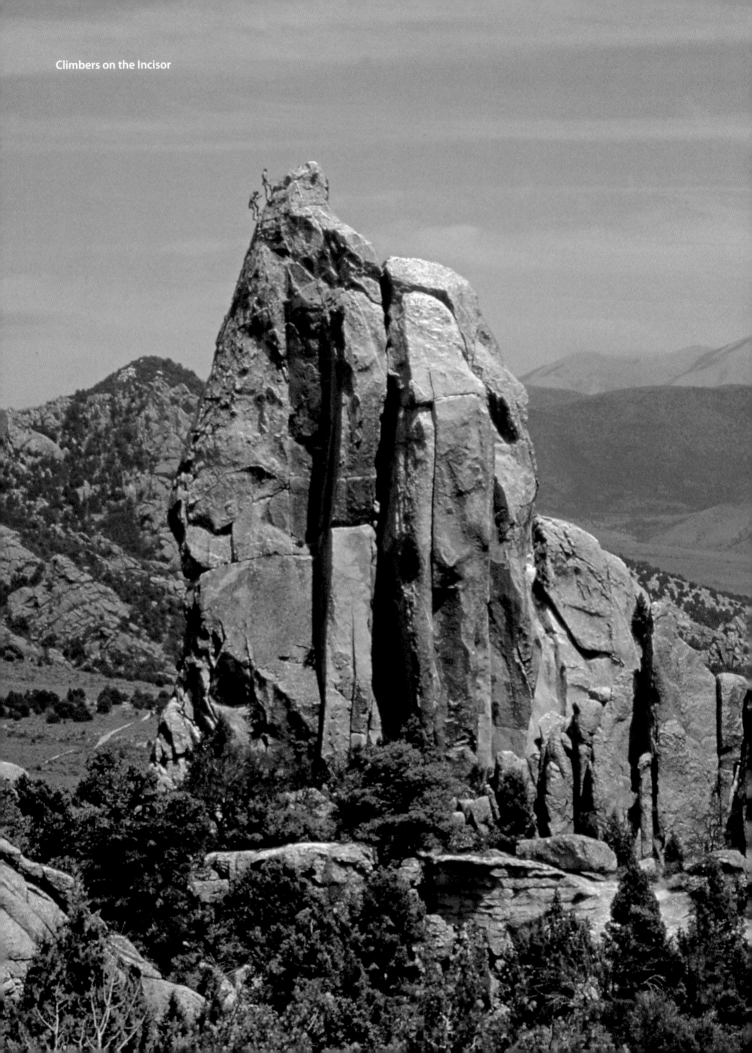

Climbers on the Incisor

Idaho Peaks and Locations Featured

Baron Peak [107351] ..44.1236N/115.0464W

Borah Peak [107503 & D07502]44.1373N/113.7811W

Mount Breitenbach (of the person)44.0651N/113.6731W
[T-501314-E]

Castle Peak [107421]44.0399N/114.5867W

Cathedral Rock [D07232 & D07234]45.1352N/114.5471W

Chimney Rock [107018 & T-07001]48.6190N/116.6978W

City of Rocks (at Bath Rock) .. 42.0754N/113.7220W
[M-07915 & M-07922]

D. O. Lee Peak [107420]44.1028N/114.6286W

Diamond Peak [M-07513] ...44.1415N/113.0827W

Goblin [D07256]...45.3183N/116.5251W

He Devil [D07256] ...45.3241N/116.5483W

Heavens Gate Peak (Lookout) [D07256].................45.3688N/116.4946W

Mount Heyburn [107301]..44.1010N/114.9766W

Horstmann Peak [207318 & 107301].......................44.1127N/115.0021W

Hyndman Peak [207408]...43.7493N/114.1312W

Leatherman Peak [M-07501]44.0820N/113.7331W

Mount McGuire [D07232 & D07234]45.1742N/114.6020W

Ogre [D07256] ...45.3195N/116.5321W

Old Hyndman Peak [207408]43.7407N/114.1171W

Mount Regan [207338 & 107330 & 107351].........44.1598N/115.0616W

She Devil [D07256] ...45.3240N/116.5406W

Tetons seen from near Driggs [107604]Various

Thompson Peak [207317]..44.1415N/115.0099W

Tower of Babel [D07251 & D07256].......................45.3300N/116.5282W

Williams Peak [207317]..44.1525N/115.0058W

The numbers in brackets are the author's file numbers for the images.

MONTANA

Glacier National Park

▲▲▲

There are few superlatives sufficient to describe the Rocky Mountains as seen in Glacier National Park. It is quite simply one of the premier mountain parks in the national park system. The summits are not as high as in some other mountain national parks, but the large number of spectacularly steep peaks in such a relatively small space is unrivaled. More than any other mountains in the United States, the peaks of Glacier National Park take on the look of their neighbors, the Canadian Rockies to the north, with their layered appearance due to the sedimentary rock from which they were formed.

Almost the whole area was once under the ocean, where for many millennia the sediments built up. As the ocean floor was uplifted to form mountains, the forces of erosion—water and ice—carved these peaks (composed of relatively soft sedimentary rock) into the sharply sculpted features we see today. There are so many fine-looking peaks in Glacier National Park that it would be possible—easy, even—to do a photographic book on this park alone. For that reason, I found it very hard to limit the number of images of the park for inclusion in this book.

John Muir, noted naturalist and conservationist, said after a visit to Glacier, "Give a month at least to this precious reserve. The time will not be taken from the sum of your life. Instead of shortening, it will indefinitely lengthen it and make you truly immortal."

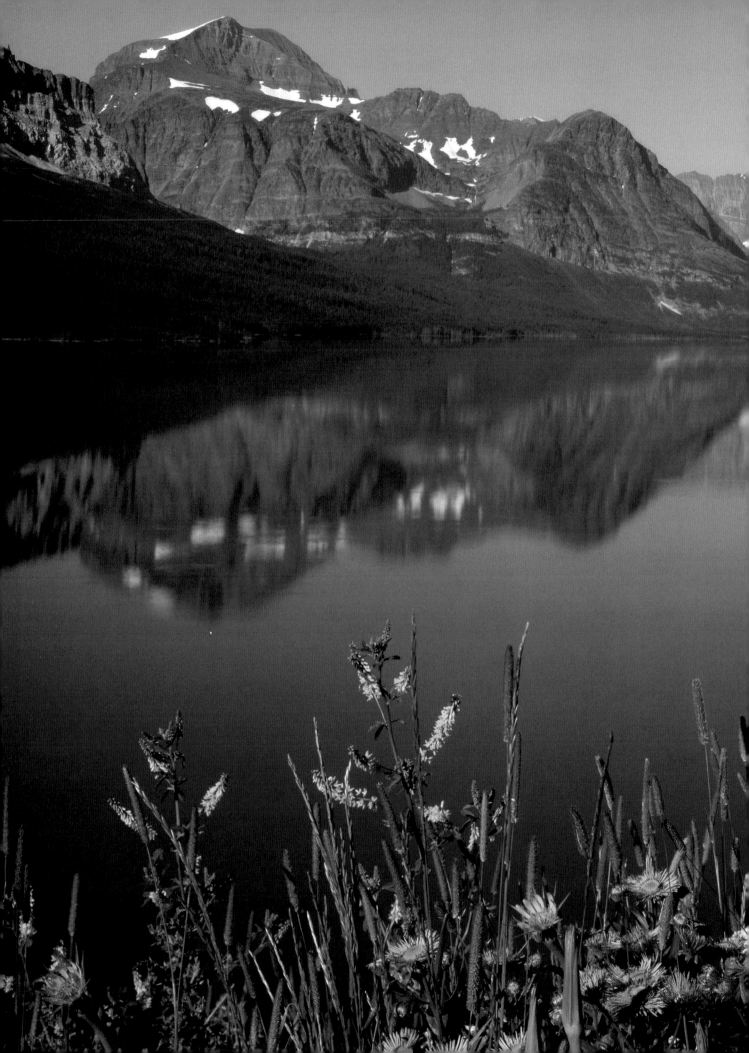

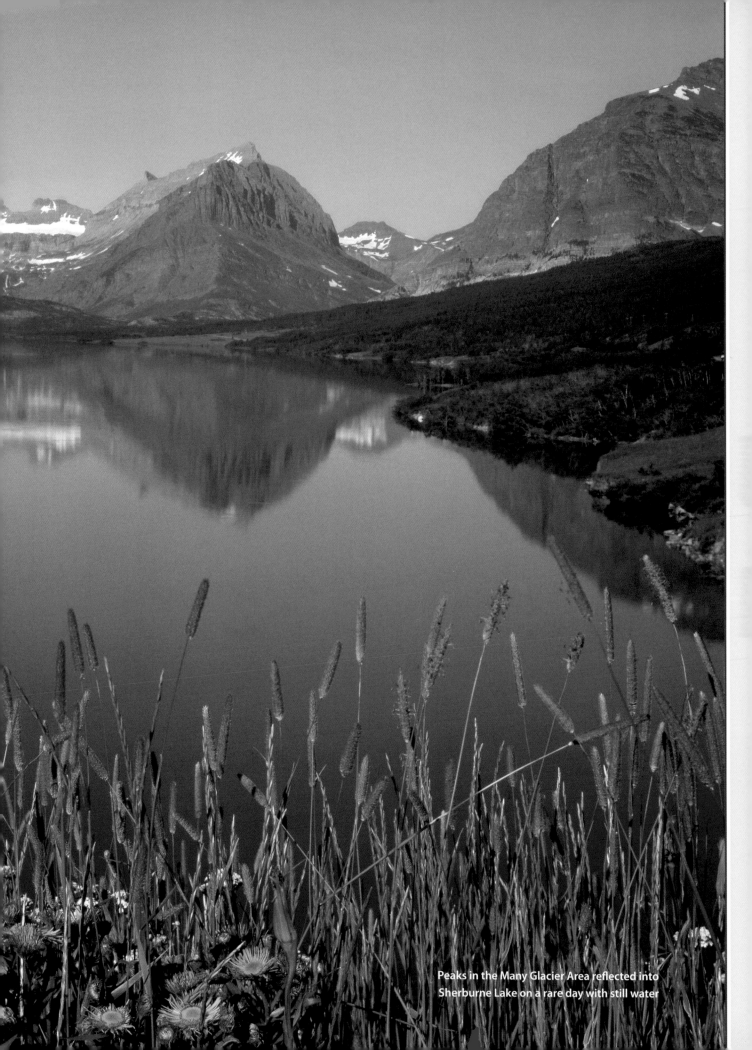

Peaks in the Many Glacier Area reflected into
Sherburne Lake on a rare day with still water

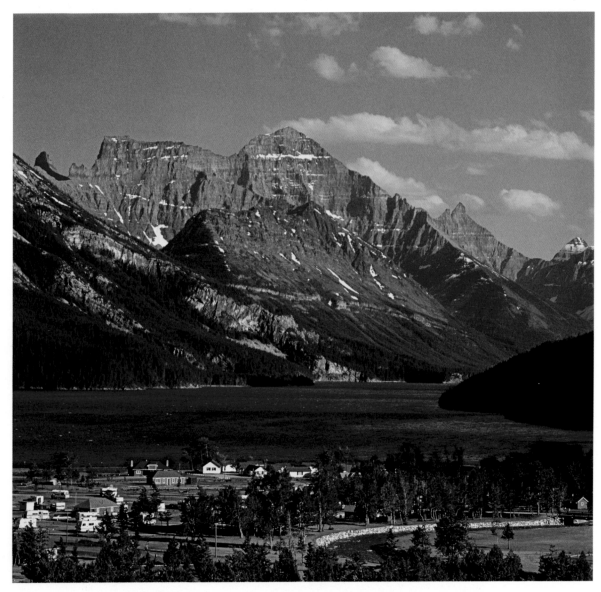

Mount Cleveland and Upper Waterton Lake as seen from Waterton Park

Waterton Lakes Area

▲▲▲

It is at Waterton Lakes that the Canadian Rockies meet the Rocky Mountains of the United States. While Glacier National Park was created in 1910, Waterton Lakes had been designated a national park first, in 1895. Since 1932 the parks have been known collectively as Waterton-Glacier International Peace Park. The international border runs right across Upper Waterton Lake, seen in this view.

In the foreground is the Waterton Park Campground in Alberta, Canada. In the background, looking across the border into the United States, are the mighty ramparts of Mount Cleveland—at 10,479c feet (3,194m), the highest peak in Glacier National Park. The summit of the peak is 6,283 feet (1,916m) above the surface of the lake.

Winter sunrise on Apikuni Mountain

Many Glacier Area

▲▲▲

A road leading 12 miles (19km) west from the community of Babb on U.S. Highway 89 brings you to the Many Glacier Area. Swiftcurrent Lake and the Many Glacier Hotel are located here, surrounded by a panoply of peaks. If you think it was cold when I shot this sunrise view of Apikuni Mountain, 9,068 feet (2,764m), you are correct! The temperature on this early January morning was –25 degrees Fahrenheit (–32 degrees Centigrade).

In the view with Mount Wilbur, 9,321 feet (2,841m) in the background, we see bighorn sheep, *Ovis canadensis*, searching for food in this seemingly inhospitable winter environment. It is almost inconceivable for us humans, with all our creature comforts, to imagine what it would be like to spend an entire winter living outdoors here!

Bighorn sheep and Mount Wilbur

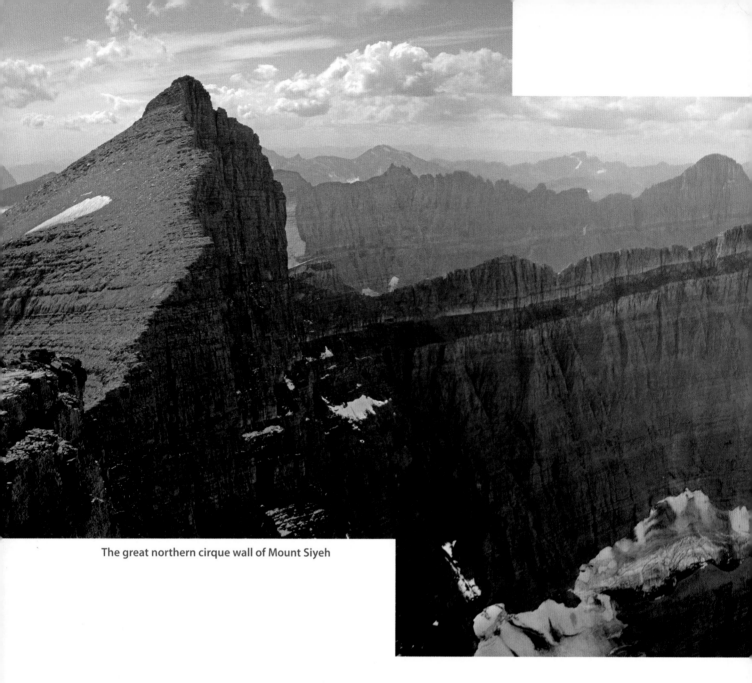

The great northern cirque wall of Mount Siyeh

Peaks Seen or Accessed from
Going-to-the-Sun Highway

▲▲▲

A fairly easy trail (albeit going through meadows frequented by grizzly bears) leaves from the Going-to-the-Sun Highway and leads to the summit of Mount Siyeh, 10,014 feet (3,052m). The strange appearance of this picture is due to the fact that I wanted to give an idea of the breadth of the northern cirque wall of this peak. I digitally patched together two separate views.

While I don't really go into photo techniques in this book, I will mention what I did in this particular case. The two pictures I stitched together were among the earliest photos in my collection appearing in this book, having been taken on August 28, 1957. The originals were two 2¼ color transparencies, badly faded and of different densities. One of the transparencies was a view across the

north face; the other was pointed downward and to the right to capture the right extension of the cirque wall.

I scanned both transparencies and corrected the colors and densities to match (no easy task). When I went to stitch the pictures together, I discovered that I had moved probably 50 to 100 feet (15m to 30m) between the two locations where I had taken the pictures. While I could stitch the cirque wall in the foreground together, the mountains in the background didn't match. I had to isolate the background mountains into yet a third digital image. The resulting match left a few small blank gaps between the foreground and background, which I had to fill by borrowing from nearby areas of the image. But the objective was achieved—showing the extent of the northern cirque wall of Mount Siyeh.

The 4,000-foot (~1,200m) north face, only the upper portion of which is seen in this image, is considered the most difficult climb in Glacier National Park, and it is not without risk due to the friable nature of the rock. The word "Sai-yeh" in the Blackfoot Indian language means crazy dog or mad wolf, and the peak was named after a Blackfoot warrior of this name who was so reckless in battle that none of his tribe members liked to accompany him when raiding enemy tribes.

One of the most interesting areas of Glacier is the area around Triple Divide Peak. In the view with Split Mountain on the right, 8,792 feet (2,680m), and Norris Mountain on the left, 8,882 feet (2,707m), Triple Divide Peak (not quite visible) is located on the continuation of the left-hand ridge of Norris Mountain.

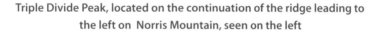

Triple Divide Peak, located on the continuation of the ridge leading to the left on Norris Mountain, seen on the left

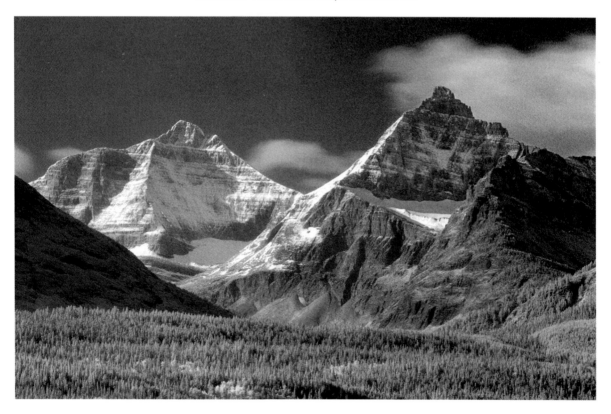

The north face of Fusillade Mountain

The northern drainage below these peaks is Hudson Bay Creek, which works its way down to St. Mary Lake (also in Glacier National Park) and eventually to Hudson Bay in Canada. From here the waters reach the Labrador Sea, which is open to both the Arctic and North Atlantic Oceans. The Continental Divide follows the ridge from Norris Mountain to Triple Divide Peak. The southeastern drainage works its way to Atlantic Creek and, eventually, the Mississippi River and the Gulf of Mexico into the Atlantic Ocean. The western drainage flows into Pacific Creek and, eventually, to the Columbia River and the Pacific Ocean.

The fearsome-looking north face of Fusillade Mountain, 8,750 feet (2,667m), may be seen off to the south (left) shortly after passing the end of St. Mary Lake when heading west on the Going-to-the-Sun Highway. It is easy to miss when traveling east on this same highway because you have to look back to the blind

Mount Reynolds as seen from the meadows above Logan Pass

side of your vehicle. This peak was originally named for a hunter in this area who supposedly had bad aim and had to fire a fusillade of shots to bag his quarry. This north face reminds me of the notorious Eiger (meaning "ogre" in English) north face in the European Alps,

and I am sure that Fusillade Mountain sends down its own fusillade of falling rocks.

The area around Logan Pass, which is at the summit of the Going-to-the-Sun Highway crossing Glacier National Park, presents a wealth of photographic

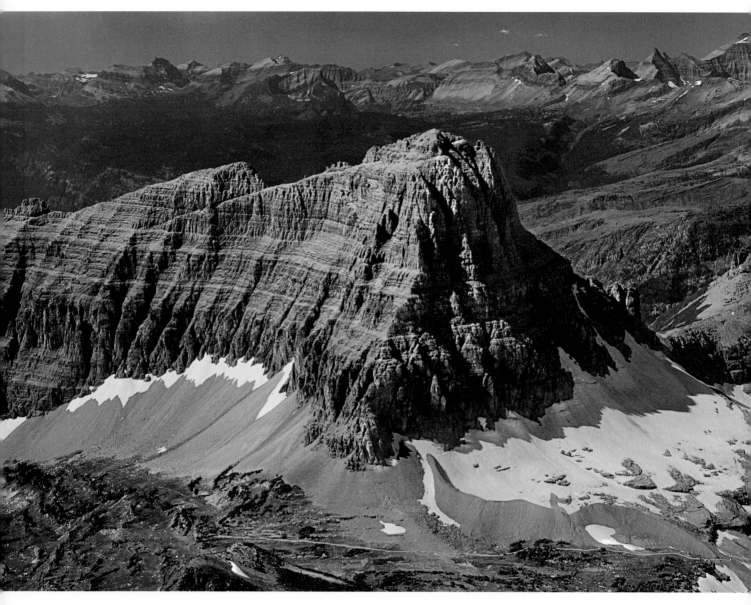

Clements Mountain as seen from Mount Reynolds

opportunities for both the novice and expert. Just point and shoot and you are bound to get some nice pictures. In one view we see Mount Reynolds, 9,125 feet (2,781m), viewed above a small creek in the meadows above Logan Pass.

In a second view we see Clements Mountain, 8,760 feet (2,670m), as seen from the top of Mount Reynolds. There is a small glacier below the east face (in the shade), and the trail to Hidden Lake may be seen near the bottom of the picture. In the background are peaks in Glacier National Park along the Continental Divide. Since both of these peaks (Mount Reynolds and Clements Mountain) are prominent in the Logan Pass area, and both take on a pyramidal aspect from some angles, tourists often confuse them.

Southern Portion of Glacier National Park

▲▲▲

Dominating the Two Medicine Lake area near the southeastern corner of Glacier National Park is Sinopah Mountain, 8,271 feet (2,521m). While not one of the higher peaks in the park, it is one of the more imposing ones. The Two Medicine Area was sacred to the Blackfeet Indian tribe, and vision quests were held in this area. Sinopah was the daughter of Lone Walker, a powerful Blackfeet chief.

Sinopah Mountain and Two Medicine Lake

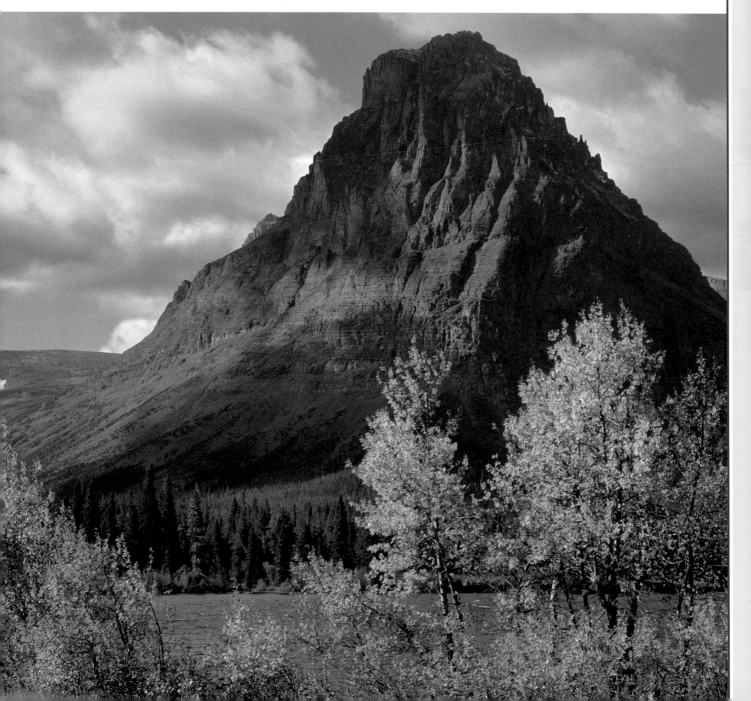

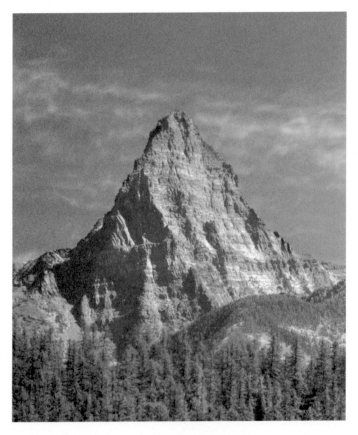

Mount St. Nicholas

Very few visitors to Glacier National Park ever see Mount St. Nicholas, 9,376 feet (2,858m), and it is considered the most difficult of the major summits in the park to reach. It is located in the remote southern part of the park. There is one place along U.S. Highway 2 (which traverses around the southern part of the park), from where this peak may be viewed from the west, weather permitting.

Almost all park visitors, however, choose to go on the Going-to-the-Sun Highway to cross the park. When this highway is closed in the winter months, US 2 must be used instead. "St. Nick," as it is sometimes called, is a classic glacial horn, glaciers on all sides during the Ice Age having carved it into this pyramidal shape. The rock on this peak is reported to be better for climbing than the rock in most areas of Glacier National Park.

Bob Marshall Wilderness Complex

▲▲▲

Immediately south of Glacier National Park lies the Bob Marshall Wilderness complex, occupying 1,535,352 acres (6,070 square kilometers). It is the second-largest wilderness area in the contiguous United States (only the Frank Church River of No Return Wilderness in Idaho is larger).

Named after Bob Marshall (1901–39), a cofounder of the Wilderness Society, this area is actually composed of three separate wilderness areas: Great Bear, Bob Marshall, and Scapegoat. For a distance of about 100 miles (160km) in a north–south direction, not a single road crosses this wilderness, often referred to as "the Bob." The east–west width is approximately 40 miles (64km). In many parts of this wilderness, you are more likely to encounter a grizzly bear than another human being. In fact, the USDA Forest Service says that the density of grizzly bears is higher in this area than anywhere else in the United States outside of Alaska.

The Swan Range forms part of the western border of the Bob. In the view appearing here, taken from a marked view point along State Route 83 south of the town of Swan Lake, we see Swan Peak, 9,291c feet (2,832m). There is also a marker at this location in memory of a man killed while on a climb of McDonald Peak, which is in the Mission Range to the west of the Swan Valley.

Swan Peak as seen from the west

I'm not quite sure why, but I was a little disappointed to learn that Swan Lake (and Swan Peak) have nothing to do with Tchaikovsky or his music. The two theories regarding the origin of the name are that it comes from: (1) Emmet Swan, an early resident of the Swan Valley, or (2) the trumpeter swans that lived on the lake in the late 1800s. No trumpeter swans live in the area currently.

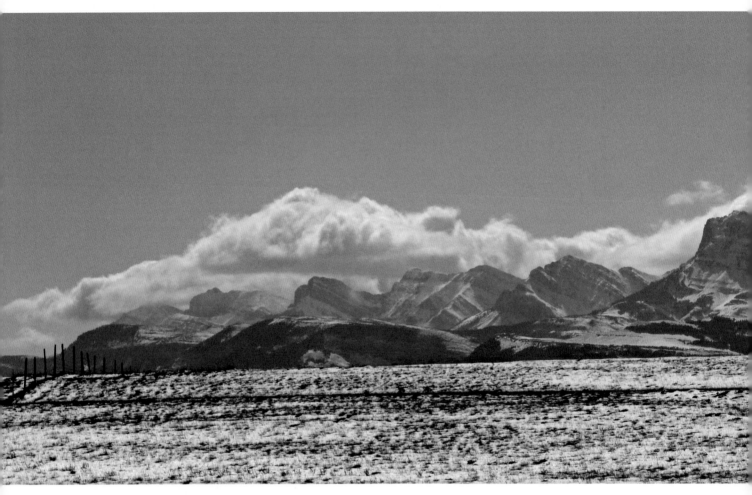

The Rocky Mountain Front, where the Great Plains meet the Rocky Mountains

The Great Plains meet the mountains at the Rocky Mountain Front on the eastern boundary of the Bob. The panoramic view here shows this dramatic meeting. Seen at the very right edge—start of Walling Reef, on the right—is Old Man of the Hills, 8,225 feet (2,507m); and in the center, Mount Frazier, 8,315 feet (2,534m).

All these peaks are in the Sawtooth Range, which is a subrange of the Rocky Mountain Front. Another view shows a spectacular unnamed rock formation in the Sawtooth Range along the South Fork of the Teton River. The road into this area offers one of the very few close approaches to the Bob.

Unnamed rock formation above the south fork of the Teton River

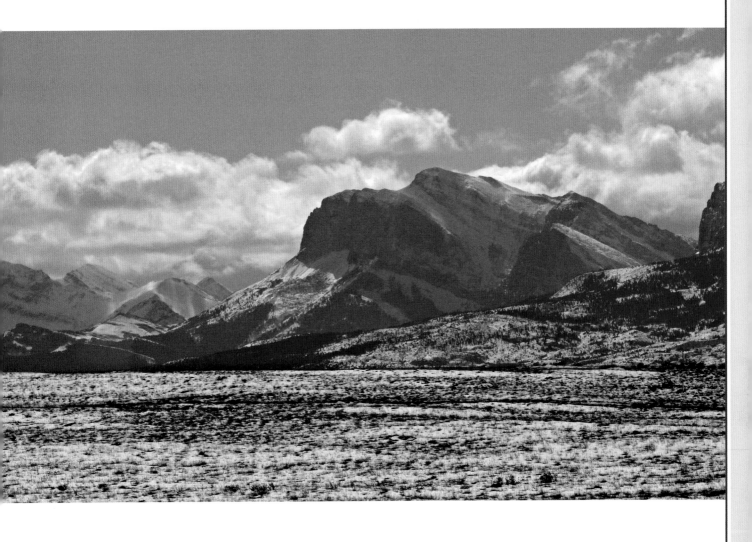

Mission Mountains

▲▲▲

The Mission Mountains were named for the St. Ignatius Mission (in the town of the same name) founded in 1854 by the Jesuits. These peaks rise in spectacular fashion more than 7,000 feet (~2,150m) above the Mission Valley to the west, to the summit of McDonald Peak at 9,820 feet (2,993m). Located southeast of Flathead Lake, these mountains, which run approximately 30 miles (48km) in a north–south orientation, contain two wilderness areas. On the eastern side of the range is the Mission Mountain Wilderness (in Flathead National Forest); on the western side is the Mission Mountains Tribal Wilderness, managed by the Confederated Salish and Kootenai Tribes, the only tribal wilderness in the United States.

McDonald Peak, seen here from the Mission Valley, is located in the tribal wilderness, and contains two small glaciers, one of which is visible in this view. It is unique among high mountain peaks in that it is closed to access from July 15 to October 1 (the prime season for climbing high peaks in the Rocky Mountains) because of the prevalence of grizzly bears.

McDonald Peak is the site of the Grizzly Bear Conservation Zone. This zone was established to prevent human–grizzly bear confrontations. The upper slopes of the peak, around timberline and above, are favorite grizzly bear feeding grounds. The bears eat ladybugs and army cutworm moth larvae that are found in abundance on talus slopes.

A second view shows a sunrise over the northern end of the Mission Mountains, with extra-rich

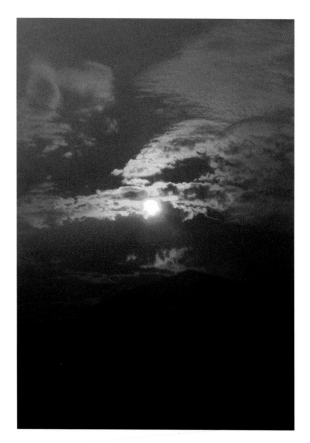

Sunrise over the Mission Mountains as seen through forest fire smoke

colors caused by the sunlight being filtered through the smoke of forest fires, which are unfortunately becoming all too common in the Rocky Mountains in the summer season.

Be advised that the Mission Mountains contain only 45 miles (72km) of trails and these trails are, for the most part, very steep with great elevation gains. These mountains have a reputation for being some of the most rugged hikes/climbs in Montana. A permit is needed for any entry on the western side into the tribal wilderness; these permits can be purchased in most Mission Valley towns.

McDonald Peak as seen from the Mission Valley

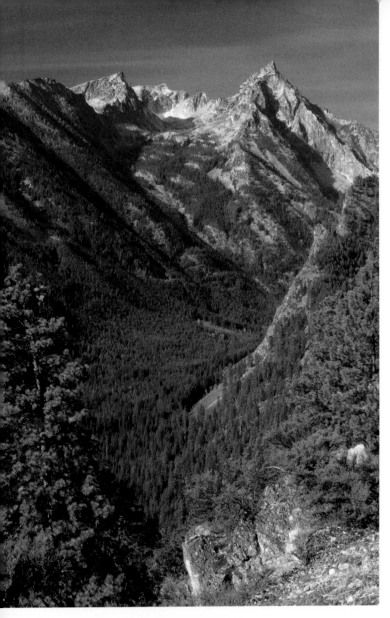

Trapper Peak as seen from Trapper Peak Observation Point

Bitterroot Range

▲▲▲

The Bitterroot Range is composed of five separate subranges: the Saint Joe Mountains, Coeur d'Alène Mountains, Centennial Mountains, Bitterroot Mountains, and Beaverhead Mountains. The Bitterroot Range, with a northwest–southeast orientation, is the longest range in the Rocky Mountains. From Cabinet Gorge in the north to Monida Pass in the south, the distance is about 325 miles (520km) as the crow flies. But the actual dis-

tance is much longer because of zigzagging. The range follows (more or less) the Idaho-Montana border, and the Continental Divide runs along its southern portion. The name "Bitterroot" comes from the small pink flower that is the Montana state flower. Its botanical name is *Lewisia rediviva*, named for Meriwether Lewis of Lewis and Clark fame. Native Americans used the roots of these plants (before the flowers bloomed) for food.

The most interesting portion of the Bitterroot Range is the subrange called by the same name: the Bitterroot Mountains. These two are not to be confused with each other, and this nomenclature has no doubt given fits to mapmakers.

The best views and easiest access to the Bitterroot Mountains are from the Bitterroot Valley to the east of the mountains. When traveling southbound on U.S. Highway 93 south of the town of Lolo, you will begin to see a series of deep canyons carved by Ice Age glaciers. Just south of Darby, your attention will be drawn to Trapper Peak, 10,157 feet (3,096m), to the western side of the highway.

This is the highest peak in the Bitterroot Mountains. It lies wholly within the state of Montana and is composed of granite, making it a delight to the mountaineer and to the rock climber. In the view seen here, taken from Trapper Peak Observation Point, we are looking at Trapper Peak rising above Trapper Creek. The highest point is the peak in the center with snow on it. The pointy peak to the right is North Trapper Peak, 9,801 feet (2,987m). Both are in the Bitterroot Wilderness in Bitterroot National Forest.

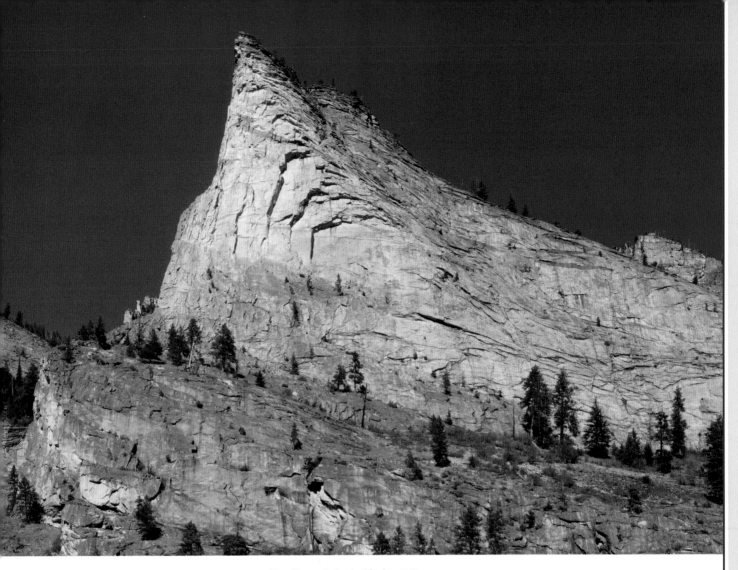

Nez Perce Spire in Blodgett Canyon

Many of the canyons are destinations in themselves. The premier center for rock climbing in western Montana is located in Blodgett Canyon, just west of Hamilton. Steep granite walls line this canyon, and there are rock routes up to 1,200 feet (~365m) in length. Two of the notable formations are seen here: Nez Perce Spire, 6,322 feet (1,927m), is the sharply pointed peak. Flathead Buttress, 6,665 feet (2,031m), looks something like Sentinel Rock in Yosemite Valley. There is a pleasant but rather small campground at the entrance to Blodgett Canyon, likely to fill early on weekends from spring to fall.

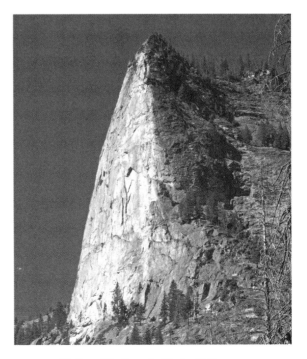

Flathead Buttress in Blodgett Canyon

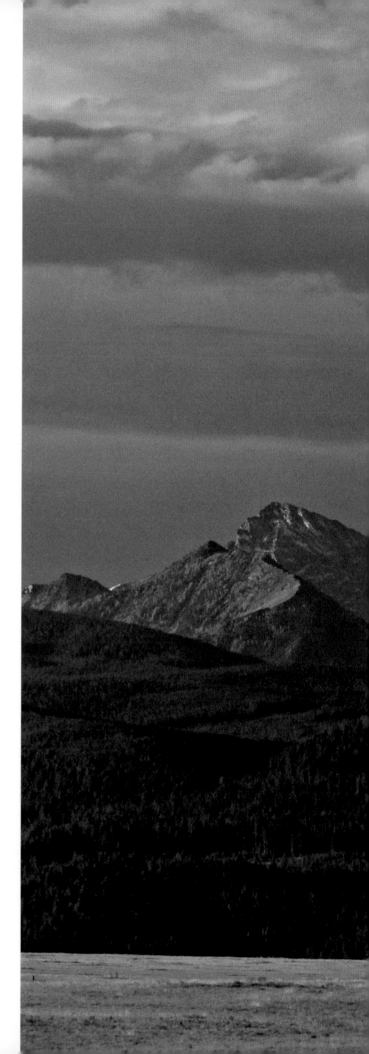

Anaconda Range

▲▲▲

The Anaconda Range extends about 50 miles (80km) from near the town of Anaconda to Chief Joseph Pass, in a northeast–southwest orientation. The Continental Divide runs along the crest of the range, much of which is included in the Anaconda-Pintlar Wilderness. Peaks in this range are not climbed very often because of their isolation and the fact that many of the peaks have no trails near them. Route finding and making your own trail are the two major challenges found in this range.

Warren Peak, 10,468c feet (3,191m), one of the higher and more prominent peaks in the range, is seen here viewed from the north. The peak to the left, 10,264c feet (3,128m), is connected to Warren Peak by a mile-long (1.6km) ridge, and although it is unnamed, it might be thought of as East Warren Peak.

Warren Peak (right) as seen from the north

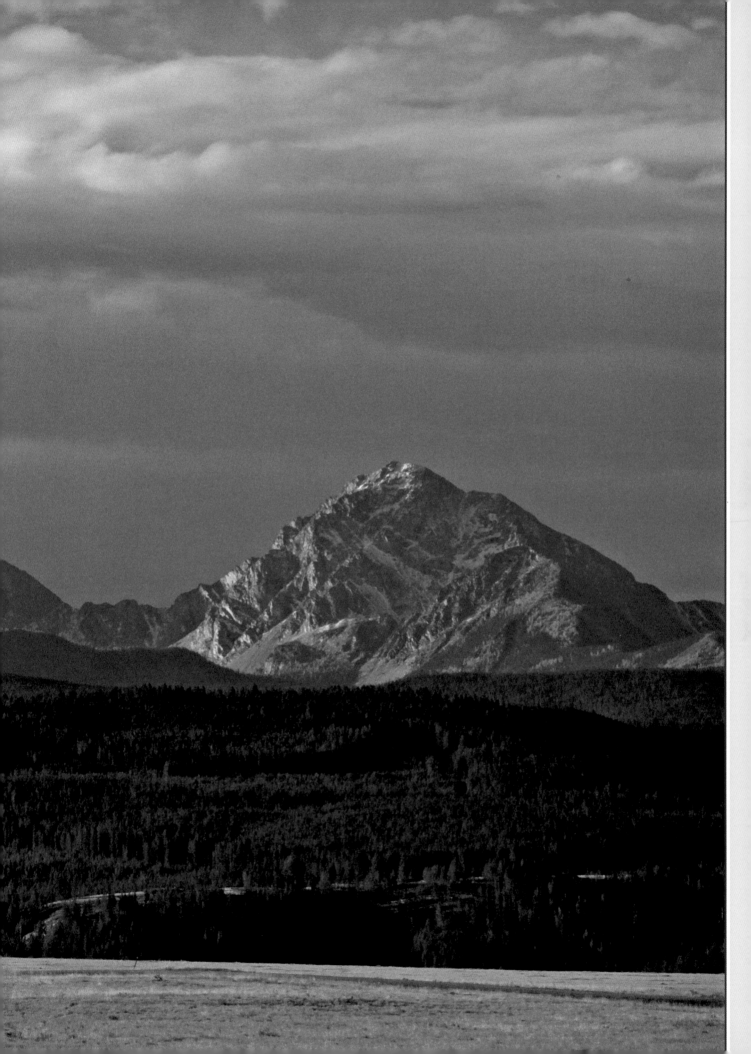

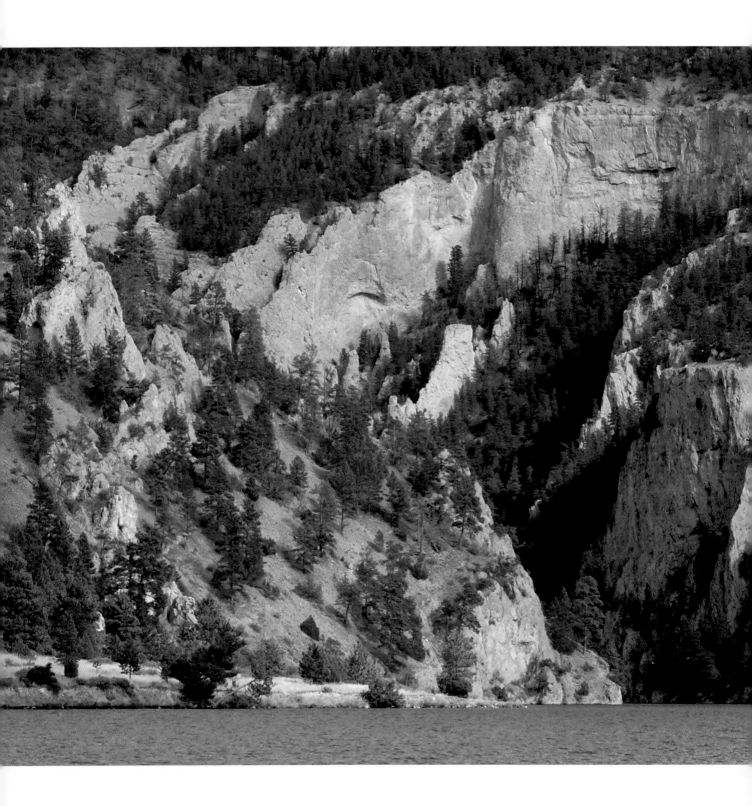

Gates of the Mountains

▲▲▲

On July 19, 1805, Meriwether Lewis (of Lewis and Clark) wrote in his journal of this area, "…the most remarkable clifts [sic] that we have yet seen. I called it the gates of the rocky mountains." Here the Missouri River is lined by 1,200-foot (~365m) limestone cliffs that were formed as the river carved its path through the Big Belt Mountains. This area, about 20 miles (~32km) north of Helena, is now designated as Gates of the Mountains Recreation Area. In the view appearing here we see Upper Holter Lake and the limestone cliffs above the entrance to Gates of the Mountains. One can take boat tours through this canyon in the summer months.

Entrance canyon to the Gates of the Mountains

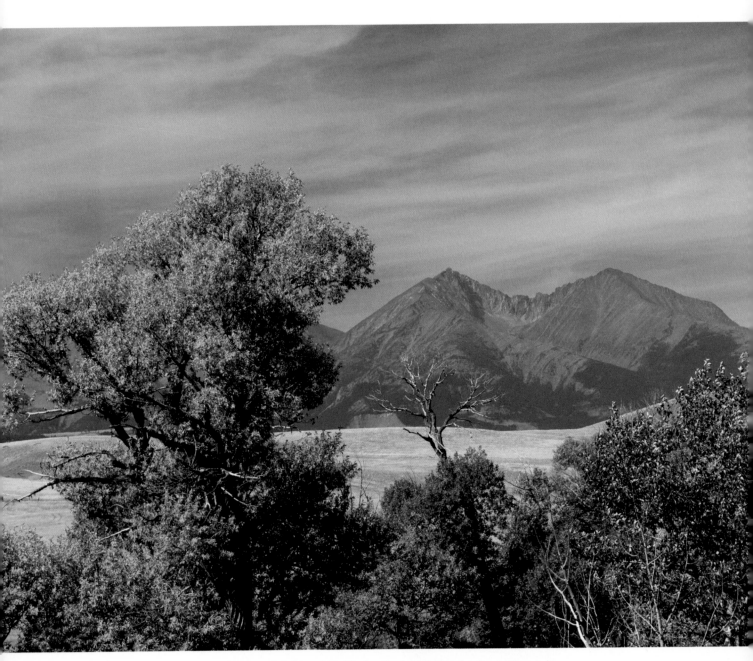

Crazy Peak (left) and Big Timber Peak (right) in the Crazy Mountains

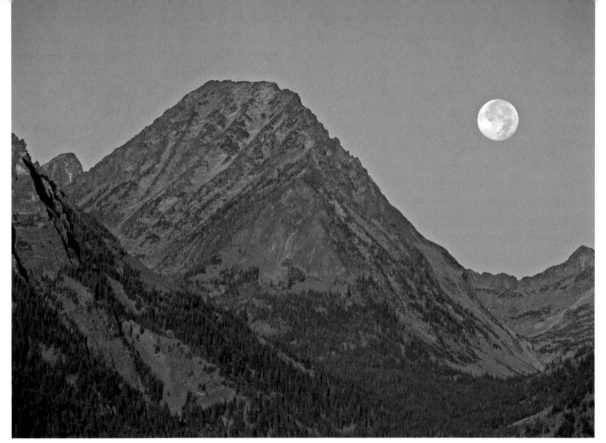

Moon over Granite Peak

Crazy Mountains

▲▲▲

The Crazies are an island mountain range, rising from the Great Plains on the east, and isolated from other ranges in the Rocky Mountains and the Continental Divide by semiarid desert areas. These mountains, 40 miles (64km) long in a more or less north–south orientation and 15 miles (24km) wide in a more or less east–west orientation, are the most spectacular alpine range in Montana without wilderness protection; also they form one of the largest exposed blocks of igneous rock in the world.

The Crazies rise 7,120 feet (2,170m) above the nearest town of any size, Big Timber to the southeast. From there they dominate the skyline. Crazy Peak, at 11,209 feet (3,417m), is the highest peak in Montana north of the Beartooth Range. The view seen here, framed by the autumn colors of cottonwood trees along Big Timber Creek, shows Crazy Peak as the left of two summits. On the right is Big Timber Peak, 10,795 feet (3,290m).

A second view shows sunrise on Granite Peak, 10,132 feet (3,088m), with the moon setting over its right shoulder. (This is not a fake moon inserted for effect, a common practice with postcard and poster manufacturers.) This peak is not to be confused with the Granite Peak in the Beartooth Range, the highest peak in the state, some 60 miles (96km) to the south of this peak with the same name.

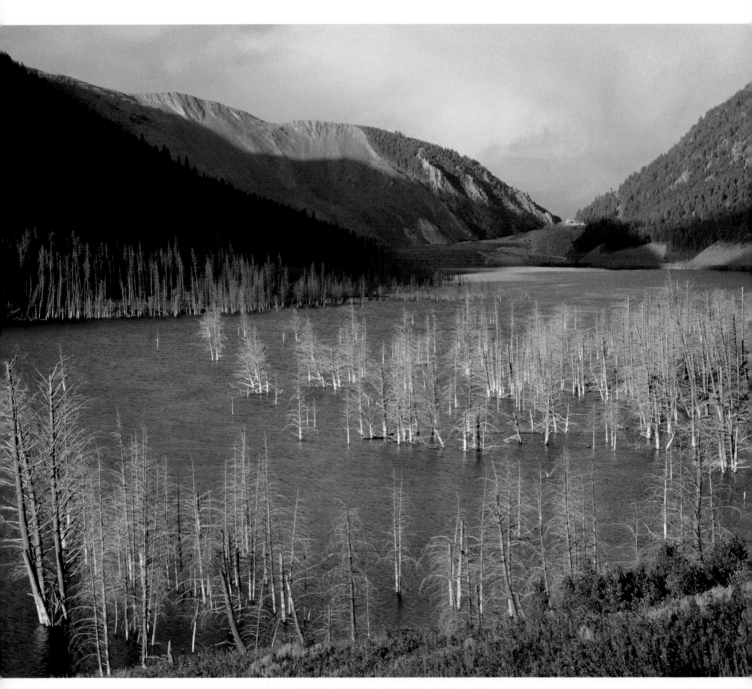

Earthquake Lake in Madison Canyon

Mountain-Building and Earth-Shaping Forces

▲▲▲

At 11:37 p.m. on August 17, 1959, the earth moved in the Madison Range, and an earthquake of magnitude 7.1 centered near the Madison River Canyon made itself felt in an eight-state area. Two large blocks of the earth's crust broke and tilted toward the north. A portion of a mountainside broke away and filled the mouth of the Madison River Canyon to depths of 200 to 400 feet (~60m to 120m). The amount of rock that fell was sufficient to fill Pasadena's Rose Bowl to the brim ten times over.

Hundreds of vacationers had been asleep in camps, trailers, and lodges along the Madison River and nearby Hebgen Lake. For twenty-eight persons, this slide became their final resting place. A new lake was formed in the now dammed Madison River Canyon and given the name Earthquake Lake. In this view of the lake, we see trees that have been killed by the rising waters. The great slide may be seen at the end of the lake. U.S. Highway 287 passes through this area, which is located in Gallatin National Forest northwest of West Yellowstone.

A second view in this area shows the earthquake rift. It is some 6 feet (1.8m) high. This earth movement is a reminder to us that the processes of mountain building and earth shaping are continual. Our lives are so short on the geological time span that we see only small changes here and there. Yet, as the millennia roll on, these small changes both build mountains and wear them down, and create such wonders as the Grand Tetons and the Grand Canyon.

Earthquake rift near Earthquake Lake

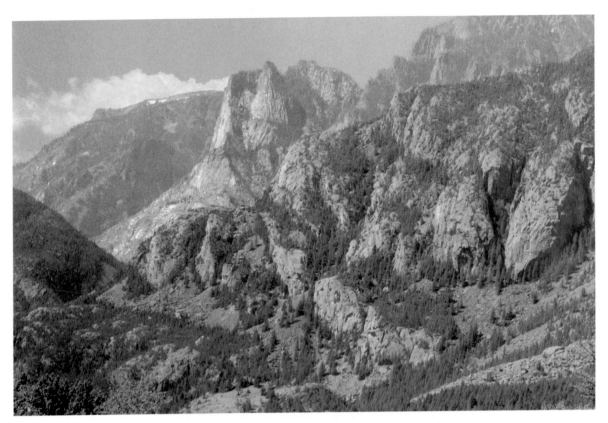

Granite formations in the Stillwater Creek Valley

Beartooth Mountains

▲▲▲

The Beartooth Mountains are located in Montana north and east of Yellowstone National Park, with a small portion of the southern end of the range in Wyoming. These mountains contain some of the oldest rock on earth—Precambrian granite and crystalline metamorphic rocks—up to four billion years old. The Beartooths are home to Montana's only peaks over 12,000 feet (3,658m), twenty-seven of them. There are also about twenty-five small glaciers. Much of the beauty of this range is hidden from the casual observer, although one can get glimpses of some of the peaks from the Beartooth Scenic Byway (U.S. Highway 212), which skirts the southeastern side of the range.

The Stillwater Creek Valley, on the north side of the Beartooth Mountains, shows the granite typical of the Beartooths. To me, this valley is somewhat reminiscent of the glacially carved granitic canyons on the western side of the Sierra Nevada in California, specifically Hetch-Hetchy or Kings Canyon. Cathedral Point, 8,800 feet (2,682m), the granite formation in the upper center of the photo above, has an appearance similar to that of the Grand Sentinel in Kings Canyon. Although a paved road leads to the mouth of the Stillwater Creek Canyon, this impressive area is practically unknown. It does not appear to be on anybody's tourist radar screen.

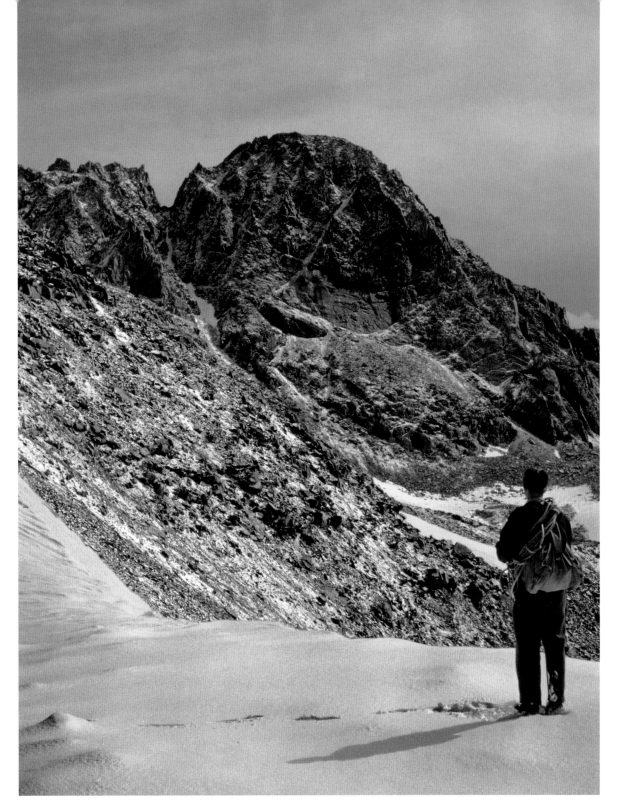

Granite Peak as seen from the southwest

Granite Peak itself, 12,807c feet (3,904m), is the highest peak in the state of Montana and is here viewed from the southwest, an angle of view almost never seen. Granite Peak is considered the most diffi- cult to reach of the state high points in the contiguous United States. Difficulty of access has as much to do with this as the difficulty of the climb itself.

One of the most isolated of the summits in the

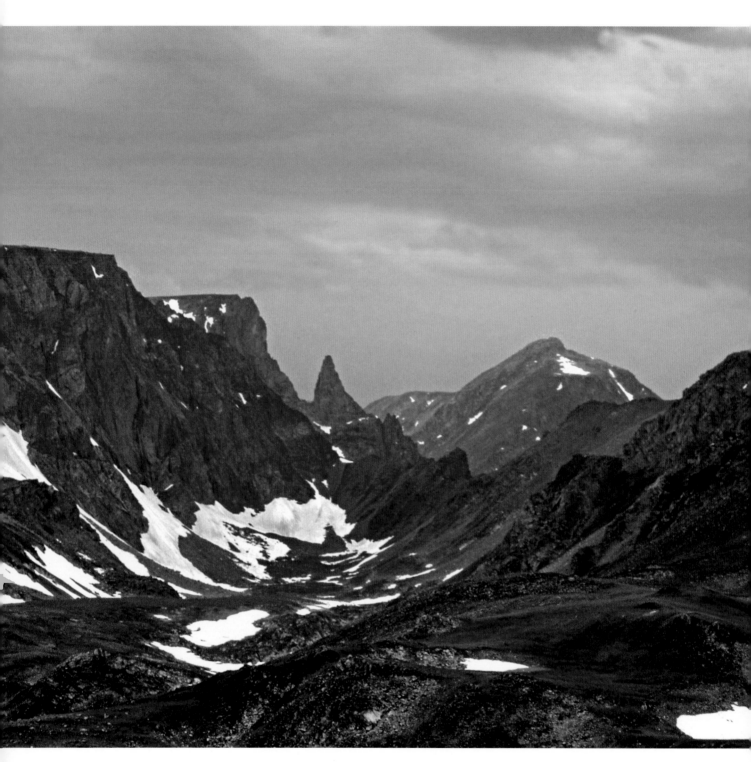

The Bears Tooth as seen from the Beartooth Highway

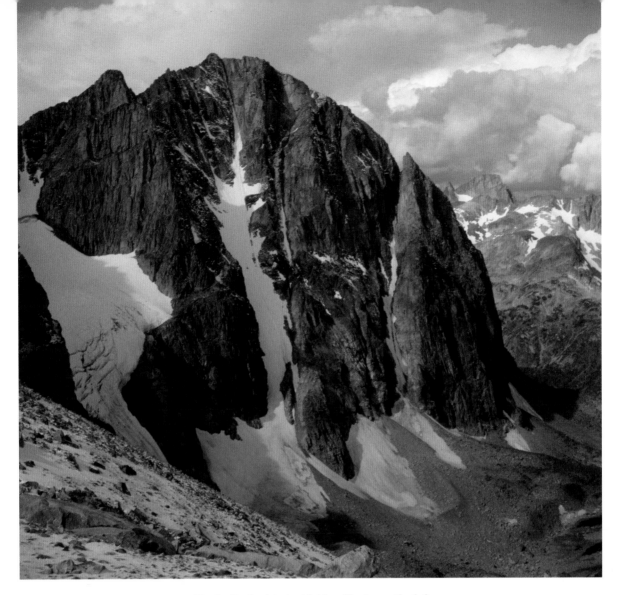

Glacier Peak with the Hidden Glacier on the left

Beartooth Mountains is that of Glacier Peak, 12,359c feet (3,767m). It is more difficult to reach than Granite Peak, although no less spectacular. This view shows the steep north face with its granite ramparts. Seen on the left is the Hidden Glacier.

Visible from the Beartooth Scenic Byway (US 212) is the Bears Tooth, from which the Beartooth Mountains received their name. This name is a direct translation from the Crow Indian name ("na pet say"). Immediately to the left of the Bears Tooth is Beartooth Mountain, 12,351 feet (3,765m). The peak on the left edge of the picture appears higher only because of perspective (this picture was taken with the camera pointing slightly upward).

As shown on the next two pages, the jagged profile of Sawtooth Mountain, 11,488 feet (3,502m), reflected into Goose Lake, is one of the premier viewpoints in the Beartooth Mountains. A rough road leads to about 1 mile from Goose Lake, and the rest of the distance is by foot. Also reachable by trail in this area is the Grasshopper Glacier, which contains untold numbers of frozen grasshoppers, including one species that has since become extinct.

Montana Peaks and Locations Featured

Apikuni Mountain [M-08007]..48.8360N/113.6542W

Bears Tooth [M-08701]..45.0620N/109.5593W

Beartooth Mountain [M-08701]..45.0608N/109.5684W

Big Timber Peak [DM8722]..46.0245N/110.2616W

Cathedral Point [1M8715]..45.3105N/109.9517W

Clements Mountain [108161]...48.6925N/113.7410W

Mount Cleveland [1M3021]..48.9248N/113.8480W

Crazy Peak [DM8722]..46.0182N/110.2766W

Earthquake Lake (near Madison Slide) [1A8607].................44.830N/111.423W

Earthquake rift [T-A8603]..near Earthquake Lake

Flathead Buttress [DM8535]..46.2785N/114.2875W

Mount Frazier [DM8409]...48.0179N/112.7518W

Fusillade Mountain [108166]...48.6398N/113.7231W

Gates of the Mountains (entrance) [DA8301].......................46.8303N/111.9354W

Glacier Peak [T-108805-B]..45.1500N/109.8494W

Granite Peak (Beartooth Range) [T-108805-C].....................45.1634N/109.8075W

Granite Peak (Crazy Mountains) [DM8710].........................46.0376N/110.3044W

McDonald Peak [DA8208]...47.3826N/113.9191W

Nez Perce Spire [DM8537]..46.2772N/114.2775W

Norris Mountain [208157]...48.5767N/113.5337W

North Trapper Peak [DM8519]..45.9005N/114.2905W

Old Man of the Hills [DM8409]...48.0529N/112.7729W

Mount Reynolds [1M8250]..48.6715N/113.7238W

Mount Saint Nicholas [108260-V]..48.3914N/113.5505W

Sawtooth Mountain [1M8706]...45.1396N/109.9007W

Sinopah Mountain [1M8301]..48.4630N/113.4123W

Mount Siyeh [T-108105]..48.7286N/113.6498W

Split Mountain [208157]..48.5978N/113.5391W

Sunrise over the Mission Mountains [DA8227].....................North of McDonald Peak

Swan Peak [DM8402]...47.7193N/113.6415W

Trapper Peak [DM8519]...45.8898N/114.2977W

Triple Divide Peak [208157]..48.5728N/113.5169W

Unnamed rock formation [DM8417]......................................47.8623N/112.6992W

Warren Peak [DM8544]..45.9864N/113.4597W

Mount Wilbur [M-08026-12]...48.8055N/113.7394W

The numbers in brackets are the author's file numbers for the images.

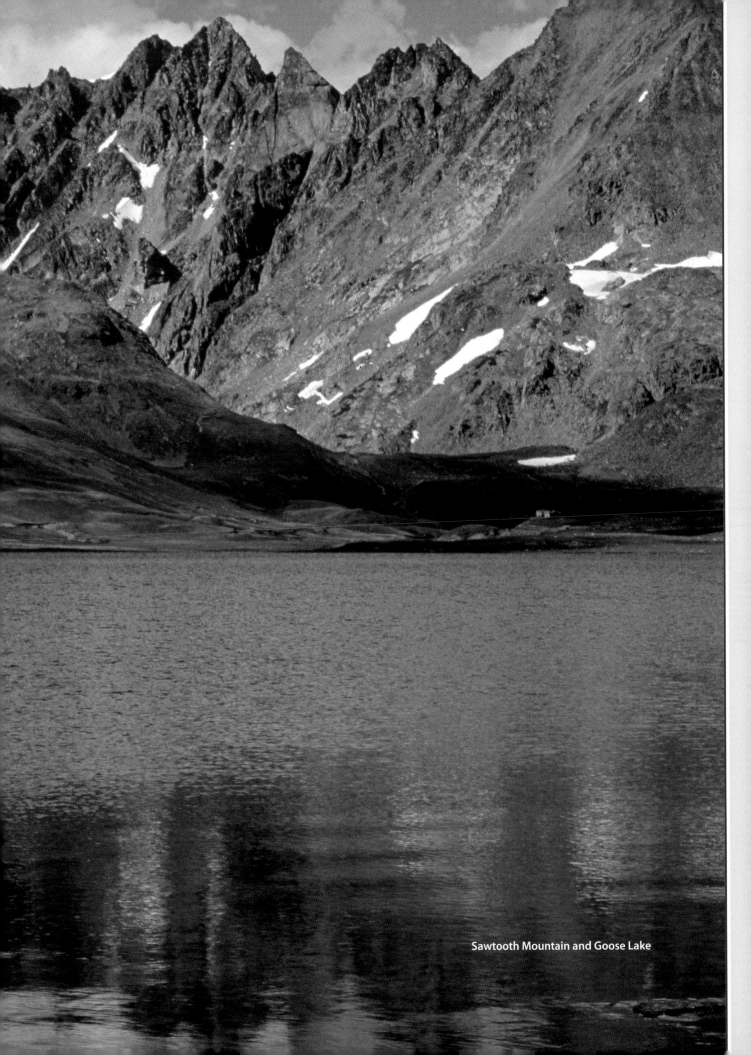

Sawtooth Mountain and Goose Lake

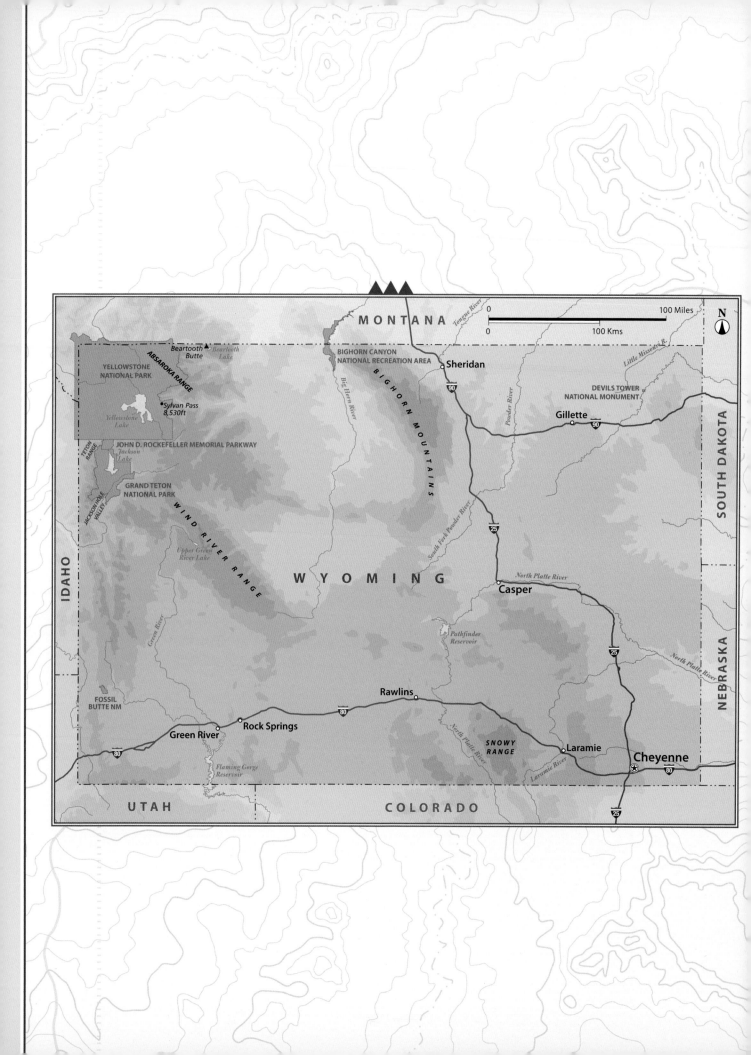

WYOMING

Beartooth Butte

▲▲▲

A small portion of the Beartooth Mountains extends into Wyoming, just east of Yellowstone National Park. Unlike many of the peaks of this range, Beartooth Butte, 10,518c feet (3,206m), permits one a front row view. The peak is seen here reflected into Beartooth Lake, which is flanked by the Beartooth Scenic Byway (U.S. Highway 212).

The rock here is quite different from the bulk of the Beartooth Range. Rising 1,500 feet (457m) above the lake, the lower part of Beartooth Butte is a remnant of ocean-deposited sedimentary rocks. The upper part of the mountain consists of compacted sand and mud that was deposited in an ancient stream channel after the area was lifted above sea level. The area abounds in fossils.

Beartooth Butte reflected in Beartooth Lake

Absaroka Range

▲▲▲

The north end of the Absaroka Range is in Montana, just north of Yellowstone National Park and west of the Beartooth Mountains. The range extends southward through the eastern portion of Yellowstone National Park and the adjacent Shoshone National Forest (in Wyoming), and then continues southward. All in all, the range is about 165 miles (264km) long and 75 miles (120km) wide at its widest point. While the most northerly peaks are granitic, the bulk of the range was formed from the erosion of ancient volcanic flows, with a few peaks being sedimentary in nature.

The Absaroka Range has one other distinguishing characteristic: It is home to a large population of grizzly bears. From the point of view of the wilderness travelers in this range, the potential problem is further exacerbated by the fact that unruly grizzly bears in Yellowstone are removed to remote parts of the Absaroka Range. In the few roads that penetrate into this wilderness southeast of Yellowstone National Park, signs in campgrounds threaten campers with hefty fines for leaving any food within the reach of bears.

Barronette Peak

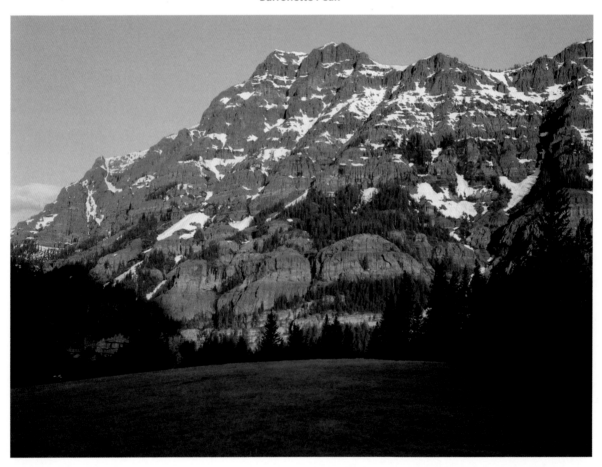

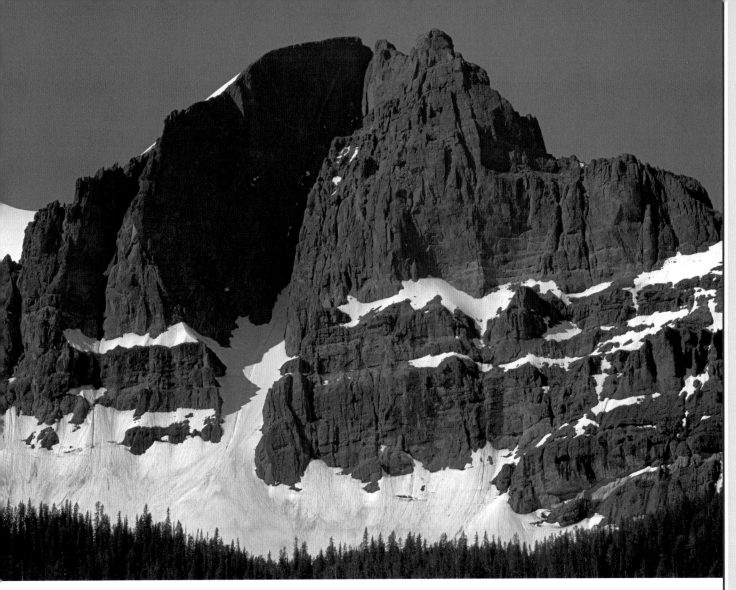

The north side of Abiathar Peak

All this being said, the nature of the rock and past glaciation have produced peaks that will inspire the imagination of any mountain lover. "Absaroka" is the Indian name for the Crow Nation, and in translation means "sparrow hawk people."

Barronette Peak, 10,449c feet (3,185m), seen at sunrise, is located in Yellowstone National Park near the northeast entrance. In recent years this peak has become a favorite viewing area for tourists looking for mountain goats. These goats are not native to this area, but were introduced into Montana between 1942 and 1959 in the Beartooth Mountains and Absaroka Range north of Yellowstone National Park. The mountain goats successfully colonized Yellowstone National Park in the 1980s. There seems to be some ambivalence on the part of park authorities as to whether goats in Yellowstone are a good idea—they do eat some native vegetation that would otherwise remain undisturbed.

Abiathar Peak, 10,935c feet (3,333m), is located only a little more than a mile (1.6km) west of the eastern boundary of Yellowstone National Park. The ramparts of the north side of this peak, seen here, are as rugged as any in the Absaroka Range. The original Abiathar was a priest in the Old Testament who served under Kings Saul and David but fell into disfavor under King Solomon. The peak was, however, actually named

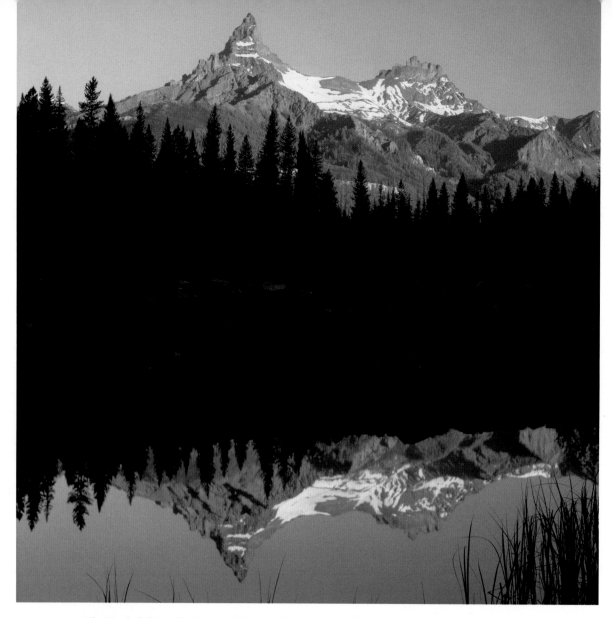

Pilot Peak (left) and Index Peak (right) reflected in the Clarks Fork of the Yellowstone River

for Charles Abiathar White, a paleontologist with the U.S. Geological Survey. (Who would give a child the name of Abiathar?)

Pilot Peak and Index Peak, located in Shoshone Forest east of the northeast entrance to Yellowstone National Park, form one of the distinguishing landmarks of the Absaroka Range and of the Rocky Mountains in northern Wyoming. The view seen here shows a sunrise on the peaks, reflected into a backwater of the Clarks Fork of the Yellowstone River. Pilot Peak (left), 11,708 feet (3,569m), and Index Peak (right), 11,254 feet (3,430m), are volcanic in origin. Pilot Peak is visible

from a long distance from every side; hence, it formed a landmark for early travelers in the area. Index Peak received its name because from some angles it looks like a closed hand with the index finger extended upward.

From below Sylvan Pass, near the east entrance to Yellowstone National Park, we see pristine forest and snow-covered mountain peaks. This is typical of the remote wilderness character of the Absaroka Mountains. Visitors to this area can expect few trails and a total wilderness experience, at the same time needing to remember that human beings are *not* at the top of the food chain.

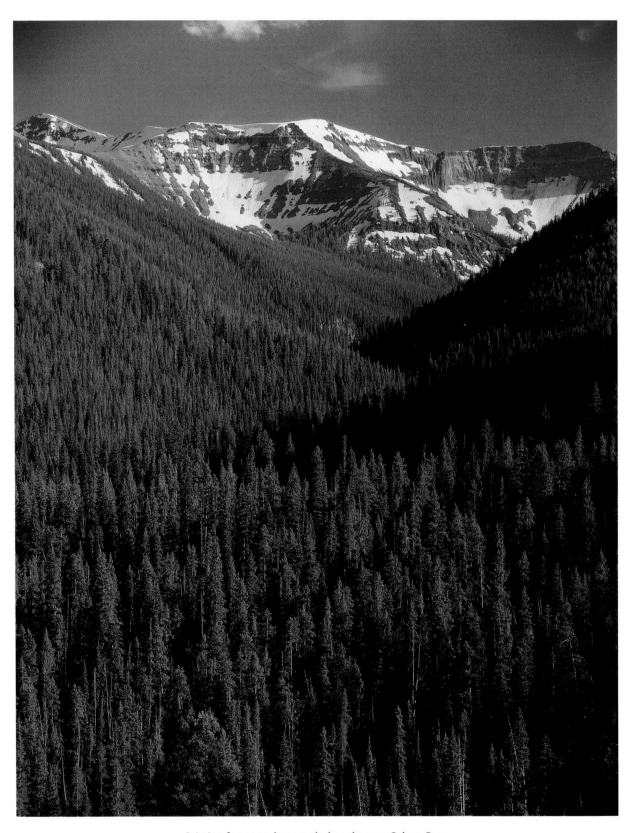

Pristine forest and snow-clad peaks near Sylvan Pass

Teton Range

▲▲▲

Running a little over 40 miles (64km) in a north–south direction, the Teton Range provides a mountain panorama unequalled elsewhere in the Rocky Mountains. This range, the youngest in the Rockies at six million to nine million years old, was formed by fault blocking. The western side of the fault rose, forming the Teton Range, while the eastern side of the fault sank, forming Jackson Hole. The origin of the name Teton is a name given by French trappers in the early nineteenth century, *trois tétons*, meaning "three teats." There is some confusion as to whether these early trappers meant the Tetons themselves or some butte formations near Craters of the Moon National Monument in Idaho.

While the Yellowstone area to the immediate north of the Tetons was made the first national park in the world in 1872, it wasn't until 1929 that this status was conferred on the Tetons, when Grand Teton National Park was created. Despite this "late" start, the Tetons and Jackson Hole have become nearly as popular as the better-known Yellowstone National Park. Indeed, most visitors to the area visit both parks. This popularity tests the nerves of those seeking serenity and solitude. On a daily basis numerous parties attempt to ascend the peaks clustered close to the Grand Teton. Even so, these peaks attract—year after year—thousands of photographers, artists, and sightseers.

Autumn is a delightful time to visit the Tetons. All the children are back in school, and the summer crush of visitors is over. In addition, the numerous aspen trees in Jackson Hole provide a colorful foreground to the peaks. Viewed here is Mount Moran, 12,610c feet

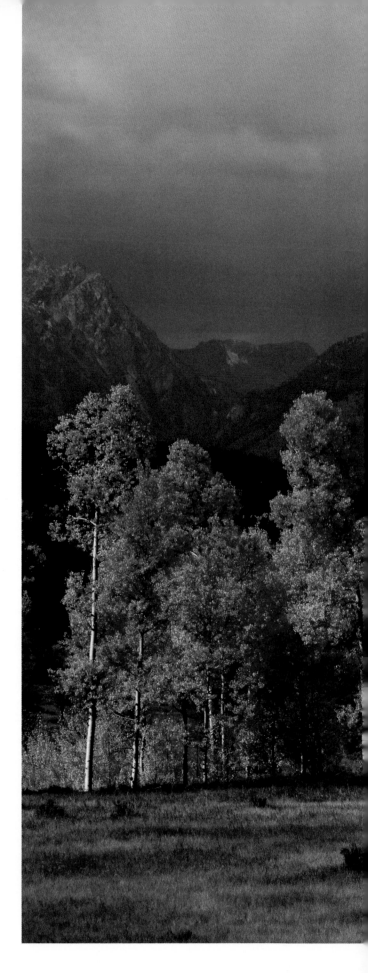

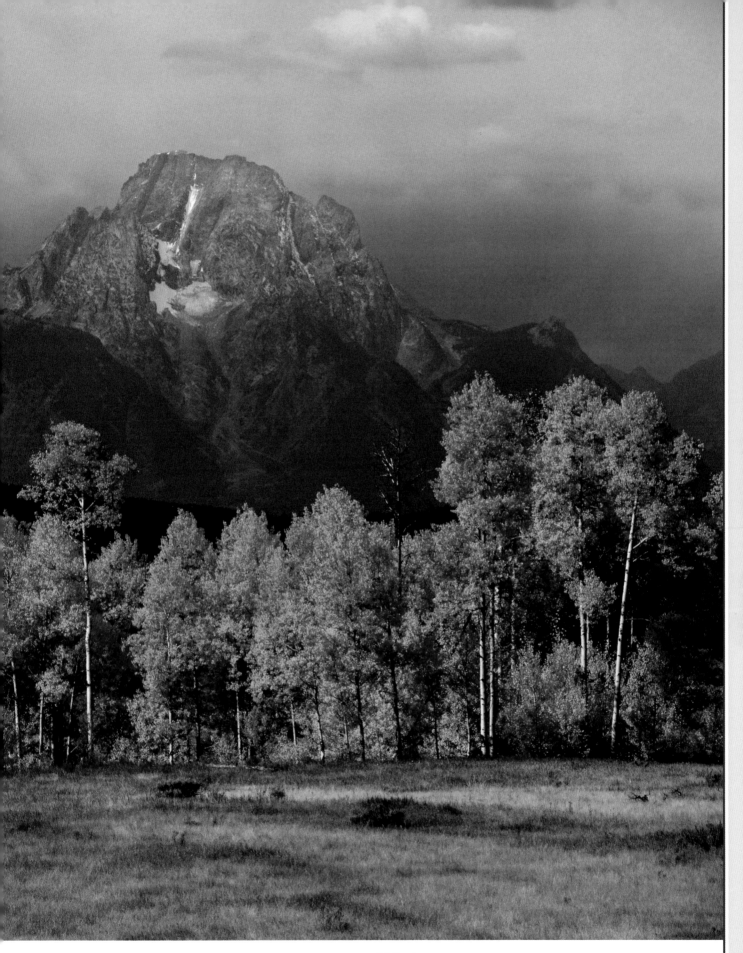

Mount Moran and fall colors

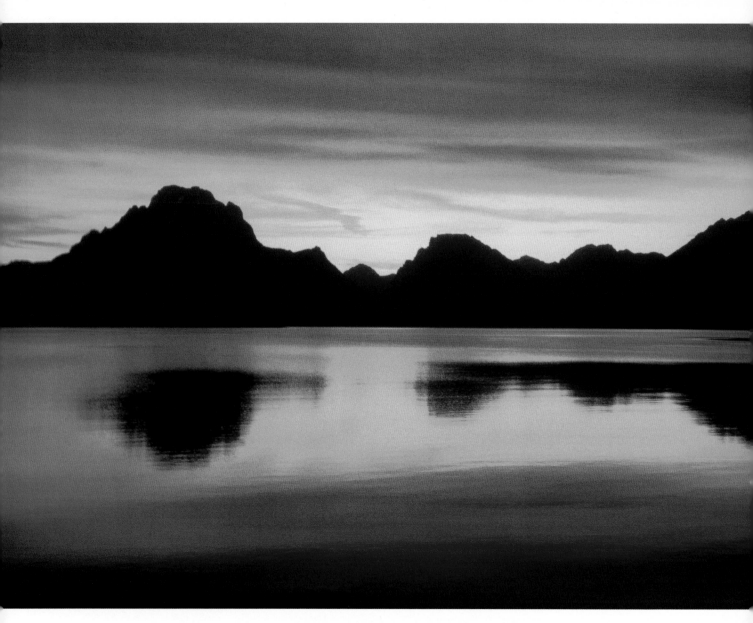

Sunset colors and the Teton Range reflected in Jackson Lake

(3,844m), the fourth-highest and most massive peak in the Teton Range, with storm clouds gathering behind the peak.

The Skillet Glacier descends on the east face (seen in this view), with the prominent black dike to the left descending the southwest face. The black dike is composed of diabase, a dark-colored igneous rock, which flowed up through overlying granite and gneiss rock. On November 21, 1950, a DC-3 airplane with twenty-one people aboard, including seven children, crashed into Mount Moran at the 11,200-foot (3,414m) level above the Skillet Glacier. Climbers ascending this route are asked not to disturb any part of the crash site.

Mount Moran is named after Thomas Moran (1837–1926), the famous artist of nineteenth-century American landscapes. I am sure Moran would be pleased with this peak having been named for him.

Another view shows Mount Moran (on the left) reflected into Jackson Lake at sunset. The flat-topped peak in the center is Bivouac Peak, 10,830c feet (3,301m), and the peak on the right edge is Eagles Rest Peak, 11,263c feet (3,433m).

Jackson Hole is still an active ranching area within Grand Teton National Park, as can be seen in this view with the magnificent profile of the Teton Range rising in the background. Scenes such as this are common along the John D. Rockefeller Memorial Parkway. In fact, for the photographer, it is difficult to make any progress on this road, as there is always a stunning view just a little farther along demanding to be photographed.

Jackson Hole and the Teton Range

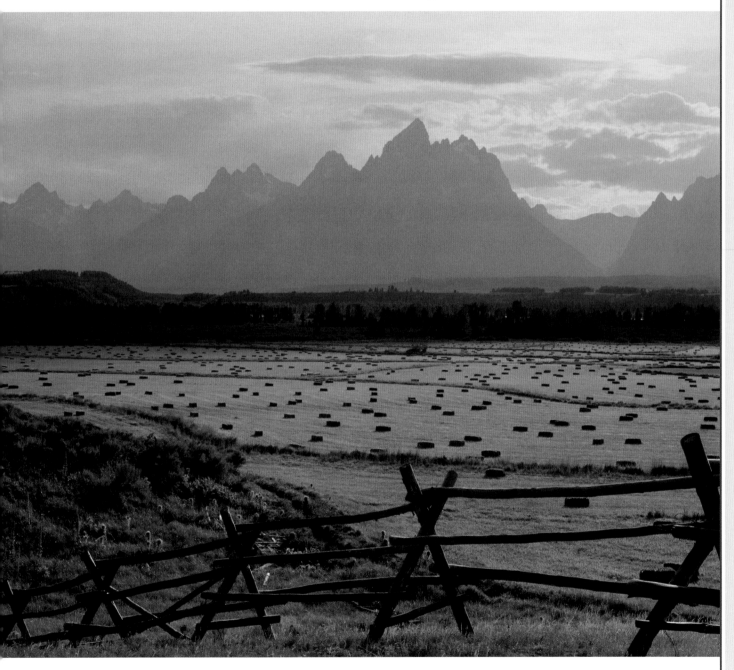

A winter visit to Jackson Hole offers the opportunity, despite very cold temperatures, of relative solitude while traveling on the few park roads that are open (once you leave the town of Jackson and the Jackson Hole Mountain Resort at Teton Village). Seen here is a February sunrise on three of the major peaks in the Teton Range.

On the left is the Grand Teton, 13,775c feet (4,199m); in the center Mount Owens, 12,933c feet (3,942m); on the right Teewinot Mountain, 12,330c feet (3,758m). Another winter view from the floor of Jackson Hole shows these same three peaks from the southeast. Strong winds have sculpted the snow into fantastic formations.

A winter sunrise on the Teton Range

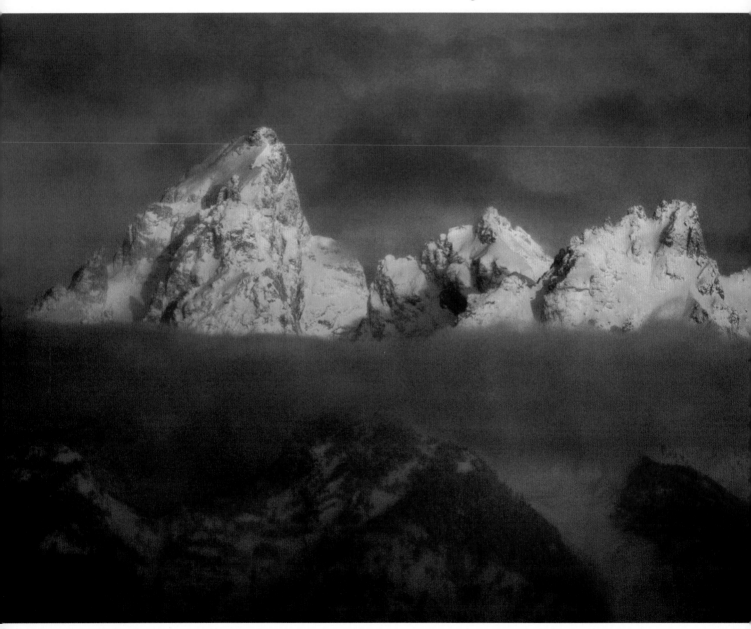

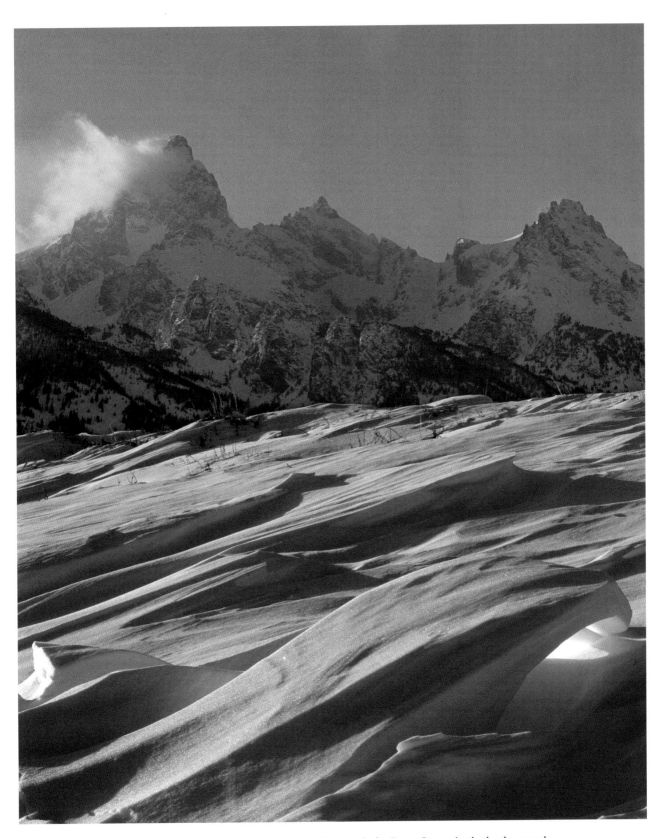

Windswept snow formations in Jackson Hole with the Teton Range in the background

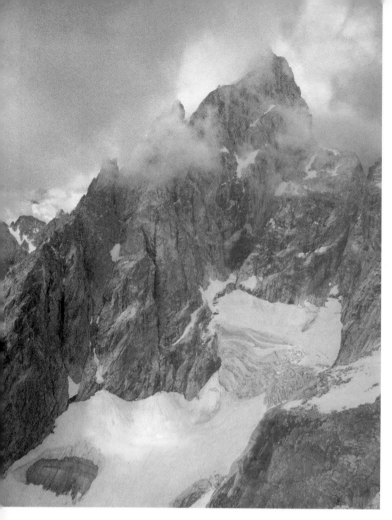

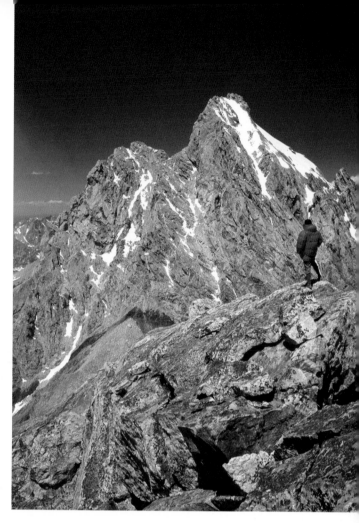

Storm clouds closing in over the north face of the Grand Teton

Self portrait of the author/photographer on top of the Middle Teton, with the Grand Teton in the background

One of the classic climbs in the history of North American mountaineering is the north face of the Grand Teton, first climbed in its entirety in August 1949. Twice I have been in a position to photograph this great face. Both times I obtained photographs, but on both occasions I was caught in vicious thunderstorms typical of the Rocky Mountains in the summer. This picture was taken during the first visit. I had just climbed Teewinot Mountain. Clouds can be seen lowering onto the Grand Teton, with the Teton Glacier below the north face. In short order I was pelted unmercifully by hail as I tried to descend Teewinot as fast as possible, while lightning flashed about me in alarmingly close proximity.

There is no finer illustration of what the Rocky Mountains are all about than this view of the Grand Teton from the summit of the Middle Teton. For the mountaineer, this is being in the right place at the right time! I took this photo with a self-timer on a 4x5 camera set on a tripod. This is the Grand Teton's southern profile. "The Grand," as mountaineers affectionately refer to it, presents a great profile no matter from what direction it is viewed.

Almost as spectacular is the view of the Middle Teton from the Grand Teton. A portion of the Middle Teton Glacier may be seen at the lower left. Another view, on the following page, shows sunrise on the Middle Teton (right) and part of the Middle Teton Glacier.

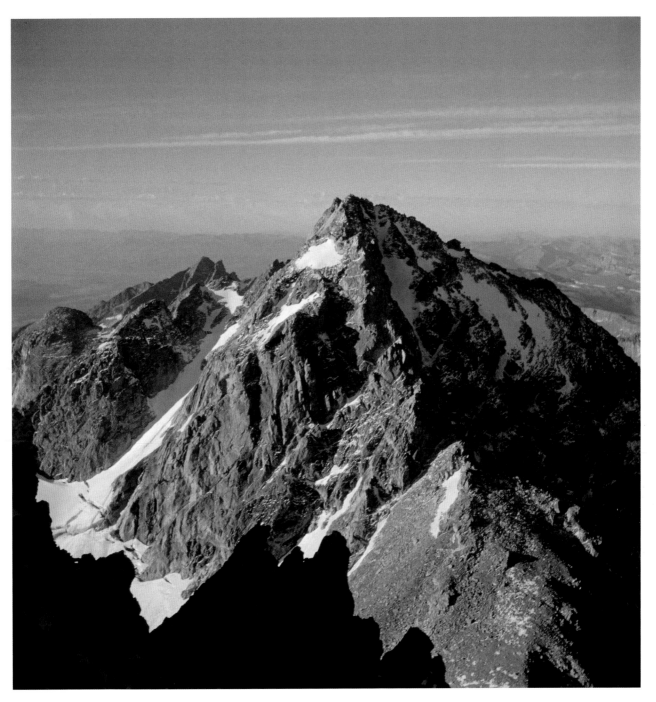

The Middle Teton as seen from the Grand Teton

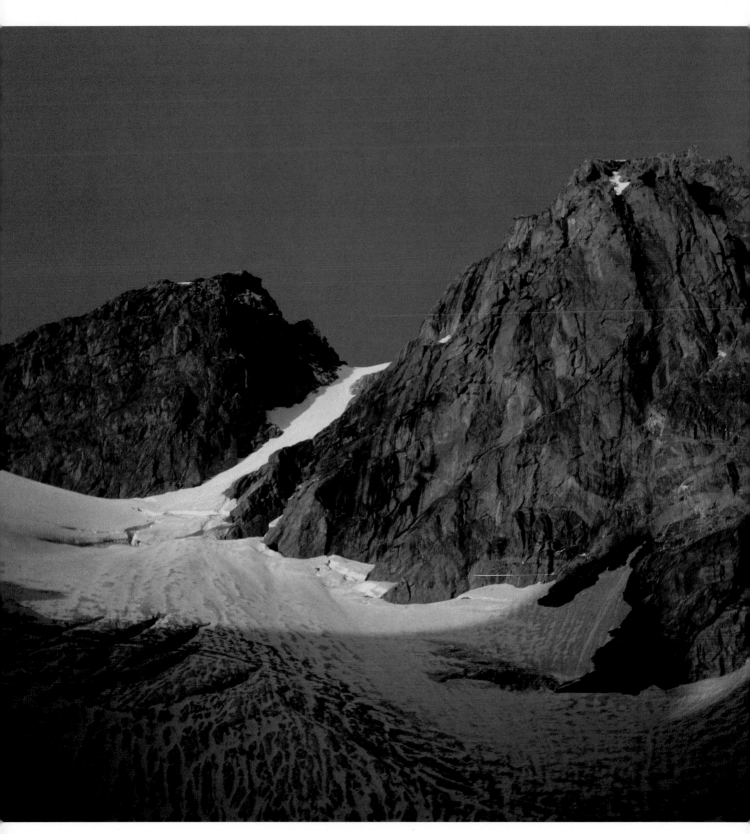

Sunrise on the Middle Teton and the Middle Teton Glacier

Viewed from the summit of the Middle Teton is the improbable-looking Schoolroom Glacier. There seems no reason for this glacier to be at this particular location, but perhaps wind currents have something to do with it. The glacier received its name because it has the classical features of a glacier: well-defined terminal and lateral moraines, as well as crevasses. Hurricane Pass is located to the right of the glacier, and leads from Grand Teton National Park into the Jedediah Smith Wilderness within Caribou-Targhee National Forest. In recent years, there have been reports of grizzly bears in this area, which have apparently migrated southward from Yellowstone National Park.

Confusing the situation with the newly calculated higher altitudes of the Teton peaks is a finding reported in 2007 in the *Journal of Geophysical Research*. Movements by magma in the earth below one of the largest super-volcanoes in the world, located in Yellowstone National Park, are affecting the altitudes in the Teton Range. While I didn't find any new altitudes listed, researchers found that the valley below the Tetons (Jackson Hole) is rising, while the mountains (the Teton Range) are dropping.

Icefloe Lake and the Schoolroom Glacier as seen from the Middle Teton

Wind River Range

▲▲▲

Southeast of the Teton Range lies the Wind River Range, much larger in extent, running in a northwest–southeast direction. The Continental Divide is on the crest of this range, which is approximately 90 miles (144km) in length as the crow flies when measured from Union Pass on the north to South Pass on the south, the latter being a very important pass along the Oregon Trail. No roads cross these mountains between the two passes. High desert country surrounds the Wind River Range, with the Green River Basin to the west and the Wind River Basin to the east.

This range is home to thirty-one of Wyoming's thirty-five peaks with altitudes of more than 13,000 feet (3,962m), and it has the largest glaciers in the contiguous United States outside of the Pacific Northwest. The Winds, as they are commonly known, are very popular with climbers due to the granite rock that composes most of the range. This rock was formed over one billion years ago as a large granite batholith. As this batholith was uplifted, overlying rock eroded away, and glaciers in the Ice Age carved these peaks into their present shape.

A recent immigrant to the Wind River Range, first reported in the 1990s, is the grizzly bear. These bears have migrated southward from their twentieth-century habitat in the Yellowstone Plateau and the Absaroka Range; they have apparently migrated roughly parallel to the Continental Divide, into the most northerly quarter of the Wind River Range, where they are now firmly entrenched. Given time, the bears will colonize the entire range, presenting the usual problems associated with encounters between grizzlies and humans. Federal and state plans as to what action to take (if any) are opposed. The state wants to limit the bears' spread southward, while the federal plan calls for allowing the bears to continue their southward migration.

Squaretop Mountain, 11,695 feet (3,565m), while not one of the higher peaks in the Wind River Range, is easily the most recognizable and photographed peak in the range. Seen in the foreground are the Green River and Upper Green River Lake. The tower on the right edge is known as the Bottle. The Green River Lakes area, at an elevation of almost 8,000 feet (~2,435m), is perhaps the only place accessible by vehicle where one can see the grandeur of the Wind River Range. The road is open only during the summer months and is closed by the first snows of autumn.

Gannett Peak, 13,809c feet (4,209m), is at once the highest peak in the Wind River Range and in the state of Wyoming. Many people think that the Grand Teton is the highest peak in the state, but it is shorter by 34 feet (10m). Unlike the Grand Teton, Gannett Peak is difficult to access, and of the highest points in each of the lower 48 states, it's the most remote. This peak can be seen from highway locations to the west, but

Squaretop and the Upper Green River Lake and River

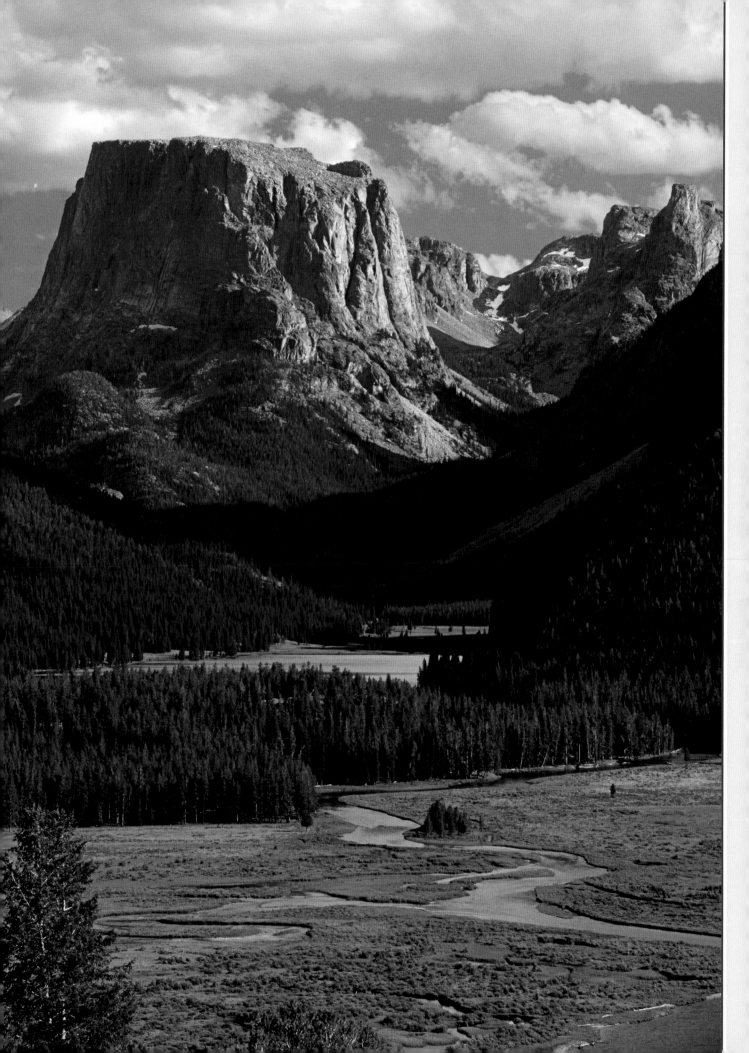

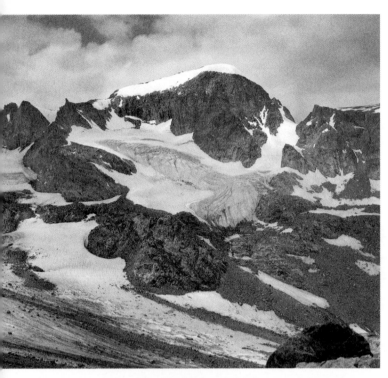

**Gannett Peak and the Gooseneck (upper)
and Dinwoody (left and lower) Glaciers**

Year-round ice and snow mantle the highest peaks of the Wind River Range. Fremont Peak, 13,750c feet (4,191m), is the second-highest peak in the Wind River Range and third-highest in the state. The Fremont Glacier system covers the area. In a remarkable ascent for its time, the explorer John C. Frémont (known as the "Pathfinder") and party climbed this peak in 1842.

Controversy has surrounded this ascent. Some believe it was Mount Woodrow Wilson at 13,507c feet (4,117m) that the party actually climbed. The matter seems to have been settled in a paper written by John Grebenkemper in 2004. He retraced on foot the ascent as it was originally described and compared all historical data available to the present observable conditions, using computer technology. He concluded that without question it had indeed been Fremont Peak that the party

only if there is good long-distance visibility and you know right where to look. In this view from the east, the Dinwoody Glacier is at the foot of the peak, the Gooseneck Glacier is directly below the summit, and Gooseneck Pinnacle is just above the upper left edge of the Gooseneck Glacier.

Gannett Peak was named for Henry Gannett (1846–1914), a member of the Hayden survey team, chief geographer of the U.S. Geological Survey, and chairman of the U.S. Board of Geographic Names. While the first ascent of Gannett Peak is generally attributed to Arthur Tate and Floyd Stahlnaker in 1922, Orrin Bonney (1902–79), noted climber and historian, makes an excellent case for the first ascent actually having taken place in 1833 by Captain Benjamin L. E. Bonneville!

Fremont Peak and the Fremont Glacier system

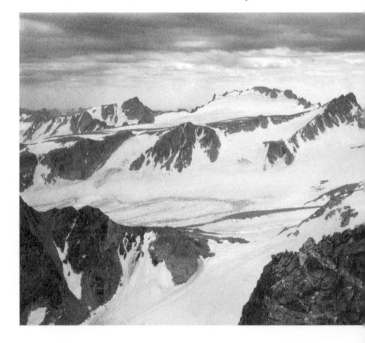

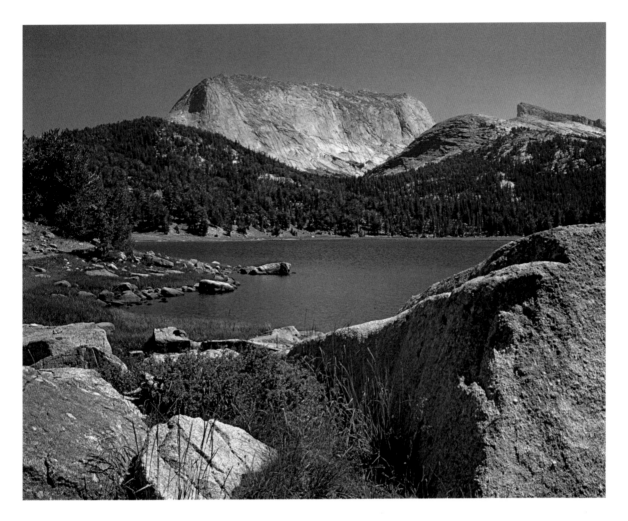

Haystack Mountain and Big Sandy Lake

ascended. A five-cent commemorative U.S. postage stamp published in 1898 (part of the Trans-Mississippi Exposition Issue) shows "Frémont on [top of the] Rocky Mountains."

Climber and historian Orrin Bonney aptly named Cirque of the Towers in the southern part of the Wind River Range. This is one of the gems of the entire Rocky Mountain chain. Almost all climbers who like to visit ranges other than the nearby ones will get to the Cirque of the Towers sooner or later. They will not be disappointed. Peaks, walls, and spires of granite rise all around this cirque in an alpine wilderness setting. The large number of climbers visiting this area in recent years has caused contaminated water supplies, so visitors are strongly advised to bring water purifiers.

In a little more than 5 miles (8km) along the trail into the Cirque of the Towers, the hiker reaches Big Sandy Lake. From here there is an excellent view of Haystack Mountain, 11,983c feet (3,652m), which bears some resemblance to a loaf of bread. The granitic

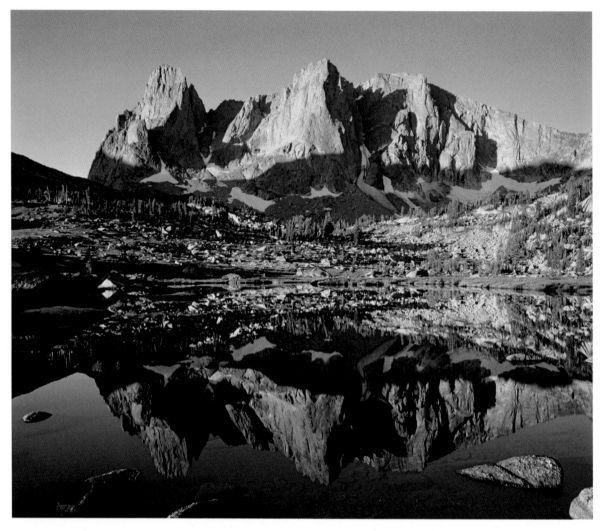

Lonesome Lake and Cirque of the Towers at sunrise

nature of the rock in the area is apparent here, both in the foreground rocks and the peak itself. The exfoliation of granite rock so apparent in many of the Sierra Nevada peaks in California is also taking place here. Just barely visible in the upper right edge is Temple Peak, with its steep profile at the left end.

An additional 4 miles (6km) brings you to Lonesome Lake. At an elevation of 10,166 feet (3,099m), it is the centerpiece of the Cirque of the Towers. Seen here is a sunrise view reflected into the lake. On the left is War Bonnet Peak, 12,374c feet (3,772m), and in the center

and right center are Warrior Peaks, the highest point being 12,411c feet (3,783m). War Bonnet Peak is often spelled as one word "Warbonnet," but in Orrin Bonney's guidebooks to the area and on the USGS topographic map, the name appears as two separate words. This peak was named by Bonney in 1940 because of rock towers or "feathers" on its wedgelike summit.

I remember Lonesome Lake well. In 1969 my wife, Debby, and I backpacked in there. As we approached the lake, we heard strains from what we recognized as Beethoven's Ninth Symphony. When we arrived at the

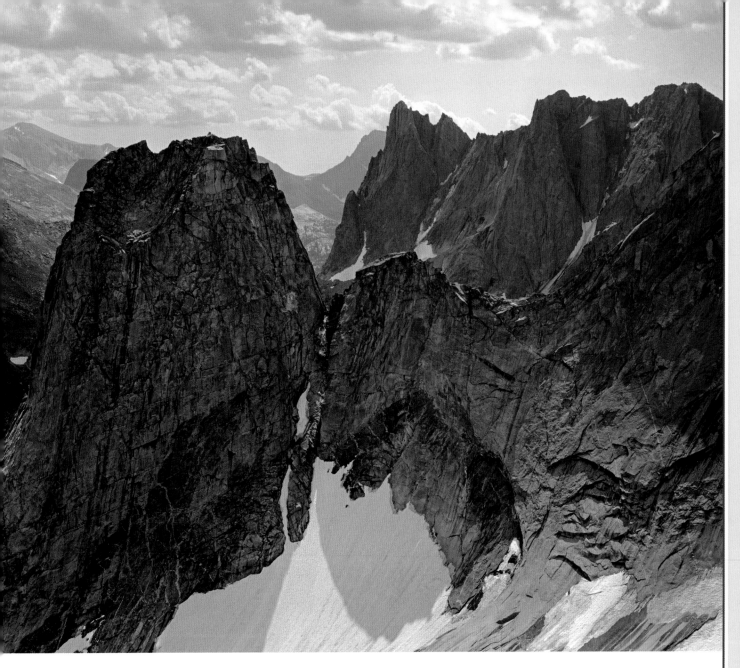

Pingora Peak as seen from New York Pass

lake, we found Chuck Pratt, a noted Yosemite climber (1939–2000), leaping energetically around his campfire as he conducted the music with a large wooden spoon. The source of the music was a battery-powered record player that Chuck had packed in. This was certainly a memorable scene.

In the view of Cirque of the Towers from New York Pass, Pingora Peak, 11,889c feet (3,624m), is on the left. This was the first technical climb made in the area, in August of 1940, by Orrin Bonney and Frank

and Notsie Garnick. "Pingora" is a Shoshone Indian word meaning high, rocky, inaccessible peak or tower, and was named by the above party. In the background, upper center, are War Bonnet Peak (left) and Warrior Peaks (right). Immediately to the left of War Bonnet Peak, in the far distance, is Wind River Peak, 13,197c feet (4,022m), the highest peak in the southern portion of the Wind River Range. The granite rock on the right side of the picture shows that exfoliation is taking place.

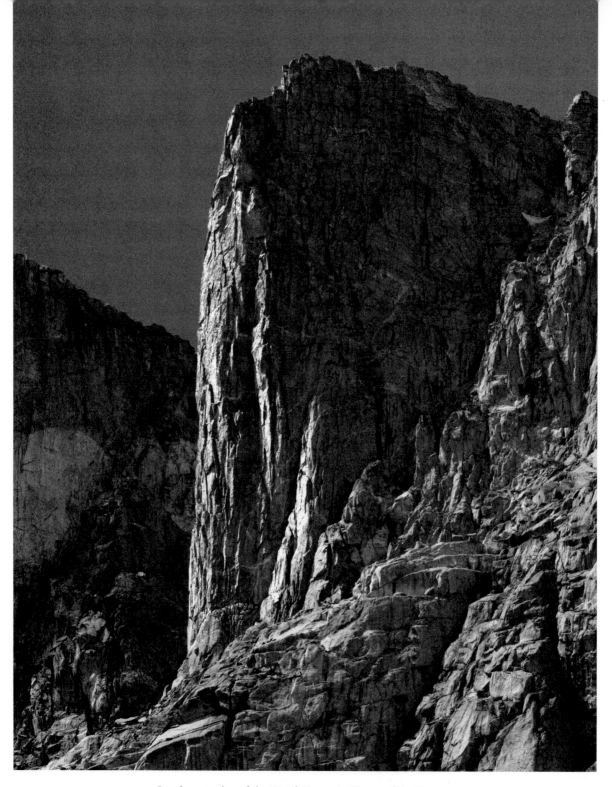

Southwest edge of the Watch Tower in Cirque of the Towers

In yet another example of the countless spectacular photographs to be found in the Cirque of the Towers, the late afternoon sun glances off the south buttress of the Watch Tower, 12,331c feet (3,758m). This picture was taken in the vicinity of Cirque Lake.

This area is a mecca for backpackers and climbers.

The same confusion exists for Watch Tower as with War Bonnet Peak. The USGS topographic map spells the name as two words, but guidebooks and other sources use it as one word.

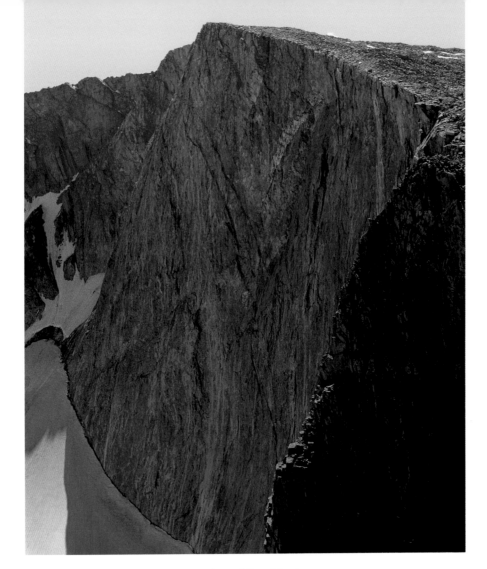

East face of Cloud Peak

Bighorn Mountains

▲▲▲

Located in north-central Wyoming, the Bighorn Mountains run in a northwest–southeast direction for about 120 miles (~190km). The northern end of this range extends into Montana to Bighorn Lake. This range has the distinction of containing the two northernmost 13,000-foot (3,962m) peaks in the Rocky Mountains. These mountains are bounded on the west by the Bighorn Basin and on the east by the Great Plains. The high country is within the Cloud Peak Wilderness Area of Bighorn National Forest. While these mountains contain some great mountain scenery, these views are not visible except to those willing to backpack and climb into this range.

The Bighorns, being approximately 100 miles (~160km) east of the Continental Divide, are very dry. Hence, they have not received the extensive glacial carving that ranges to the west have received and, as a result, are more rounded. This generalization, however, certainly does not apply to the sheer east face of Cloud Peak, 13,167c feet (4,013m), the highest peak in this range. Although the summit is relatively flat and has never been subjected to glacial erosion, glaciers

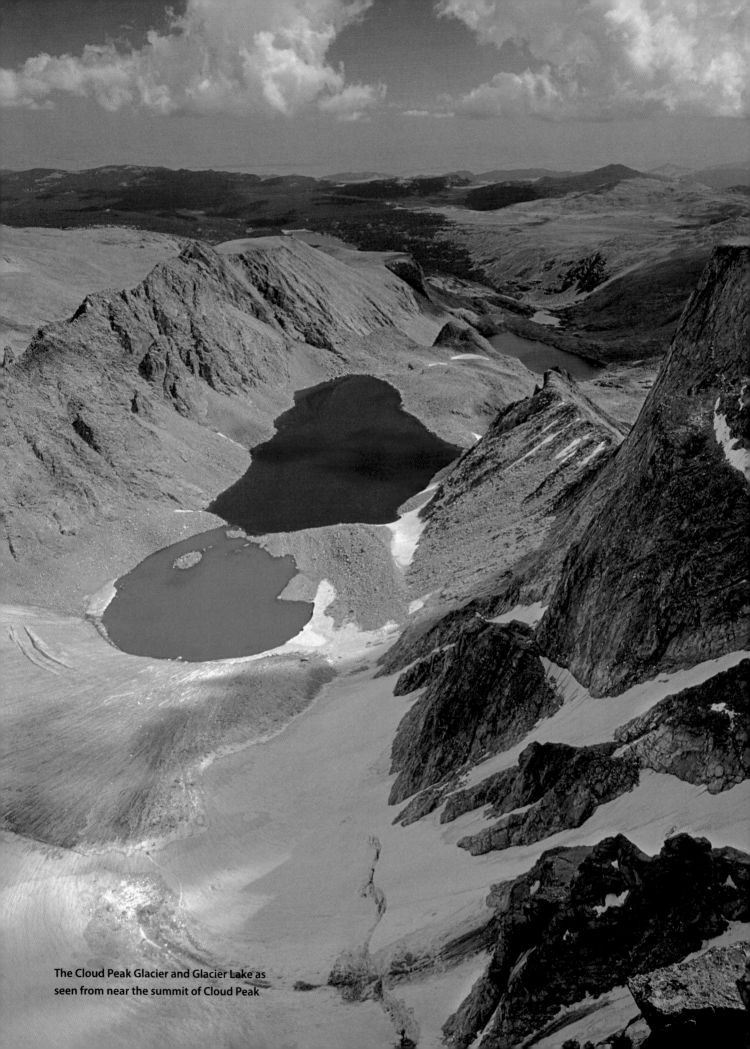

The Cloud Peak Glacier and Glacier Lake as seen from near the summit of Cloud Peak

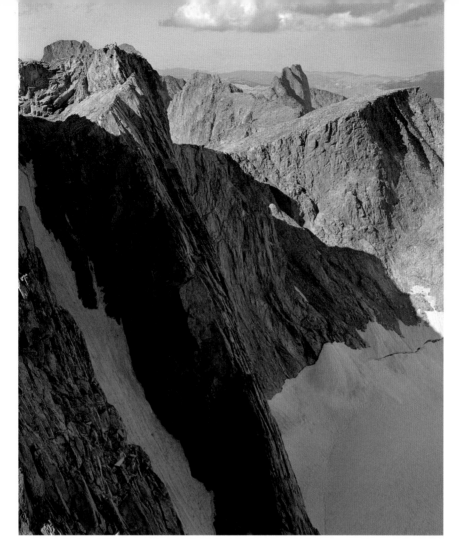

Looking across the east face of Cloud Peak toward Hallelujah Peak (pointy peak)

were active on the east side of this peak; the upper portion of the currently existing Cloud Peak Glacier may be seen at the lower left edge of the photo. There is even a bergschrund (a fissure at the upper end of a mountain glacier) at the upper left edge of the glacier, separating it from the snow above.

Visible in a view looking east from the summit of Cloud Peak toward the Great Plains, the Cloud Peak Glacier, the largest glacier in the Bighorn Mountains, is seen at the bottom left. The very colorful Glacier Lake is at the foot of the glacier. The colors are caused by glacial silt suspended in the water. The narrow neck connecting the two parts of the lake prevents the more heavily silt-laden water of the upper portion of the lake (just be-

low the glacier) from mixing freely with the water in the lower portion of the lake, hence the different colors. This lake is at an elevation of 11,490 feet (3,502m).

Judging from this view, you would never know that the Bighorn Mountains are more rounded than high mountain ranges to the west. This view looks across the east face of Cloud Peak, the most highly glacially sculpted region of these mountains. A portion of the Cloud Peak Glacier appears at the lower right. On the skyline near the left edge of the picture (poking above part of Cloud Peak) is Black Tooth Mountain, 13,005 feet (3,964m), the other 13,000-foot peak in the Bighorn Mountains. The pointy peak in the distance is Hallelujah, at 12,590 feet (3,837m).

Devils Tower at sunset

Devils Tower

▲▲▲

Although a bit out of the mainstream of the Rocky Mountains, Devils Tower, located in the northeast corner of Wyoming (in Devils Tower National Monument), is an important destination for tourists. It also is a magnet for rock climbers everywhere. At an elevation of 5,112 feet (1,558m), it rises 867 feet (264m) above its base. It was formed originally from magma intrusions into sedimentary rock. As the land rose, all the sedimentary rock was eroded away, leaving the tower we see today. This view of Devils Tower is from the south at sunset.

This outcropping was first climbed in 1893 by two local ranchers, who hammered wooden stakes into the cracks between the columns, forming a ladder to the top. The first actual climbing ascent was in 1936. On October 7, 1941, a man parachuted onto the top of Devils Tower; it's hard to imagine what he had in mind, because he ended up trapped there for six nights. It took eight experienced climbers, under conditions of ice and rain, to rescue him.

A second view shows climbers ascending a crack in the basalt columns of Devils Tower. The yellow seen on the rock is actually lichen growing there.

Climbing on basalt columns at Devils Tower

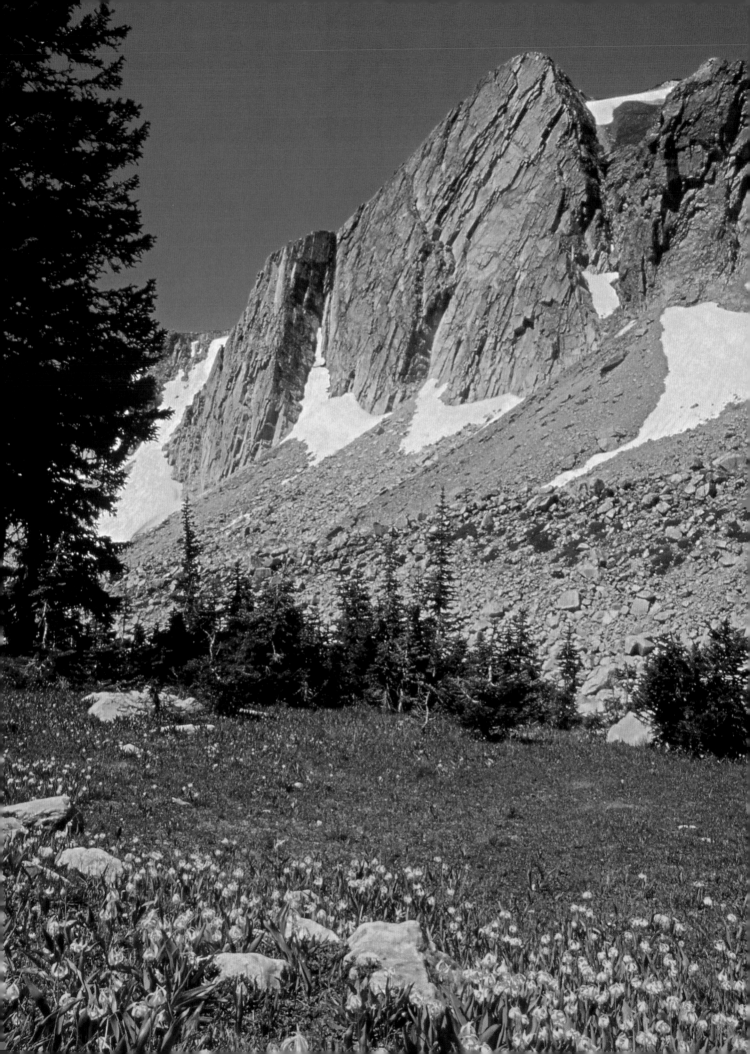

Snowy Range

▲▲▲

One delightful little area is the Snowy Range in the Medicine Bow Mountains in Medicine Bow National Forest in southeastern Wyoming near the Colorado border. U.S. Highway 130, designated as the Snowy Range Scenic Byway (open only in summer months), crosses Snowy Range Pass at an elevation of 10,847 feet (3,306m), and passes right below the peaks. The highlight of the area is the mile-wide (1.6km) cliff on the southeast side of Old Main Peak, 11,758c feet (3,584m). There are several lakes at the base of this peak, the largest being Lookout Lake, seen in the view on the next two pages. The Snowy Range is a high Precambrian quartzite ridge above the plateau of the Medicine Bow Mountains, a ridge exposed after the area was uplifted by tectonic plate movements and thousands of feet of overlying softer rock were eroded away.

On October 6, 1955, a United Airlines flight failed to clear the ridge to the left of the summit by less than 100 feet (~30m) and crashed, killing sixty-three passengers and three crew members. Parts of the wreckage are still at the crash site, although much of it has fallen to the talus (a sloping pile of rock fragments) below the cliffs. This section of the cliff is now known as Disaster Wall.

At the southwestern end of Old Main Peak is a rock formation known as the Diamond, pictured here. In this photograph taken in July, alpine meadows spring to life quickly with a profusion of flowers, in this case glacier lilies (*Erythronium grandiflorum*). This feast for the eyes is just one of many thousands of magical scenes to be found in the mountains.

Glacier lilies and the Diamond, at the southwest end of Old Main Peak

Wyoming Peaks and Locations Featured

Abiathar Peak [1M9026] .. 44.9752N/110.0322W

Barronette Peak [1M9023] .. 44.9754N/110.0881W

Beartooth Butte [1A9211] .. 44.9546N/109.6099W

Bivouac Peak [T-109206] .. 43.8683N/110.7840W

Cloud Peak [109723 & 109717] 44.3820N/107.1740W

Devils Tower [109851-C & M-09801-A12] 44.5904N/104.7153W

Diamond [M-09701] .. southwest end of Old Main Peak

Eagles Rest Peak [T-109206] 43.8986N/110.7590W

Fremont Peak [509437] .. 43.1247N/109.6183W

Gannett Peak [509427] .. 43.1842N/109.6543W

Grand Teton ... 43.7412N/110.8024W
[107604 & 1M9339 & 1M9342 & 409215 & 409222-A]

Hallelujah Peak [109729] .. 44.4089N/107.1694W

Haystack Mountain [109620] 42.7315N/109.1662W

Index Peak [1A9209] .. 44.9857N/109.8831W

Middle Teton [107604 & T-109207 & T-209207] 43.7298N/110.8113W

Mount Moran [1M9235 & T-109206] 43.8350N/110.7765W

Old Main Peak [M-09702] .. 41.3478N/106.3258W

Mount Owen [107604 & 1M9339 & 1M9342] 43.7469N/110.7973W

Pilot Peak [1A9209] .. 44.9761N/109.8812W

Pingora Peak [209615] ... 42.7789N/109.2257W

Pristine forest near Sylvan Pass [209150] near east entrance, Yellowstone N.P.

Schoolroom Glacier [T-109212] 43.726 N/110.849 W

South Teton [107604] .. 43.7186N/110.8185W

Squaretop Mountain [1M9418] 43.2239N/109.7906W

Teewinot Mountain [1M9339 & 1M9342] 43.7472N/110.7800W

The Teton Range & Jackson Hole [409254] various

War Bonnet Peak [109634 & 209615] 42.7613N/109.2158W

Warrior Peaks (highest point) 42.7628N/109.2251W
[109634 & 209615]

Watch Tower [209618] ... 42.7740N/109.2347W

The numbers in brackets are the author's file numbers for the images.

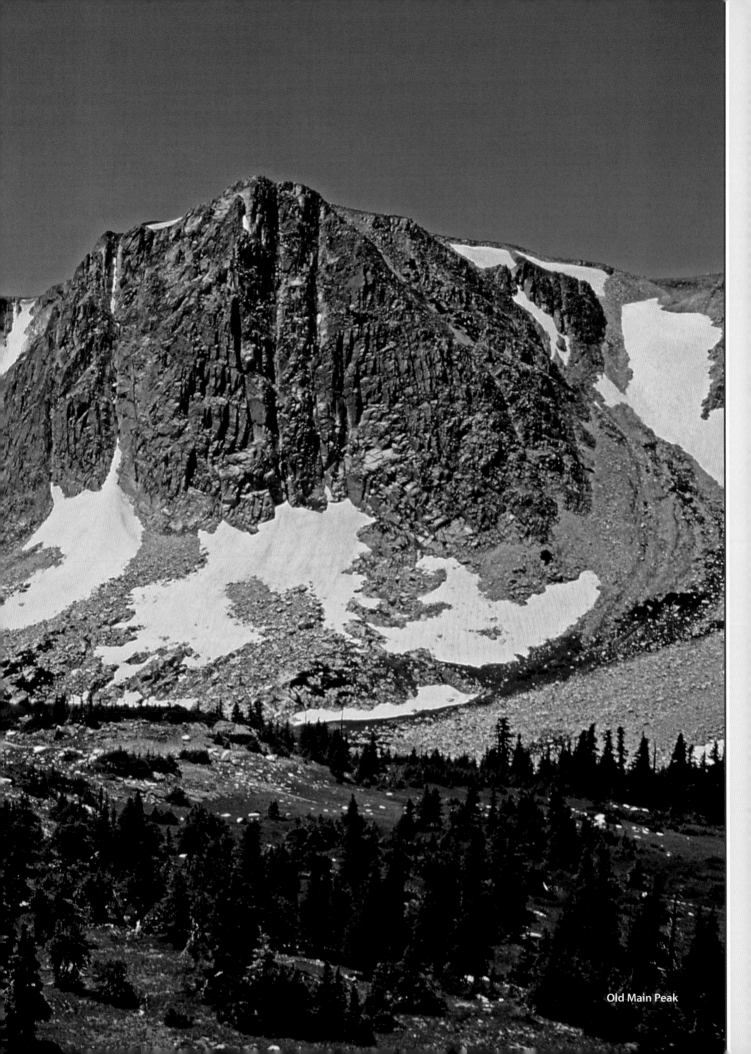

Old Main Peak

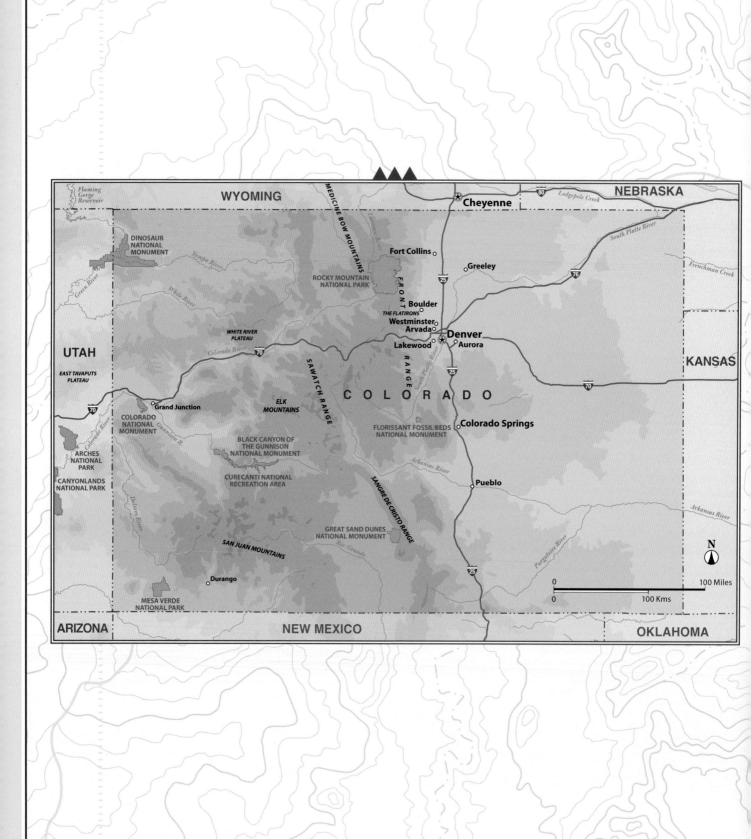

C O L O R A D O

In many ways, Colorado can claim to be the heart of the Rocky Mountains. It has the only 14,000-foot peaks in the Rocky Mountains—fifty-four of them. It has the highest low point of any state at 3,315 feet (1,010m). It has the highest peak in the Rocky Mountains, Mount Elbert, though not the highest peak in the contiguous United States. That honor belongs to California, whose Mount Whitney is 14,505c feet (4,421m), 65 feet (20m) higher than Mount Elbert.

Colorado is the four-wheel-drive capital of the United States and has a multitude of ski resorts famous for their powder snow. Coloradans love their mountains, attested to by the fact that on weekends it is almost impossible to find a parking place at some of the better-known trailheads (in summer) and ski areas (in winter).

One expression that has become common in the central and southern Rockies is referring to the months of July and August as "monsoon season." Afternoon thunderstorms are common (in fact, the norm) during summer months throughout the entire Rocky Mountain chain. I was somewhat surprised, however, to hear the term "monsoon" in common use in the Rockies, a term that is normally used in reference to tropical areas. There is no doubt that July and August see the highest rainfall total in the area; I can attest to this, having been caught in more than one summer downpour in these mountains!

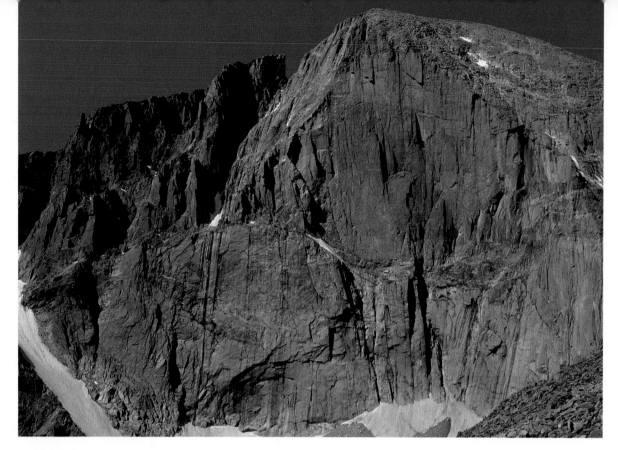

The east face of Longs Peak

Front Range

▲▲▲

For almost 150 miles (~240km) when you are traveling the Interstate 25 corridor from north of Fort Collins to south of Colorado Springs, the Front Range (to the west) draws your attention. This range is where the Great Plains meets the Rocky Mountains in the longest continuous uplift in the state. The vertical relief from the plains to the summits, depending on where you are, is up to 9,000 feet (~2,750m), the greatest in the Rocky Mountain chain. Two of America's best-known mountains—Pikes Peak and Longs Peak—are located in this range, as well as the highest auto road in the United States, on Mount Evans. One of the best known of our mountain national parks is also situated in the Front Range: Rocky Mountain National Park.

Longs Peak is, at 14,259c feet (4,346m), the highest peak in Rocky Mountain National Park as well as the most northerly of the Rocky Mountain "fourteeners" (peaks higher than 14,000 feet). It was named for Major S. H. Long, who explored the plains in 1820. The first recorded ascent was in 1868, but it is speculated that Native Americans may have had eagle traps on the mountaintop earlier than that.

Longs Peak is the most frequently climbed fourteener in Colorado, not surprising in view of the fact that the trailhead for the climb is located a little more than an hour's drive from the Denver metropolitan area. On a weekend day in the summer, there may be several hundred people on the easiest route (the Keyhole Route), causing backups in the narrow sections where it is not easy to pass other climbers.

Many consider the east face of Longs Peak, seen in this view, the heart and soul of Colorado mountaineering. The

Climbers on the Diamond on Longs Peak as seen from Chasm View

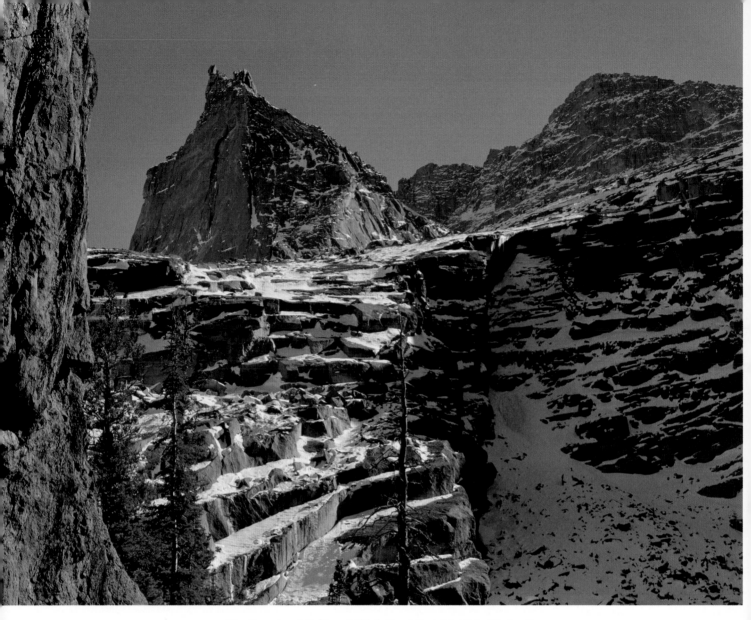

The Spearhead (left) and Chiefs Head Peak (right) in Glacier Gorge

upper two-thirds of the face is referred to as the "Diamond" because of its shape. Broadway Ledge crosses the face below the Diamond, and the ice below the face is called the Mills Glacier. The first climb up the center of the Diamond was made in 1960. Aspiring climbers in Colorado, and many climbers from out-of-state as well, sooner or later attempt this classic climb known for its firm granite.

Chasm View provides an almost breathtaking view across the east face of Longs Peak. In my experience there are only a few other places in North America that awe one with the power of rock the way this view does. (Another would be the view of the northwest face of

Half Dome in Yosemite Valley seen from the Diving Board.) Broadway Ledge runs along the lower left edge of the image, with snow and ice partially obstructing passage along its length. Six climbers are visible on the Diamond (circled in red) on the busy day in August when this picture was taken. The lowest climber appears to be rappelling.

The Spearhead, 12,575 feet (3,833m), is one of the most dramatic sights in Rocky Mountain National Park. Located in Glacier Gorge, it is flanked on the right by Chiefs Head Peak, 13,579 feet (4,139m), the third-highest peak in the park, which received its name due

to its resemblance (when seen from the southeast) to a warrior lying down, with a war bonnet on his head.

The well-known profile of the north face of Hallett Peak, 12,720c feet (3,877m), in Rocky Mountain National Park, rises above a hillside covered in aspen trees, some of which are displaying their autumn colors. This is the most popular summit hike in the park, since an easy trail leads to the top. Not so with the north face (in the shade in this photo; we see only a portion of the face), which harbors some of the most difficult rock climbs in the park. The Tyndall Glacier, one of five glaciers in Rocky Mountain National Park, is the large patch of snow and ice seen to the right of the peak.

Hallett Peak and the Tyndall Glacier

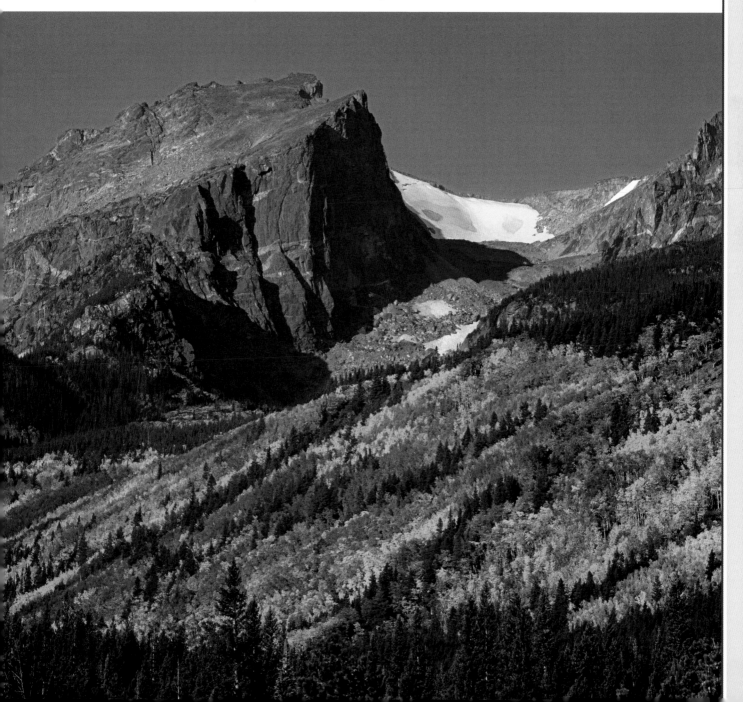

The Flatirons as seen from Scott Carpenter Park in Boulder

The Flatirons in the Front Range are seen from Scott Carpenter Park in Boulder in this photo. In terms of numbers of climbers, this is the most popular rock-climbing area in the state, with hundreds, if not thousands, of routes. This is not surprising in view of its proximity to the largest metropolitan area in Colorado. The uplift of the Front Range is clearly seen in this view, with the exposed rock poised upward at the angle of the uplift.

Pikes Peak as seen through Gateway Rocks at Garden of the Gods

Pikes Peak, one of America's most famous mountains, rises over 8,000 feet (~2,440m) above nearby Colorado Springs. From its 14,115c-foot (4,302m) summit, Katharine Lee Bates was so inspired by the view that she penned her most famous poem, "America the Beautiful," in its honor. This particular view shows Pikes Peak as viewed through Gateway Rocks in Garden of the Gods, an area of red sandstone rocks in the northwest part of Colorado Springs.

Pikes Peak has a long history behind it. It formed a landmark for early travelers, who could see it from

about 150 miles (~240km) to the east, given the right atmospheric conditions. It was named after Zebulon Pike, who in an 1806 expedition made an unsuccessful attempt to climb it. He reported, "No human being could have ascended to its pinical [sic]." The peak was successfully climbed in 1820, the first recorded ascent of a 14,000-foot (4,267m) peak in the United States, and by 1887 a carriage road had been built to the summit.

The peak itself is now part of Pike National Forest and there is a U.S. Forest Service visitor information display at the summit, now reached by a 19-mile (31km)

toll road. This is the second-highest auto road in the United States, and the site of the yearly Pikes Peak International Hill Climb, which draws crowds of participants and spectators alike. (The highest auto road in the United States ascends to near the summit of Mount Evans, 14,265c feet [4,348m], also in the Front Range of Colorado, less than 75 miles [120km] air distance away.)

Sawatch Range

▲▲▲

Lying southwest of the Front Range is the Sawatch Range. "Sawatch" is a Ute word meaning "blue-green color" or "waters of the blue earth." The major peaks of the range, which include the highest peaks in Colorado, run in a north–south direction for about 80 miles (~130km).

In the northern part of the range is located the famous Mountain of the Holy Cross, 14,009c feet (4,270m). This mountain was brought to the attention of the American public by the photograph taken by pioneer photographer William Henry Jackson on August 24, 1873. He personally carried about one hundred pounds of photographic gear up a 13,000-foot peak to capture this view. The photograph created a sensation when it was published, and the peak became the destination of Christian pilgrimages in the early twentieth century. It was declared a national monument by President Herbert Hoover in 1929. The feature that appears to be a cross measures about 1,400 vertical feet (~425m) by 450 horizontal feet (~135m).

By the 1950s, interest in the peak had declined to the point that fifty or fewer visitors per year came to the area, and this became one of very few areas in the United States that has ever been declassified as a national monument. It had become too expensive to maintain a ranger station there for so few visitors. That is all changed now, as new generations once again visit the area in large numbers, this time for the climbing, backpacking, and scenic opportunities the area has to offer.

But it is still necessary to climb a mountain to get a good view of the Mountain of the Holy Cross. The view reproduced here was taken from the summit of Notch Mountain, 13,241c feet (4,036m), not far from the spot where Jackson took his famous 1873 photograph. In the 133 intervening years between the two photographs (mine is from 2006), geologists speculate that the part of the ledge system that used to form the right portion of the cross has disintegrated, so that the cross is now not as well defined.

The blue flower in the foreground is Sky Pilot, *Polemonium viscosum*, which may be the highest-altitude Rocky Mountain flower. The lichens growing on the rocks supply the yellow colors.

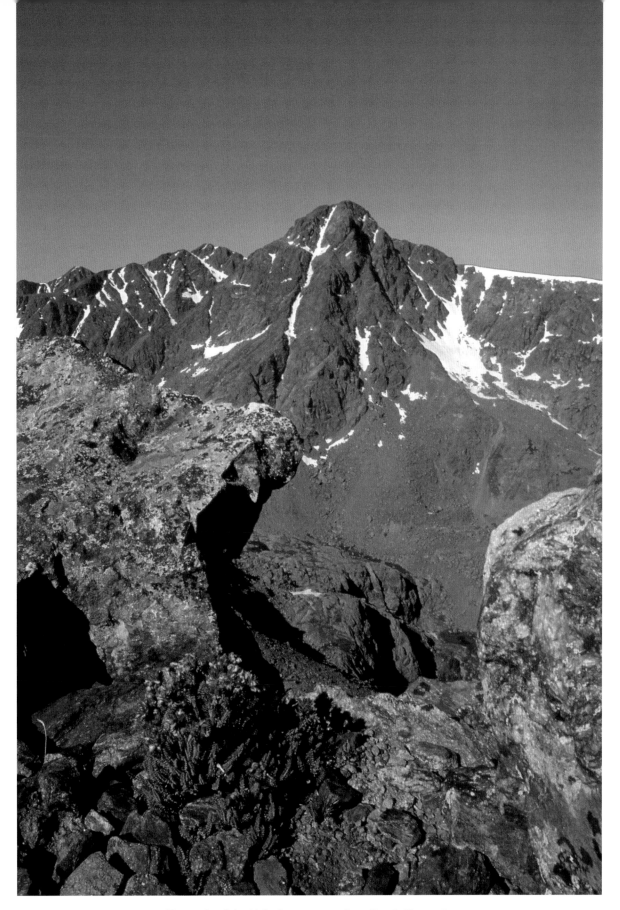

Mountain of the Holy Cross as seen from Notch Mountain

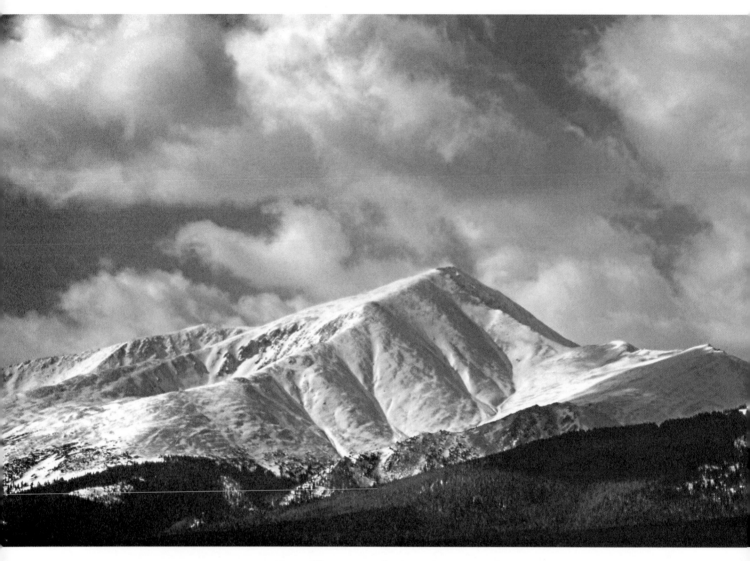

Mount Elbert as seen from near Turquoise Lake

At 14,440c feet (4,401m), Mount Elbert is the highest peak in Colorado and the Rocky Mountains, second only to Mount Whitney in California in the contiguous United States. This view of the peak is from Turquoise Lake near Leadville, America's highest city, at an altitude of 10,152 feet (3,094m). Parts of the town are even higher than this, and a sign near the north entrance to the city says WE LOVE LEADVILLE—GREAT LIVING AT 10,200 FEET. The winters here are severe, even by Rocky Mountain standards.

La Plata Peak, at 14,361 feet (4,377m), is the fourth-highest summit in Colorado. The name means "silver" in Spanish and became the mountain's name because of silver deposits in the area. There is some confusion as to the height of this peak; the figure of 14,336 feet for this peak is seen frequently, even on the 2006 official Colorado State road map. This confusion has come about as a result of the two different altitudes posted on USGS topographic maps. On the 1:250,000 scale map (dated 1975), the lower el-

evation is listed. On the 1:100,000 scale map (dated 1981), the higher elevation is listed (in the metric scale at 4,377m). The elevation on the more recent map is used here. The view of La Plata Peak seen here was taken from the west, from State Route 82, the Independence Pass Highway. The North Fork Lake Creek Valley and part of SR 82 can be seen in the foreground of the picture.

La Plata Peak and the North Fork Lake Creek Valley

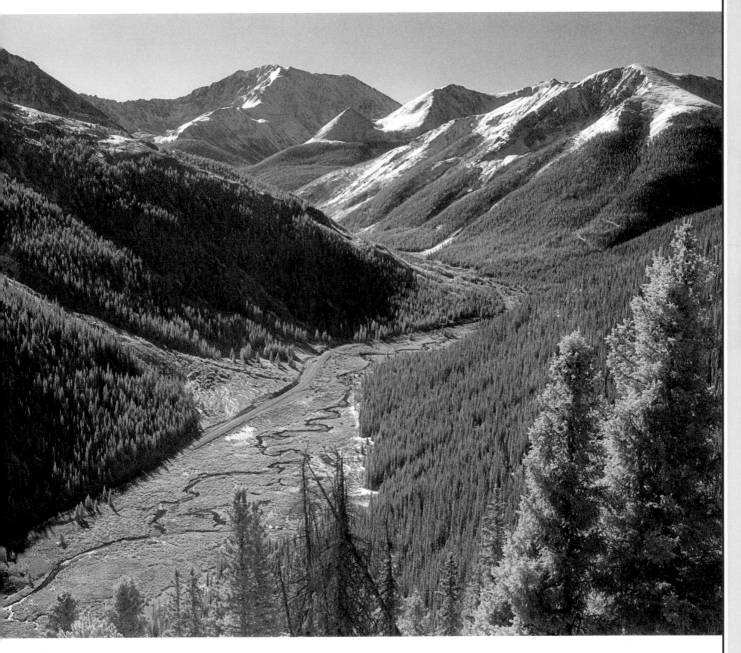

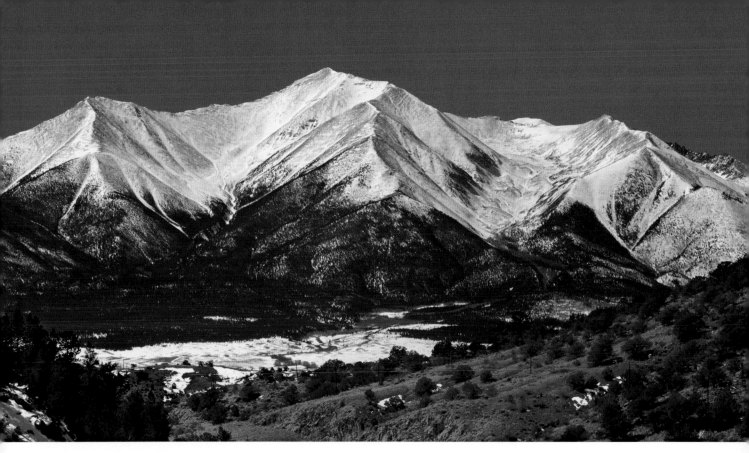

Mount Princeton rising above the Arkansas Valley

Mount Princeton, 14,204c feet (4,329m), is one of the most visible and graceful peaks in Colorado. It is located in the southern portion of the Sawatch Range and is part of the Collegiate Group of peaks that include Mounts Yale, Harvard, Columbia, and Oxford. In the view seen here, taken from near U.S. Highway 24, Mount Princeton rises some 7,400 feet (~2,250m) above the Arkansas River Valley and the community of Buena Vista. A couple of hundred feet below the summit there is a plaque placed in memory of avid outdoors enthusiast Catherine Pugin, who was struck and killed by lightning at that spot. It is a reminder that danger is always present in mountain adventures.

Elk Mountains

▲▲▲

Located west of the Sawatch Range and on the western side of Independence Pass lie the Elk Mountains. Independence Pass, which is crossed by SR 82, lies on the Continental Divide at 12,095 feet (3,687m), the highest paved mountain pass road in the United States outside of Trail Ridge Road in Rocky Mountain National Park. One of the most famous mountain resort communities in the world—Aspen—is located in these mountains.

Maroon Bells is one of America's most photographed mountains, and with good reason. It is hard to beat the combination of the lush green foliage in the summer (or aspen gold in the autumn), the reddish rock of this elegantly shaped mountain, and Maroon

Lake in the foreground. The name Maroon Bells refers collectively to the two separate summits.

The higher-appearing North Maroon Peak, 14,021c feet (4,274m), on the right, is actually lower than Maroon Peak, 14,163c feet (4,317m), on the left. This is due to the fact that North Maroon is closer to the viewer.

A fresh snowfall highlights the "stripy" appearance of these peaks, similar to that of many peaks in the Canadian Rockies due to the conspicuously layered sedimentary rock.

This view of the Maroon Bells from Maroon Lake is reached by a 10.5-mile (16.9km) road leaving from SR

Maroon Bells reflected in Maroon Lake

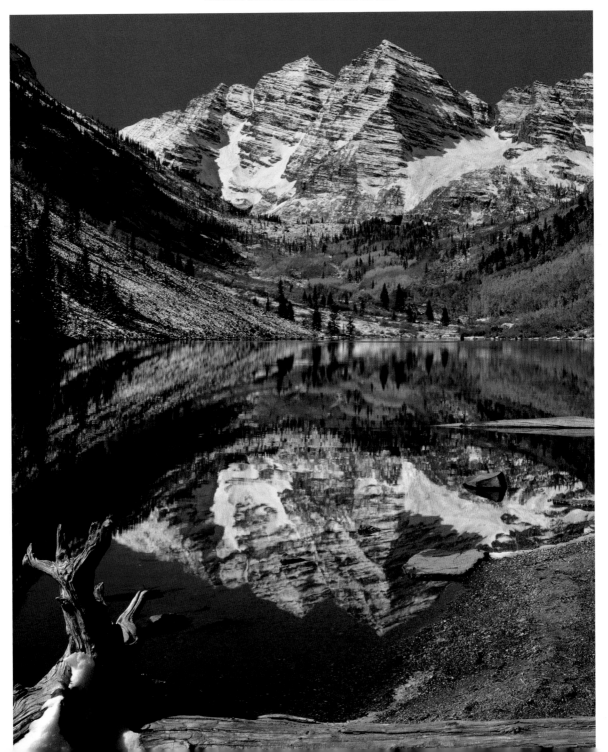

82 at the western edge of Aspen. To ease heavy traffic, this road is closed to private vehicles (except those with camping permits) from 8:00 a.m. to 5:00 p.m. from mid-June through September. There is a free shuttle bus that runs to the lake during that time from Rubey Park in downtown Aspen. The road to the lake is closed due to snow during the winter months.

Pyramid Peak, 14,025c feet (4,275m) rises at the head of the glacier-carved West Maroon Creek Valley. This view, taken at sunrise, may be seen very close to the famous resort of Aspen, just a short distance along the Maroon Lake Road, past its junction with SR82. This rugged, steep, and aesthetically pleasing mountain takes its name from its shape.

Pyramid Peak

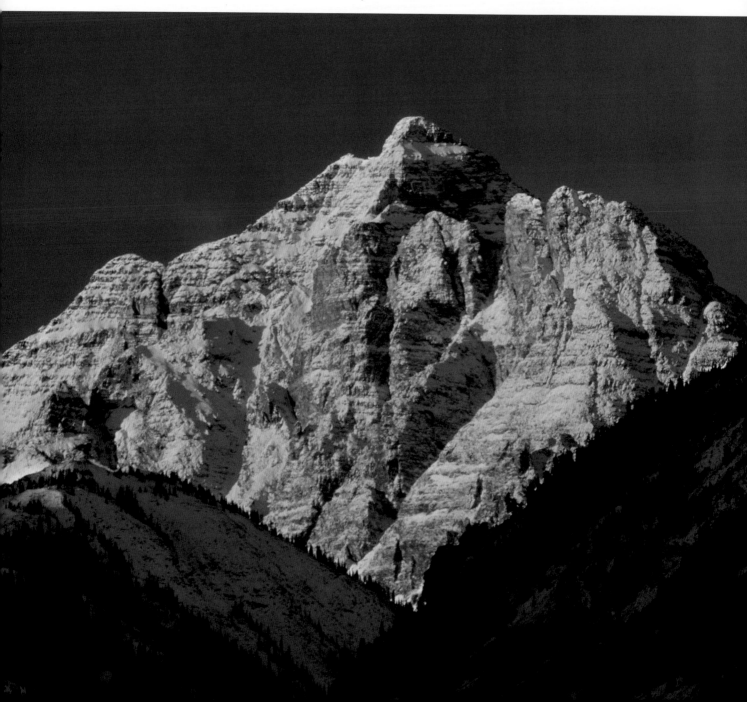

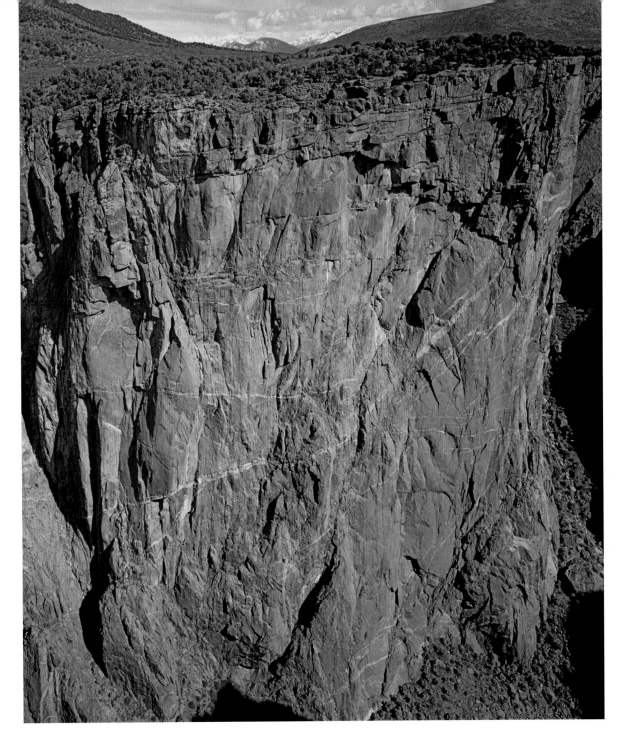

North Chasm View Wall in Black Canyon of the Gunnison

Black Canyon of the Gunnison

▲ ▲ ▲

This view of the North Chasm View Wall, seen from Chasm View on the south rim of Black Canyon of the Gunnison National Park, almost takes one's breath away. You arrive at the view point and, almost without warning, you see a deep crack in the earth, with this 2,000-foot (610m) wall of granite opposite you. Outside of Yosemite Valley in California, the cliffs in Black Canyon of the Gunnison are the tallest in the

contiguous United States. In fact, this area is often referred to as Colorado's Yosemite Valley, with climbs comparable to some of the more difficult climbs in Yosemite.

The words of geologist Wallace R. Hansen (with the U.S. Geological Survey) in the mid-1950s are perhaps still the best description of this canyon: "No other canyon in North America combines the depth, narrowness, sheerness, and somber countenance of the Black Canyon." The canyon depths range from about 1,700 to 2,700 feet (518m to 823m) in the 14-mile (22.5km) stretch within Black Canyon of the Gunnison National Park. At its narrowest point it is only 40 feet (12m) wide at the base. At Chasm View (seen here), at an elevation of about 7,800 feet (2,377m), the width at the canyon rim is only 1,100 feet (335m).

Sangre de Cristo Range

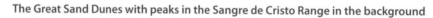

The Colorado portion of the Sangre de Cristo Range stretches about 115 miles (~185km) in the south-central portion of the state to the border with New Mexico, soaring in places as much as 7,000 feet (~2,135m) above the surrounding valleys. The New Mexico portion continues south for another 100 miles (160km).

"Sangre de Cristo" means "blood of Christ" in Spanish, and the mountains may have received their name from the sunrise or sunset colors viewed on the reddish Crestone Conglomerate (a mix of pebbles, stones, and larger rocks cemented in sandstone), which forms the upper portion of many of the peaks.

When you think of the Rocky Mountains, you don't think of sand dunes, yet seen here on the left is Star Dune, the tallest dune in North America. It is located at the base of the Sangre de Cristo Range, in Great

The Great Sand Dunes with peaks in the Sangre de Cristo Range in the background

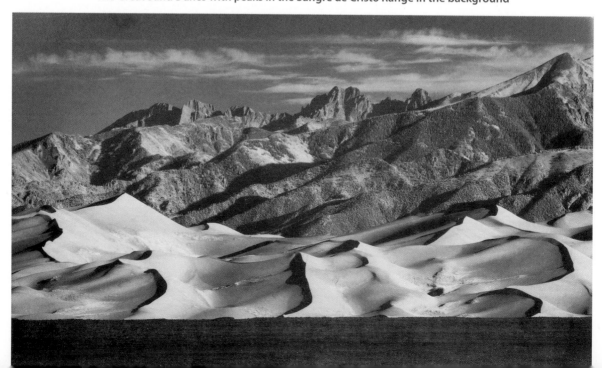

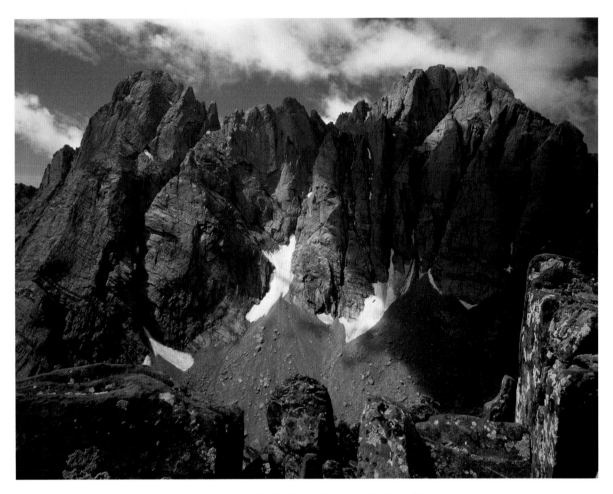

Crestone Needle (left) and Crestone Peak (right)

Sand Dunes National Park, and is about 750 feet (229m) above the floor of the San Luis Valley. It exceeds in height the highest dune in the Eureka Dunes, 680 feet (207m), located in Death Valley National Park in California, the second-highest dune in North America. In the background rise peaks of the Sangre de Cristo Range.

At left center in this view, from left to right, are three separate summits: Challenger Point, 14,080 feet (4,292m); Kit Carson Peak, 14,165 feet (4,317m); and Columbia Point, 13,980 feet (4,261m), formerly known as "Kat Carson" until renamed on June 10, 2003. The Prow, a finlike feature, can be seen leading to the summit of Kit Carson Peak.

There is a plaque on top of Challenger Point honoring the crew of the Challenger Shuttle, the space shuttle that exploded shortly after liftoff on January 28, 1986. There is a similar plaque on top of Columbia Point honoring the crew of the Columbia Shuttle, which disintegrated on reentry into the atmosphere on February 1, 2003.

The famed Kit Carson, for whom the highest peak of the trio is named, was for a time the commander of the U.S. Army garrison at Fort Garland, at the base of the Sangre de Cristo Range. At the right center are, on the left, the twin summits of Crestone Peak, the highest of which is 14,294 feet (4,357m), and on the right, Crestone Needle, 14,197 feet (4,327m).

A closer view of the Crestones from the north, above South Colony Creek Basin, clearly shows the rugged nature of these peaks, with Crestone Needle on the

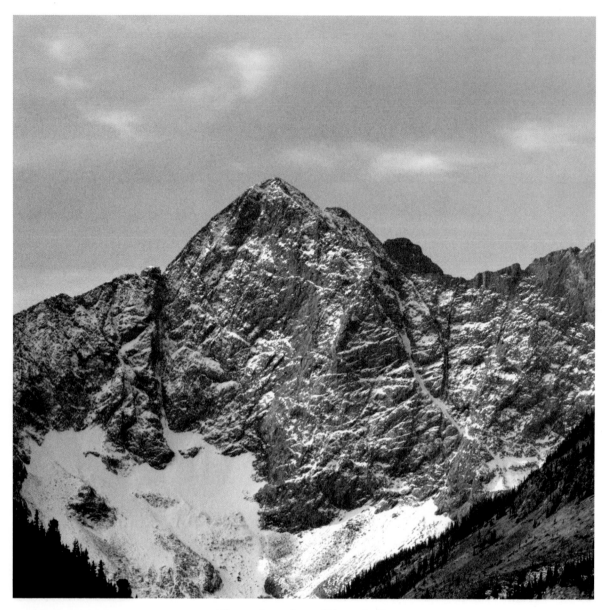

The northeast face of Blanca Peak

left and Crestone Peak on the right. In fact, there are no easy routes up these peaks, and they were the last of Colorado's fourteeners to be climbed. Colorful lichens adorn the rocks in the foreground.

Blanca Peak, 14,345 feet (4,372m), is the highest peak in the Sangre de Cristo Range, and the fifth-highest summit in Colorado. The northeast face, seen in this view over the Huerfano Valley, is one of the most impressive mountain facades of rock in the state. Frequent summer thunderstorms can cover the ledges on this face with hail or snow, which can linger because of the northeastern exposure. Perhaps the name Blanca, an adjective meaning "white" in Spanish, came about for this reason.

The first recorded ascent of Blanca Peak was made by the Wheeler Survey on August 14, 1874, but they found evidence of a stone structure on the summit, built by either the Ute Indians or Spanish explorers. The peak was known to the Navajos as "Tsisnassjini" (White Shell Mountain) and is their "sacred mountain of the east."

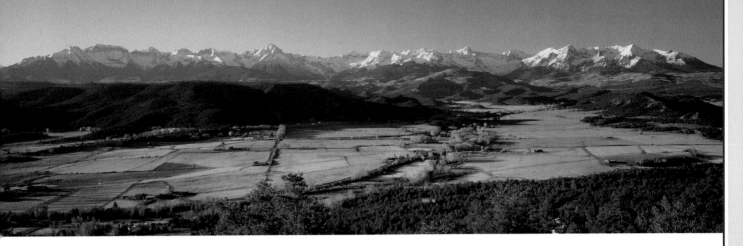

The Sneffels Range and Pleasant Valley as seen from Log Hill Mesa

San Juan Mountains

▲▲▲

Occupying about 10,000 square miles (~26,000 sq km) in southwestern Colorado, the San Juan Mountains are truly an area of scenic splendor. The area is rich not only in mountain scenery but also in history. The San Juan Skyway, a 232-mile (371km) loop road, displays many of the highlights as well as providing access to Mesa Verde National Park. Additional sights may be viewed by riding on the Durango & Silverton Narrow Gauge Railroad, driving on State Route 149, traveling any of the numerous dirt roads and four-wheel-drive roads, and hiking on the countless trails into seven different designated wilderness areas.

The San Juans have a reputation for being a storm factory, with weather likely to come from almost any direction. It is often stormy here when it is more or less clear in other Colorado mountains. The months of July and August, the "monsoon season," see vicious thunder and lightning storms almost every afternoon. Many of the main peaks are composed of notoriously loose rock, though there are exceptions. Much of the rock is volcanic in origin and has been steeply eroded by past glacial activity, leading to sharply carved peaks. This "tour" of the San Juan Mountains will start at the north end, near Ridgway, and proceed in a counter-clockwise direction.

A good introduction to the San Juan Mountains is the view from the Log Hill Mesa Road just west of Ridgway. The two panoramic views shown here were taken from this area. The upper view, looking south, shows the Sneffels Range in the Mount Sneffels Wilderness rising above Pleasant Valley. State Route 62 passes through this valley. The highest peak, slightly to the left of center, is Mount Sneffels, 14,158c feet (4,315m).

The lower view, looking east and taken from the

The Cimmaron Range and the Cimmaron Valley as seen from Log Hill Mesa at sunset

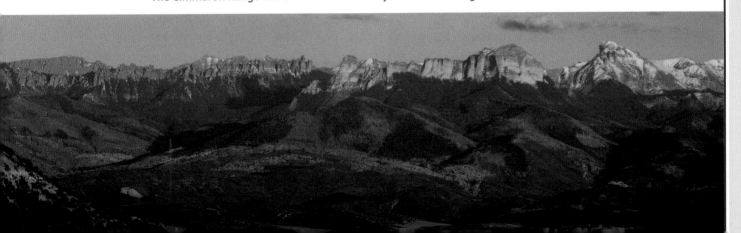

same spot at sunset, shows the Cimarron Range in the Uncompahgre Wilderness rising above the Cimarron Valley. U.S. Highway 550 passes through this valley. (The town of Ridgway is out of view to the right.) The highest peak seen is Precipice Peak, 13,144 feet (4,006m), on the right. The dome-shaped peak to the left of it is Courthouse Mountain, 12,152 feet (3,704m). The latter peak is closer to the viewer, and because of perspective, appears to be almost as high as Precipice Peak. This area was featured prominently in the Hollywood films *How the West Was Won* and the John Wayne classic *True Grit*.

Chimney Rock, 11,781 feet (3,591m), is one of the most spectacular rock formations in the San Juan Mountains. Located in the Cimarron Range, this spire forms the backdrop to one of the chase scenes in *True Grit* where Rooster Cogburn (John Wayne) is pursuing three bad guys on horseback, clutching a rifle, and, because his hands are full, holding the reins in his mouth.

A winter view shows Mount Sneffels seen from Dallas Divide, 8,970 feet (2,734m), on SR 62. The fence made an attractive foreground. This peak is affectionately known as the "Queen of the San Juans" and is regarded by many as Colorado's most beautiful mountain. Next to the Maroon Bells, Mount Sneffels is probably the most photographed mountain in Colorado. It was first climbed by the Hayden Survey on September 10, 1874, but there are as well many difficult mountaineering routes on the north face, the upper portion of which appears in the shade in this view. The peak was named by the members of the Hayden survey for an Icelandic volcano, Snæfell, which had a prominent role in the classic science-fiction novel *Journey to the Center of the Earth*, written by Jules Verne in 1864.

Even though it may seem as if there are no new routes to climb on the Colorado mountains, especially on those peaks near a highway, that is not always the

Chimney Rock and Courthouse Mountain (right) in the Cimmaron Range

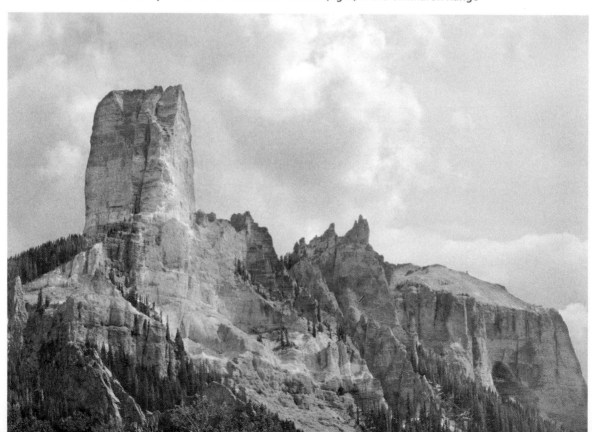

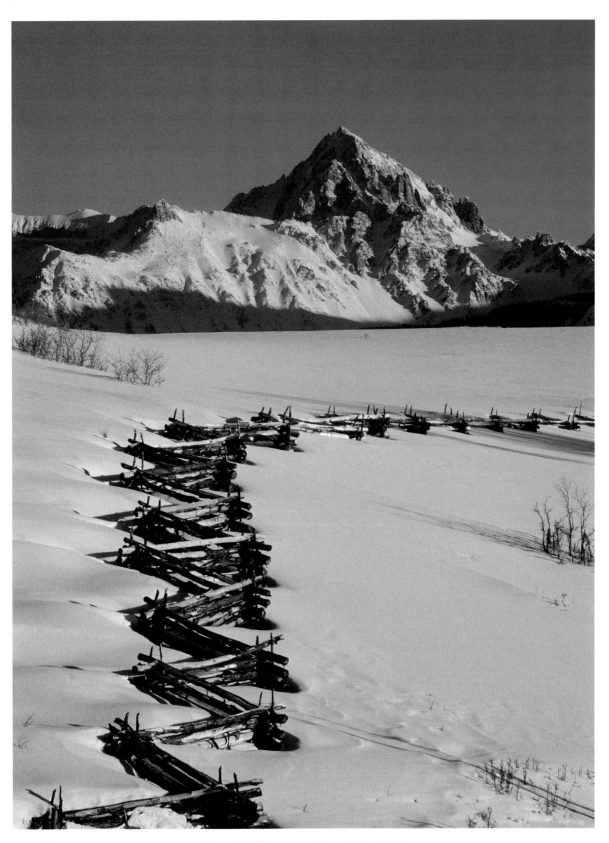

Mount Sneffels as seen from Dallas Divide

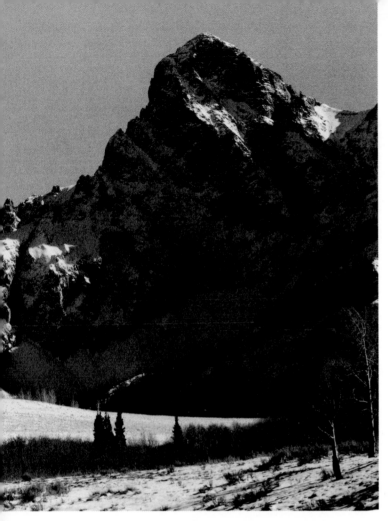

Peak 13,134 as seen from Dallas Divide

case. The north face of this fine-looking peak, Peak 13,134 (4,003m), visible from the Dallas Divide, was not climbed until October 2006. The route, while requiring technical skill, is not of death-defying difficulty; it ascends the snow-covered ramp sloping up and to the left, intersecting the summit ridge to the left of the summit.

Continuing south on the San Juan Skyway loop on State Route 145, the next picture shows another winter view. This one, taken at sunrise, features Wilson Peak, 14,017 feet (4,272m). Located a short distance southwest of the resort community of Telluride, it is located in the compact San Miguel Mountain group, a subrange of the San Juan Mountains that contains three fourteeners. Wilson Peak is not to be confused with the nearby Mount Wilson (also in this group), which is 14,250 feet (4,343m), one of the other three fourteeners in this San Miguel group.

A winter sunrise on Wilson Peak

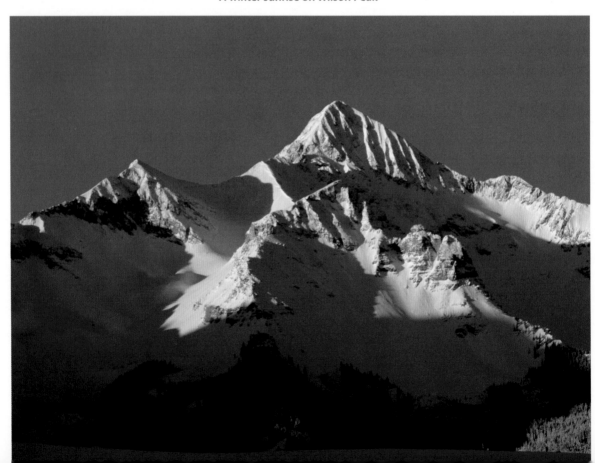

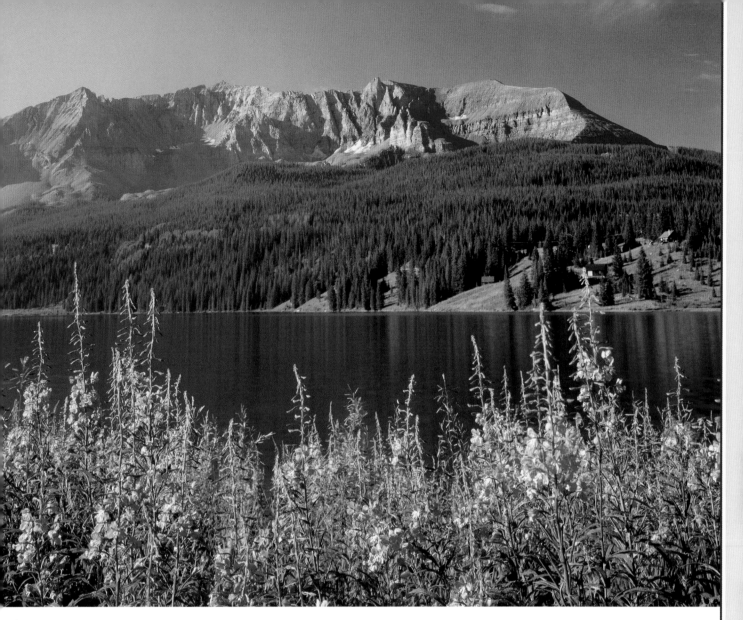

Fireweed, Trout Lake, and Sheep Mountain

On September 15, 2006, a light plane crashed into the summit of Wilson Peak, spreading wreckage on the mountain for more than 2 miles. The plane was on an approach to the ill-conceived and ill-placed Telluride Airport, built to accommodate the needs of the "beautiful people," who have virtually taken over the Telluride area. (A common sight at the small airport is the presence of several private jets.) If the almost symmetrical pyramidal shape of Wilson Peak looks familiar, it may be because you have seen it in television commercials for Coors beer.

One of the highlights along SR 145 as you continue farther south is Trout Lake, set in a glacially carved amphitheater surrounded by mountains, just north of Lizard Head Pass. The view seen here shows the lake and Sheep Mountain with fireweed, *Epilobium angustifolium*, providing a colorful foreground. The benchmark station on west end of Sheep Mountain is at an elevation of 13,194c feet (4,021m), but the topographic map shows that part of the eastern end of the mountain is higher. This Sheep Mountain is not to be confused with the other Sheep Mountain in the San Juan Mountains. This other Sheep Mountain is east of Silverton and has an altitude of 13,292 feet (4,051m).

Not too far from Trout Lake going south on SR 145, a little past Lizard Head Pass, you can see Lizard Head, 13,113 feet (3,997m), when looking to the west. Part of the San Miguel Range and located in the Lizard Head Wilderness, this peak is widely regarded as the hardest and most dangerous of Colorado's major summits to attain.

The first ascent was made in 1920 by pioneer climbers Albert Ellingwood and Barton Hoag, and it was undoubtedly the hardest rock climb in the United States at the time. The advice given by Robert Ormes in an early edition of *Guide to the Colorado Mountains* is: "When you reach the base, take photograph and go away." Recent visitors have formed the opinion that the peak has become noticeably more rotten and therefore more dangerous. Lizard Head is volcanic in origin; the highly fractured and brittle rock is the remnant of an old volcanic plug. (The original volcano eroded away.)

There is room for only one person on the pre-

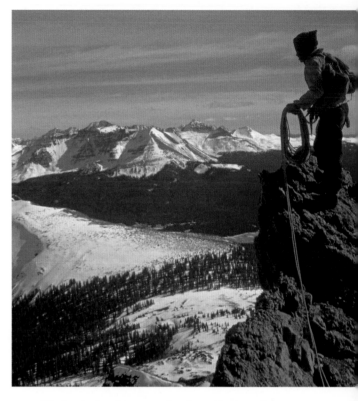

Climber balancing precariously on the top of Lizard Head

carious summit of Lizard Head, as attested to by the accompanying photograph. A second view shows a very long rappel on the descent of Lizard Head.

Lizard Head as seen from just south of Lizard Head Pass

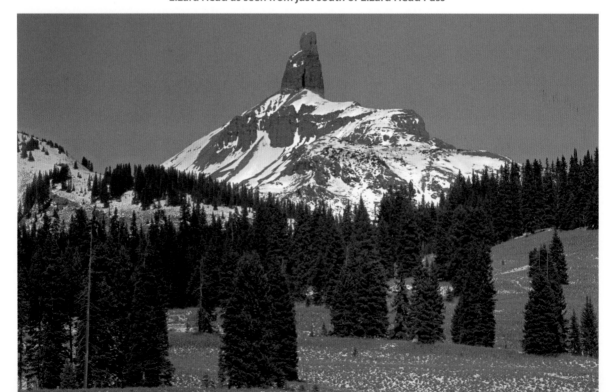

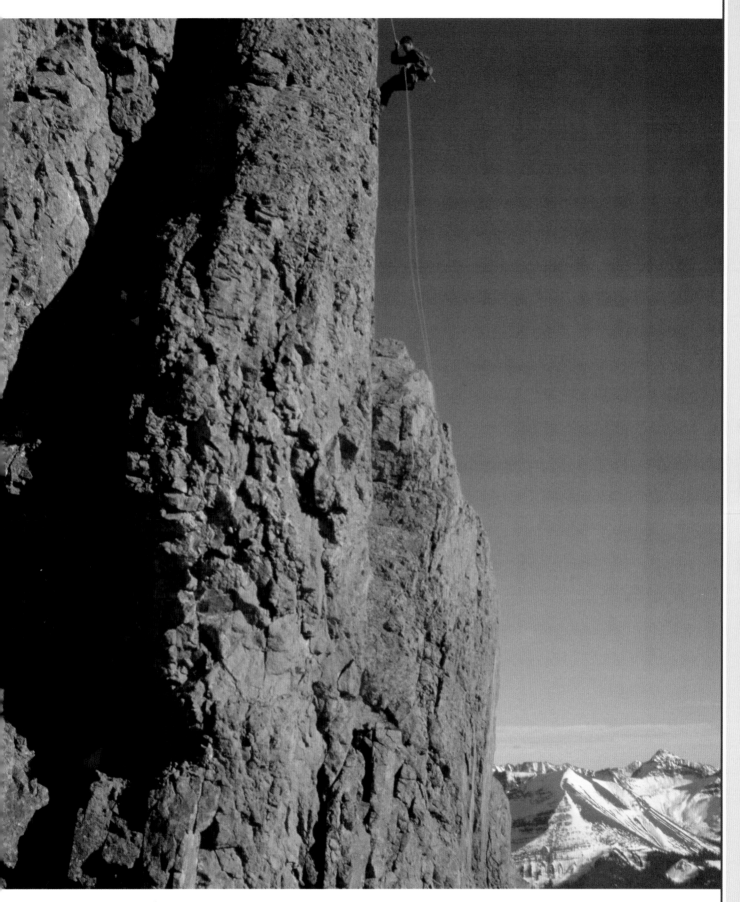

Long rappel on Lizard Head

Continuing on the San Juan Skyway loop, this time circling the southern end and heading north on the eastern portion on US 550, you arrive at Molas Lake at about 10,500 feet (3,200m). In one of Colorado's most outstanding mountain scenes, we see a reflection view displaying the Grenadier Range of the San Juan Mountains. While these peaks look enticingly close, they are actually difficult to reach, and people who venture into these mountains will not see the crush of people seen in some of Colorado's more popular mountain playgrounds.

What cannot be seen in this view is the Animas River Valley, which lies between the viewer and the peaks. The Grenadier Range, in the Weminuche Wilderness (and the nearby Needle Mountains), is composed of two-billion-year-old quartzite, which provides relatively good rock for climbing, unlike most of the San Juan peaks, which are volcanic in origin and whose rock is therefore more friable.

In the center of the peaks seen in this view, what appears to be one summit is actually two different mountains. The snow-clad peak in the front is Electric Peak, 13,292 feet (4,051m). Peeking up from behind this mountain is the shaded summit of Arrow Peak, 13,803 feet (4,207m). The peaks to the right of Electric Peak are Graystone Peak, 13,489 feet (4,111m), and Mount Garfield, 13,074 feet (3,985m), the latter forming the western end of the Grenadier Range.

Molas Lake and peaks of the Grenadier Range

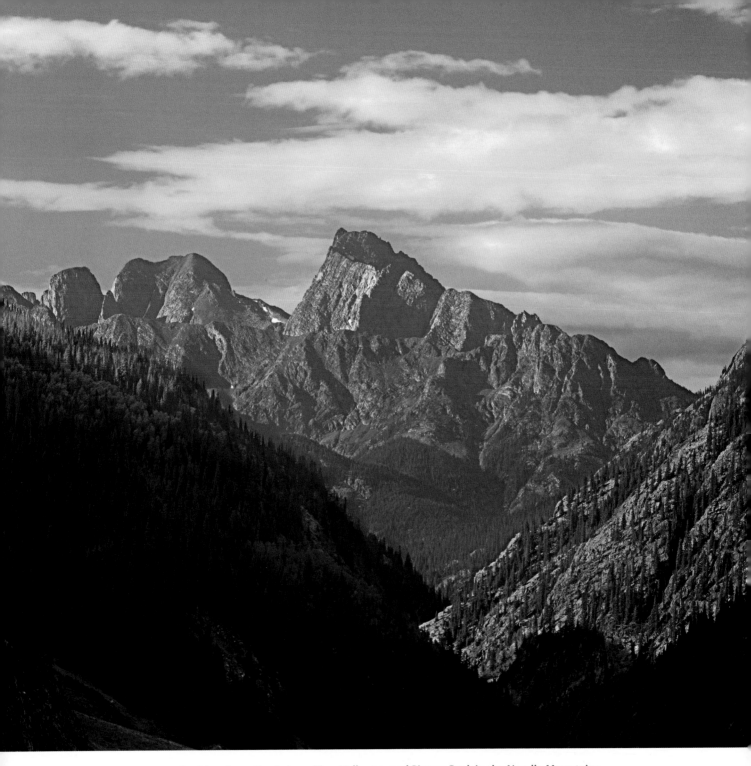

Looking down the Animas River Valley toward Pigeon Peak in the Needle Mountains

The peaks immediately to the left of Electric Peak, which appear lower only because they are more distant, are Vestal Peak, 13,864 feet (4,226m), mostly in sunlight, and the Trinity Peaks, 13,805 feet (4,208m), in the shade. On the far left is Peak 3, with an altitude of 13,478 feet (4,108m).

This Electric Peak is not be confused with two other Colorado peaks with the same or similar names. There is an Electric Peak in the Sangre de Cristo Range with elevation of 13,598 feet (4,145m), and an Electric Pass Peak (an unofficial name) in the Elk Range, at 13,635 feet (4,156m).

Continuing north on the San Juan Skyway loop on US 550, we come to historic Silverton, now a National Historic Landmark. Situated in the Animas River Valley at about 9,300 feet (2,835m) and virtually surrounded by mountains, this town was the scene of frenetic mining activity in the late 1800s.

Silverton is the location of the northern terminus of the Durango and Silverton Narrow Gauge Railroad, in continuous use since 1882. Its route south from Silverton heads down the deep canyon of the Animas River Valley toward Durango, with the Needle Mountains in the Weminuche Wilderness, Colorado's largest wilderness area, on both sides. These spectacular peaks can be accessed only by this railroad, unless one is willing to both backpack many extra miles and lose considerable elevation in the effort before having to regain the lost altitude.

Seen at left, from the north, looking down the Animas River Valley, is Pigeon Peak, 13,972 feet (4,259m), in the Needle Mountains. To the left of Pigeon Peak is Turret Peak, 13,835 feet (4,217m). At the far left is Turret Needle, which actually consists of several individual peaks, not obvious in this view. The vertical relief seen here is over 4,600 feet (~1,425m).

Moving north and crossing Red Mountain Pass we view a group of peaks that are, without doubt, among Colorado's most colorful. These are Red Mountains Number 1 to Number 3. Seen in this view is Red Mountain No. 3 at 12,890 feet (3,929m), with aspen trees in their autumn dress adding to the color. The unusual coloring of these mountains is caused by mineral deposits, mainly iron. The area surrounding these peaks is peppered with mine shafts, most of them inactive,

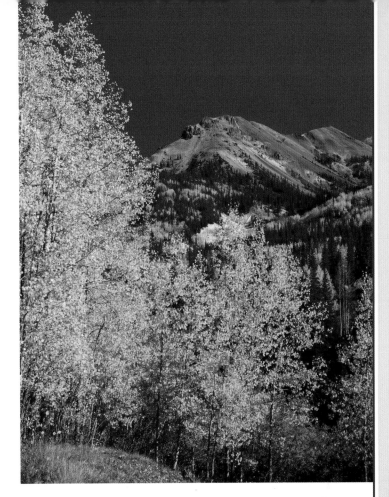

Red Mountain No. 3 and fall foliage

that form deadly traps for the unwary. The water runoff from this area creates a very unpleasant and sickly looking yellow brown color in Red Mountain Creek, which merges into the Uncompahgre River several miles to the north.

Continuing north on US 550, we travel on the precipitous Million Dollar Highway leading down into the community of Ouray, known as the "Switzerland of America" and also designated as a National Historic District. Ouray, pronounced You-ray, is named for a Ute Indian chieftain of the same name. Seen in this view on the next two pages is part of Ouray, set in the beautiful Uncompahgre Valley, with Abrams Mountain, 12,801 feet (3,902m), as the backdrop. Continuing 10 miles (16km) north, we arrive at the town of Ridgway, where we started on the San Juan Skyway loop.

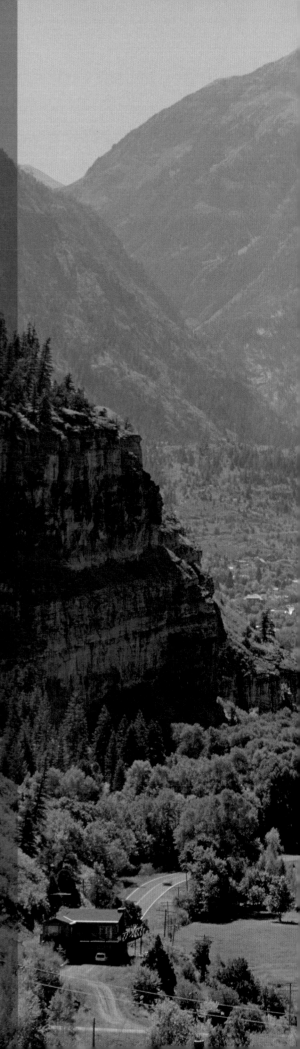

Colorado Peaks and Locations Featured

Abrams Mountain [210648]....................................37.9622N/107.6406W
Arrow Peak [310674] ...37.6928N/107.6101W
Blanca Peak [210957] ..37.5774N/105.4857W
Challenger Point [210952]......................................37.9803N/105.6065W
Chiefs Head Peak [210240]40.2496N/105.6416W
Chimney Rock [310669-E]38.1462N/107.5692W
Cimarron Range seen from Log Hill Mesa [310678] various
Columbia Point [210952]..37.9790N/105.5982W
Courthouse Mountain [310678]...............................38.1352N/107.5738W
Crestone Needle [210926 & 210952]......................37.9647N/105.5766W
Crestone Peak [210926 & 210952]..........................37.9668N/105.5855W
Mount Elbert [M-10407]...39.1177N/106.4453W
Electric Peak [310674] ...37.6990N/107.6171W
Flatirons [210546].......................................various, near Boulder
Mount Garfield [310674] ...37.6946N/107.6363W
Graystone Peak [310674]...37.6892N/107.6196W
Hallett Peak [310221]..40.3029N/105.6860W
Kit Carson Peak [210952]37.9796N/105.6026W
La Plata Peak [210434]...39.0294N/106.4729W
Lizard Head [210657 & T-110501 & T-110502]..........37.8358N/107.9506W
Longs Peak [310218 & 210526]40.2550N/105.6151W
Maroon Peak [210426]..39.0708N/106.9889W
Mountain of the Holy Cross [M-10401]39.4667N/106.4816W
North Chasm View Wall [210363]38.584 N/107.711W
Notch Mountain [M-10401]......................................39.4774N/106.4605W
Peak 13134 [210634-V]...38.0252N/107.8911W
Peak 3 [310674]..37.6965N/107.5774W
Pigeon Peak [310622] ...37.6323N/107.6463W
Pikes Peak [210839]..38.8405N/105.0446W
Precipice Peak [310678] ..38.1194N/107.5351W
Mount Princeton [210715]......................................38.7492N/106.2424W
Pyramid Peak [210418]..39.0716N/106.9501W
Red Mountain No. 3 [310639]37.9015N/107.6891W
Sheep Mountain [310658]..37.7854N/107.8861W
Mount Sneffels [210603 & 310677].......................38.0037N/107.7922W
Sneffels Range seen from Log Hill Mesa [310677] ..various
Spearhead [210240] ..40.2552N/105.6381W
Trinity Peaks (highest peak) [310674]37.6849N/107.5812W
Turret Peak [310622] ...37.6275N/107.6399W
Vestal Peak [310674] ...37.6893N/107.6027W
Wilson Peak [210604]...37.8603N/107.9846W

The numbers in brackets are the author's file numbers for the images.

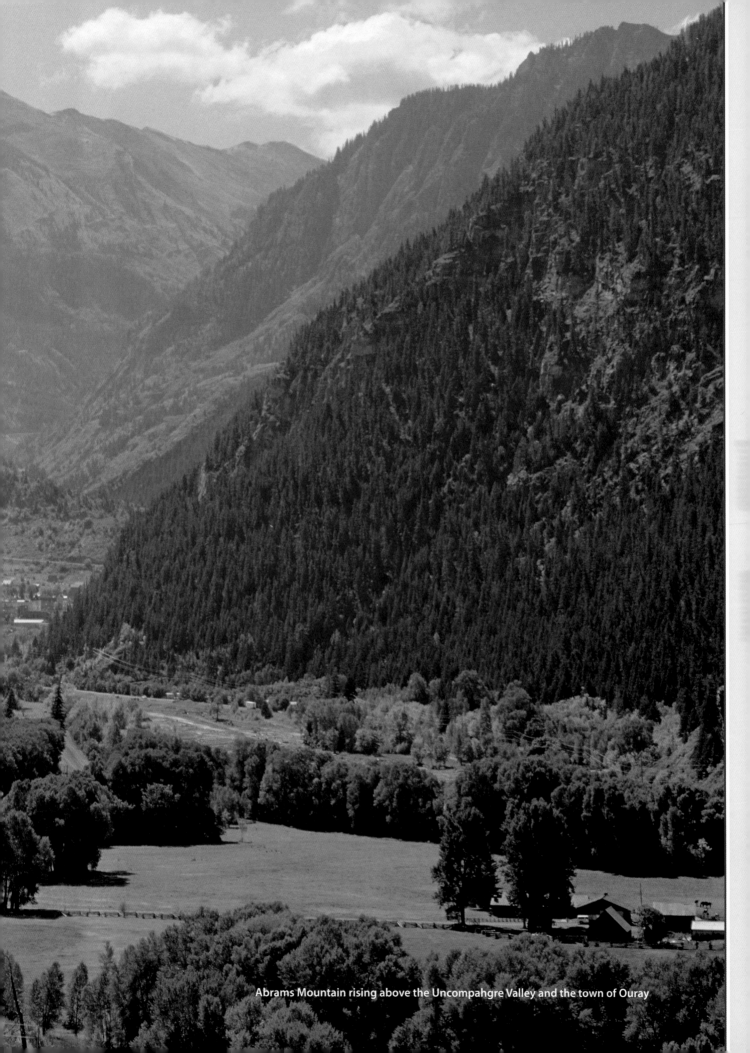
Abrams Mountain rising above the Uncompahgre Valley and the town of Ouray

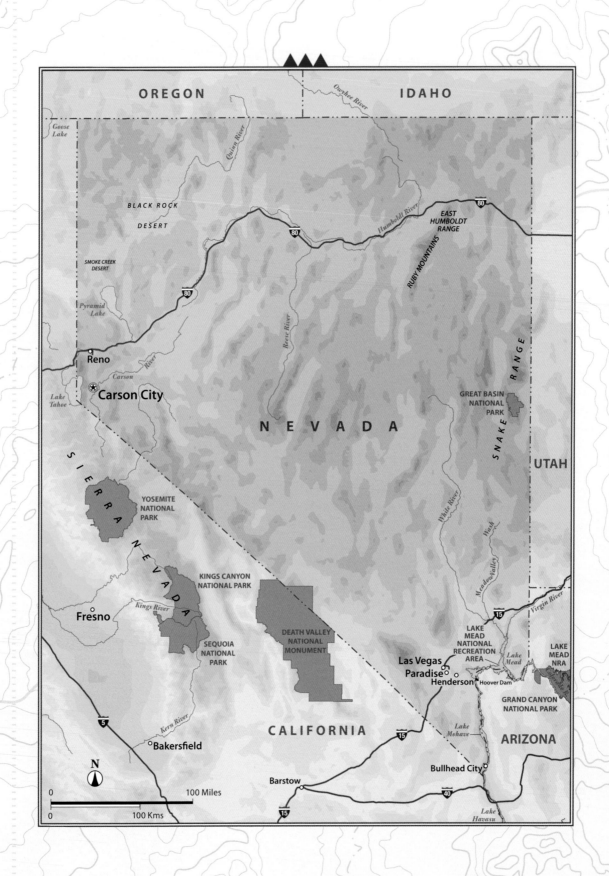

OREGON
IDAHO

Owyhee River

Goose Lake

BLACK ROCK
DESERT

Quinn River

EAST
HUMBOLDT
RANGE

Humboldt River

80

80

SMOKE CREEK
DESERT

80

RUBY MOUNTAINS

Pyramid Lake

Reese River

Reno

Carson River

⊛ Carson City

GREAT BASIN
NATIONAL
PARK

Lake Tahoe

N E V A D A

S N A K E R A N G E

UTAH

S
I
E
R
R
A

YOSEMITE
NATIONAL
PARK

White River

Meadow Valley Wash

N
E
V
A
D
A

KINGS CANYON
NATIONAL PARK

Kings River

Virgin River

Fresno

15

DEATH VALLEY
NATIONAL
MONUMENT

SEQUOIA
NATIONAL
PARK

LAKE
MEAD
NATIONAL
RECREATION
AREA

Lake Mead

LAKE
MEAD
NRA

Las Vegas
Paradise
Henderson Hoover Dam

GRAND CANYON
NATIONAL PARK

5

Kern River

CALIFORNIA

Lake Mohave

ARIZONA

Bakersfield

15

Bullhead City

N

0 100 Miles

Barstow

40

0 100 Kms

15

Lake Havasu

NEVADA

Ruby Mountains

▲▲▲

When traveling east on Interstate 80 after leaving the Lake Tahoe–Reno area, you cross a seemingly endless succession of long treeless valleys interspersed with desert mountain ranges. Yet, near the eastern side of Nevada lies a surprise: real alpine mountains. The Ruby Mountains, also known as the "Alps of Nevada," run in a north–south direction for approximately 60 miles (~100km). Located in the Great Basin and visible from I-80, they were named for the garnets found in the area by early explorers. These mountains may be approached via State Route 227 from Elko, and the closer you get to them, the more spectacular they become.

This sunset view, shown on the next two pages, from Lamoille Valley towards the heart of the Ruby Mountains shows Ruby Dome, 11,387 feet (3,471m), the highest peak in the range. (Not surprisingly, it is the dome-shaped peak in the center.) The deep canyon on the left is Lamoille Canyon, sometimes called "Nevada's Yosemite." A road goes up this canyon, which shows evidence of extensive glaciation, including U-shaped canyons, moraines, hanging valleys, and glacial cirques.

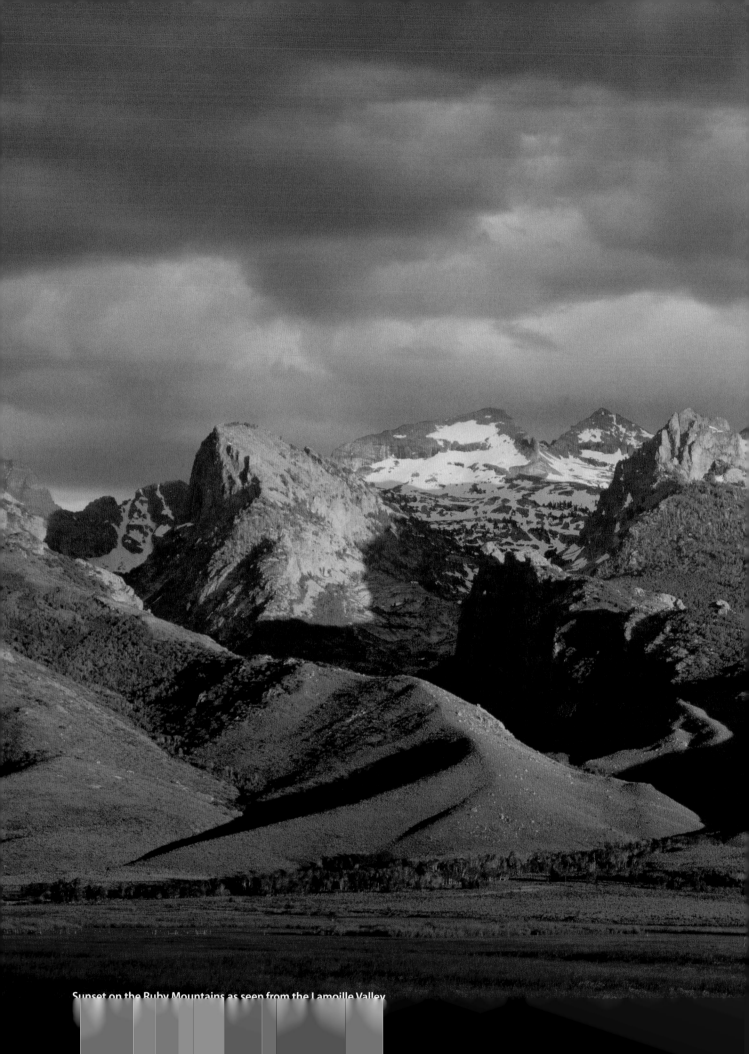

Sunset on the Ruby Mountains as seen from the Lamoille Valley

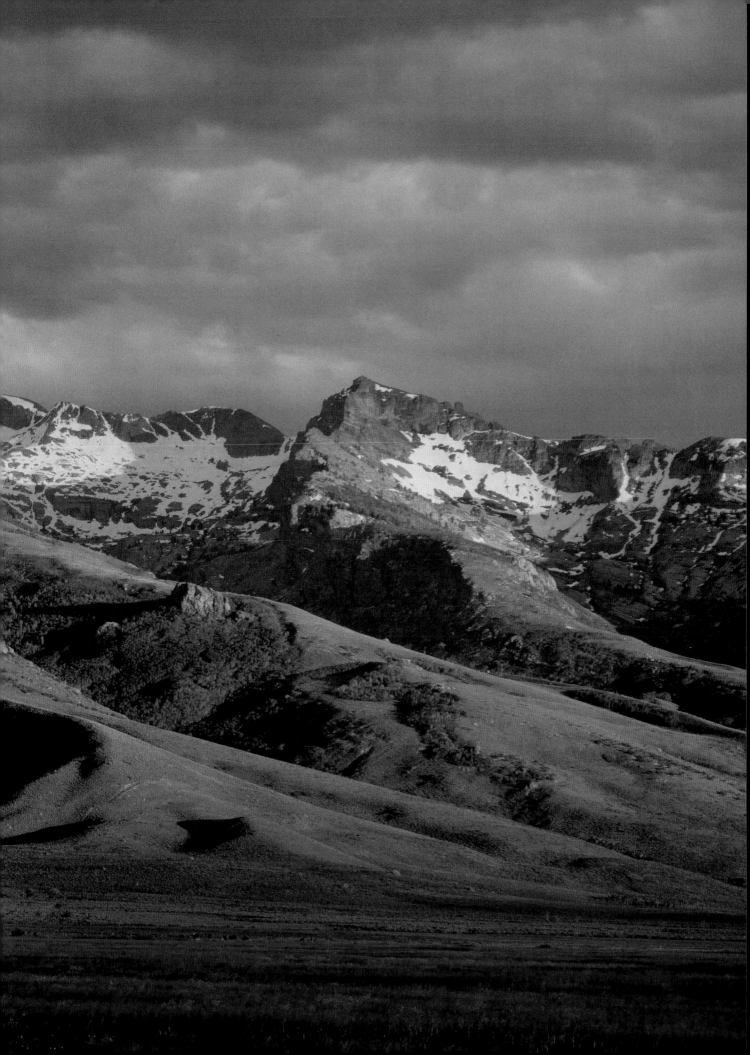

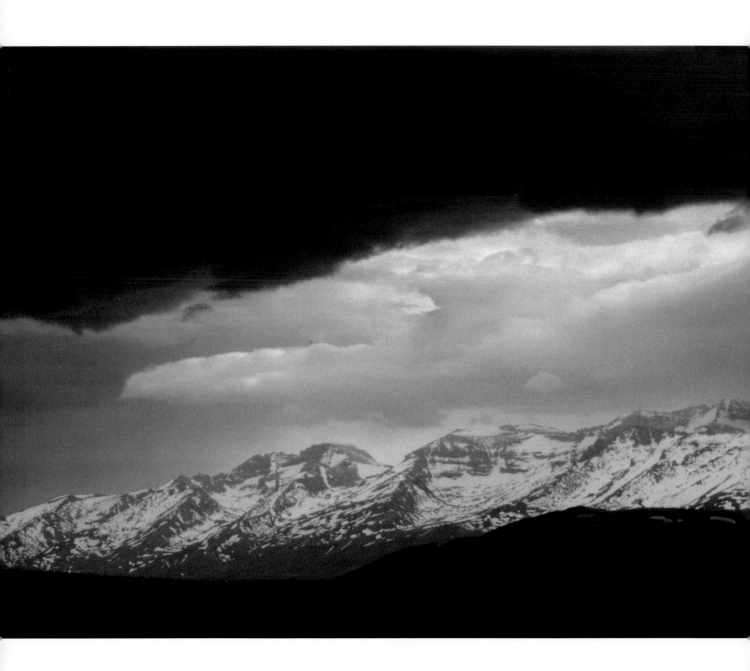

East Humboldt Range

▲▲▲

A second surprise is the East Humboldt Range, about 30 miles (48km) long, which lies immediately to the northeast of the Ruby Mountains, separated from the latter by Secret Pass. A late spring panoramic view of this range from the vicinity of U.S. Highway 93 north of Wells shows the range (formed

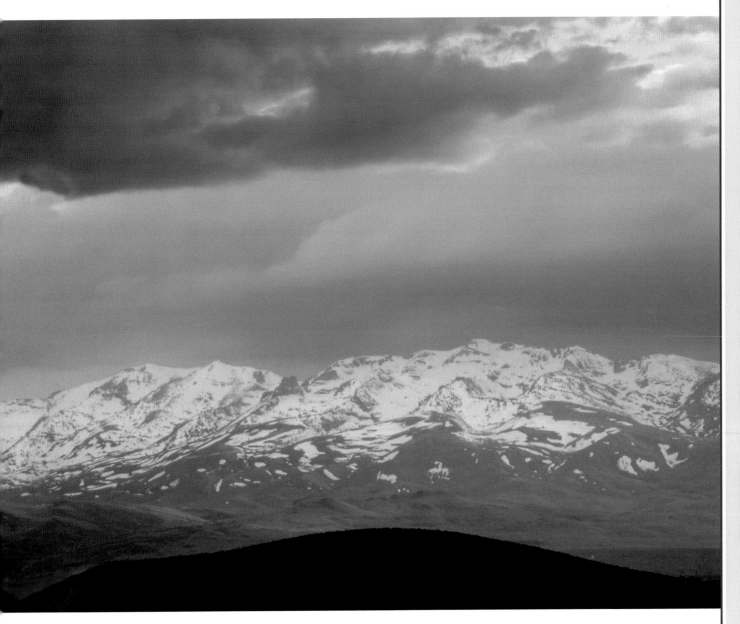

Storm clouds brood over the East Humboldt Range

by a tilted fault block process) almost in its entirety, with storm clouds brewing above the peaks. Hole in the Mountain Peak, 11,306 feet (3,446m), is the highest peak in the range, and in this view is the peak just left of center that shows a lot of exposed rock in the summit area.

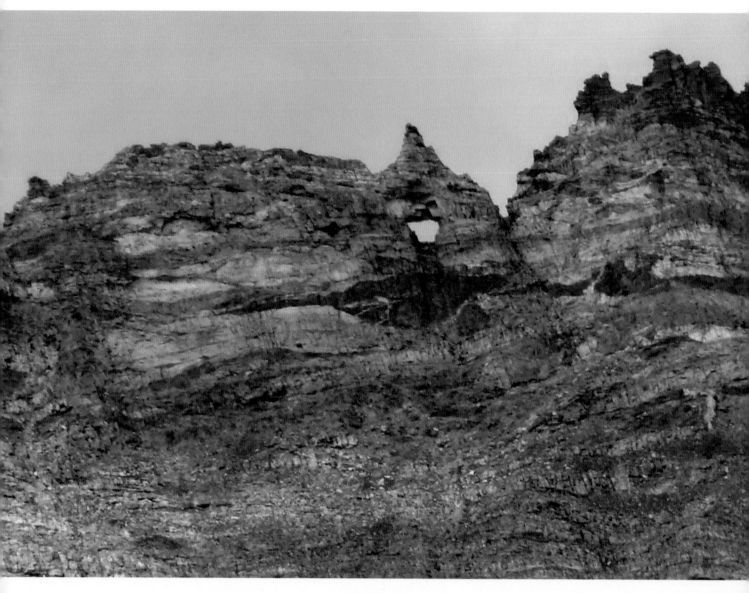

Hole in the Mountain

The actual Hole in the Mountain is located slightly south of the peak with the same name. The elevation of the hole is given as 11,127 feet (3,392m). The hole is sometimes referred to as Lizzie's Window, named after a pioneer woman in the area who was given credit for first noticing the hole. A telephoto view of the hole seen from the east is shown here. From the road, the hole is difficult to see with the naked eye, although the spire above it can be seen fairly easily.

Technical rock climbing is necessary to reach Hole in the Mountain from this eastern side, which is obvious when looking at the picture. The hole can more easily be reached from the other side of the East Humboldt Range.

One of the gems in the East Humboldt Range is Angel Lake, at 8,378 feet (2,554m), which may be reached by auto. In the background are the granite cliffs of Greys Peak, 10,676c feet (3,254m).

Interestingly, there is a West Humboldt Range in Nevada (on some maps it is called simply the Humboldt Range), but it is nowhere near the East Humboldt Range. It is located almost all the way across the state, about 60 miles (~100km) northeast of Reno.

These ranges were named by explorer John C. Frémont for the famed German naturalist Alexander von Humboldt, whose full name was Friedrich Wilhelm Heinrich Alexander Freiherr von Humboldt. (Imagine having to fill out forms with a name like that!) Humboldt was one of the first of the men of science to suggest that the Americas, Europe, and Africa were once joined in a single supercontinent.

Angel Lake and Greys Peak

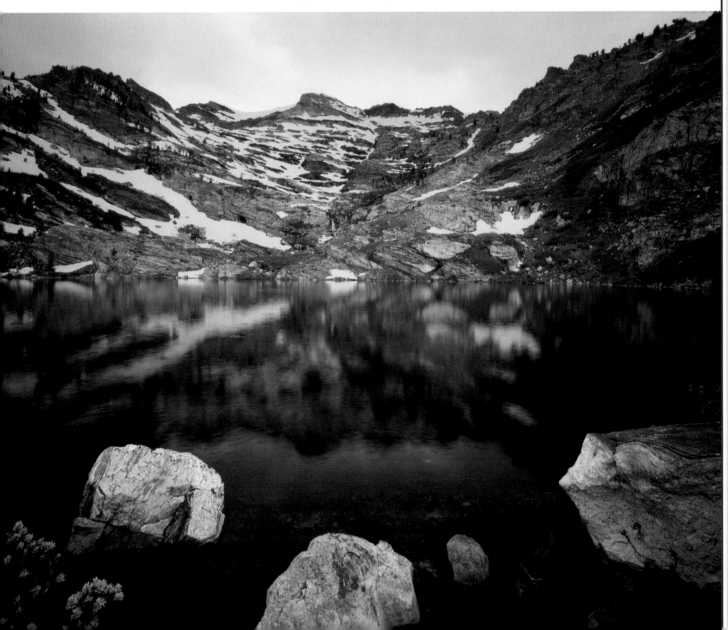

Snake Range

▲▲▲

The Snake Range, located in eastern-central Nevada near the border with Utah, is divided into the North and South Snake Ranges, which are separated by Sacramento Pass. This range is home to the only permanent ice in the Great Basin (that area where there is no drainage to an ocean, which covers most of Nevada, half of Utah, and smaller portions of California, Oregon, Idaho, and Wyoming). This permanent ice forms what geologists call a small rock glacier, which is located beneath the northeast face of Wheeler Peak, 13,065c feet (3,982m), the centerpiece of Great Basin National Park. A rock glacier is a mix of rocks and interstitial ice, which flows like a glacier. The flow patterns may clearly be seen in this view taken from near the summit of Wheeler Peak looking down at the rock glacier.

Wheeler Peak, in the South Snake Range and composed of limestone, is the highest peak that lies wholly within the state of Nevada. Boundary Peak, at 13,147c feet (4,007m), is officially the highest peak in the state, but it lies in California's White Mountains, which barely manage to reach the Nevada border at the range's north end. Actually, Boundary Peak is the lower of the twin summits of Montgomery Peak, 13,441 feet (4,097m). The higher of the two summits is in California, and the boundary between the two states passes through the saddle between the two summits.

Wheeler Peak was named after Army Major George Montague Wheeler, who was the leader of the Wheeler Survey, a party of surveyors and naturalists in the late nineteenth century that explored the area now occupied by seven western states. This Wheeler Peak is sometimes confused with the Wheeler Peak in New Mexico, the highest peak in that state, which is named for the very same person. (The New Mexico peak, at 13,167c feet [4,013m], is, in addition, very close in height to Nevada's Wheeler Peak.)

The Great Basin bristlecone pine tree, *Pinus longaeva*, is found at timberline in the Snake River Range, as well as in other desert ranges in eastern Nevada. Some specimens of these trees are the oldest living things on earth, approaching 5,000 years in age. In a view appearing on the next page, the gnarled wood of a bristlecone

Flow patterns in the rock glacier below the northeast face of Wheeler Peak

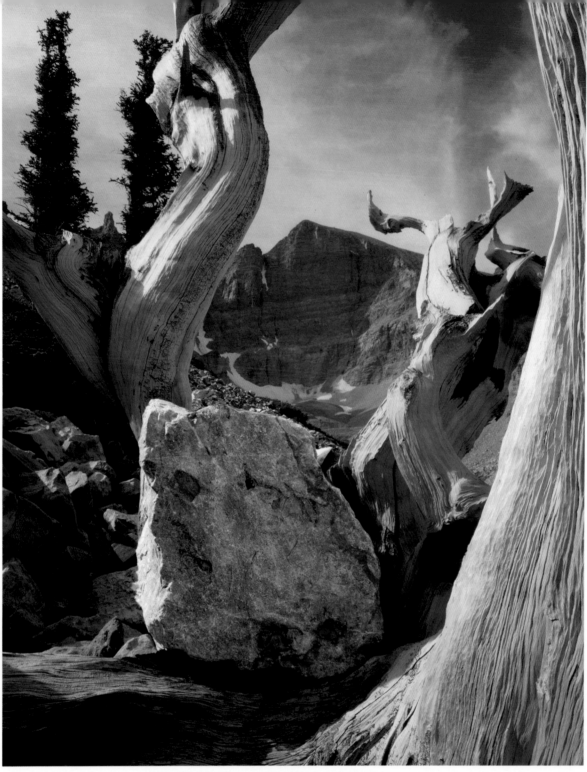

Wheeler Peak framed by ancient bristlecone pine wood

pine frames Wheeler Peak. The full extent of the sheer 1,600-foot (488m) northeast face of this peak, as viewed from the southeast ridge, is shown in a second view.

Mount Moriah, 12,072c feet (3,680m), the highest peak in the North Snake Range, is seen on pages 136 and 137 from the summit of Wheeler Peak near sunset. The side lighting highlights the desert landscape surrounding Sacramento Pass, which separates the North and South Snake Ranges. In the distance, visible to the right of Mount Moriah, is Ibapah Peak, 12,092c feet (3,686m), in the Deep Creek Range of western Utah.

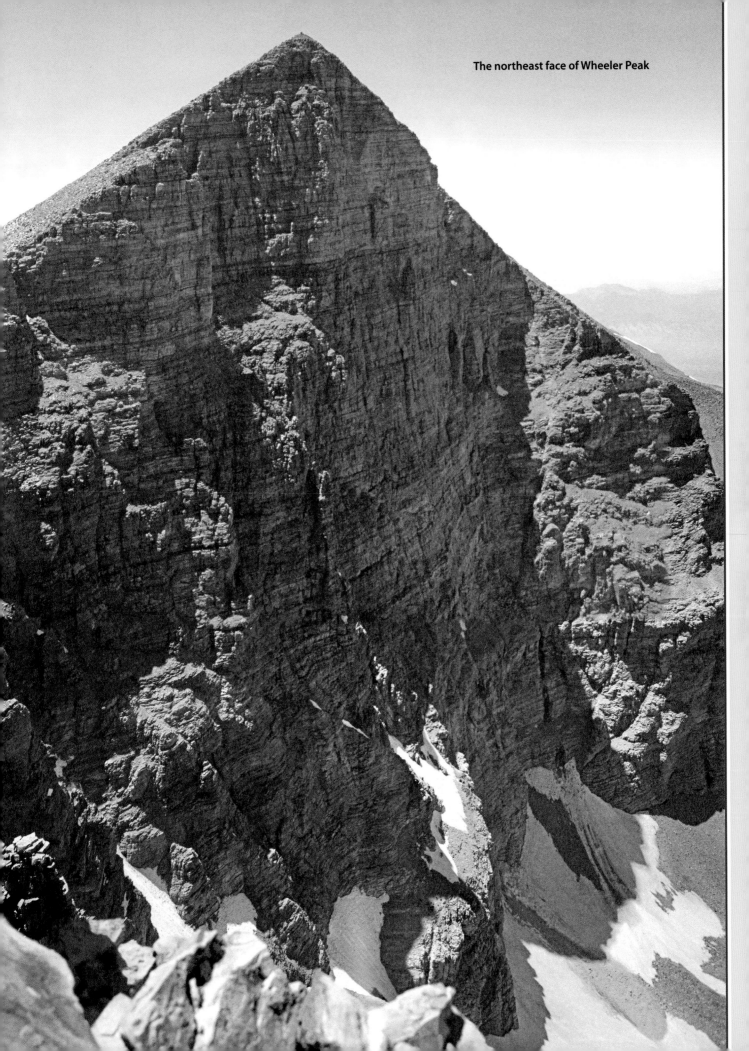

The northeast face of Wheeler Peak

Nevada Peaks and Locations Featured

The numbers in brackets are the author's file numbers for the images.

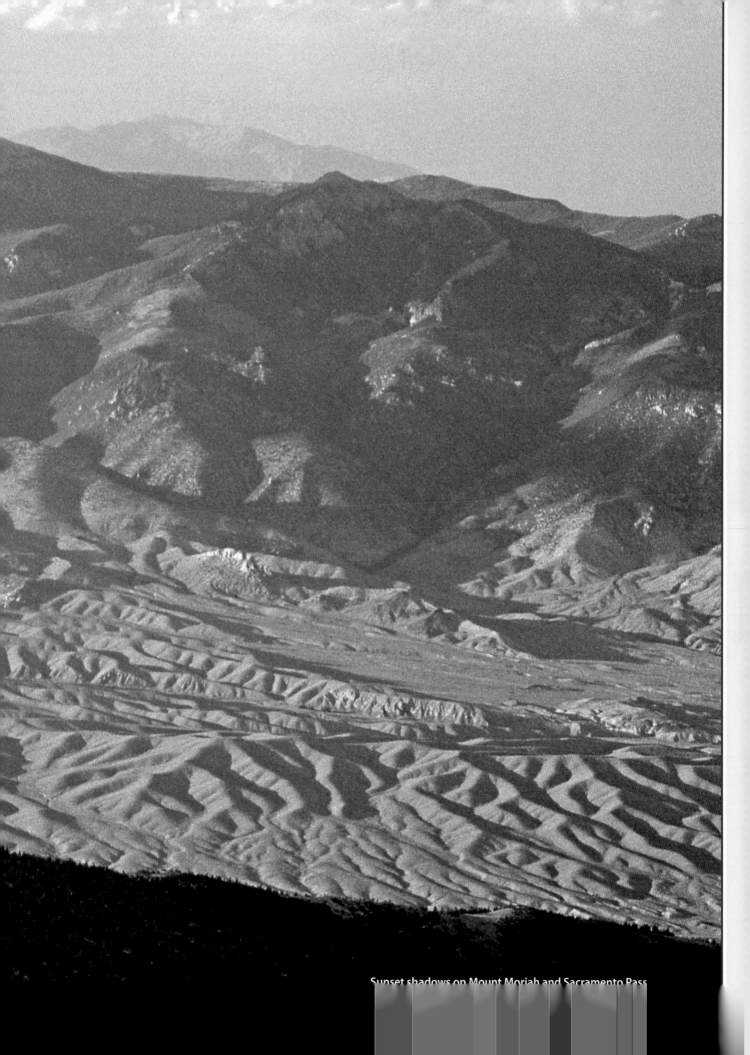

Sunset shadows on Mount Moriah and Sacramento Pass

UTAH

Uinta Mountains

▲▲▲

The Uinta Mountains, located in the northeastern portion of the state just south of the Wyoming border, have the distinction of being the only major mountain range in the contiguous United States with an east–west orientation. Approximately 120 miles long (~192km), the Uintas contain all of Utah's peaks over 13,000 feet in height, all of them within the High Uinta Wilderness.

At 13,534c feet (4,125m), Kings Peak, in the center of this wilderness, is the highest peak in the state. Unlike most of the mountains in Colorado, which are, for the most part, quite accessible, most peaks in the High Uinta Wilderness are climbed as part of a backpacking trip. In fact, the shortest route to climb Kings Peak involves a 29-mile (46km) round-trip.

In the view seen here, which looks over Atwood Lakes Basin, Kings Peak is on the right, separated from South Kings Peak by a very broad saddle. Up until 1966, it was thought that South Kings Peak, 13,518c feet

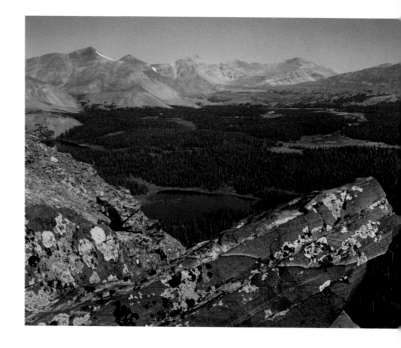

Kings Peak (rightmost peak in distance) and Atwood Lakes Basin

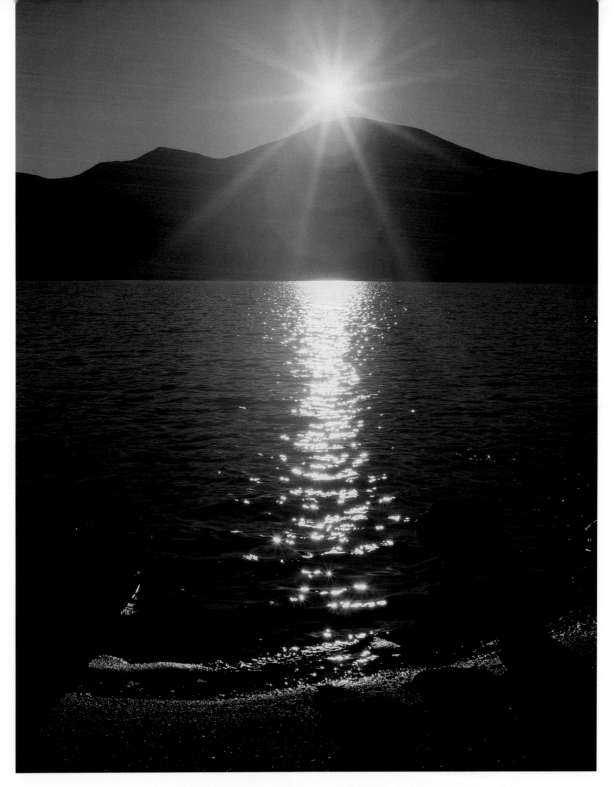

Sunburst over Mount Emmons and First Chain Lake

(4,120m), was the higher of the two summits until satellite measurements showed otherwise. In fact, the original geodetic marker station is on top of the south peak. When the error was discovered, the name "Kings Peak" was reassigned to the higher north summit.

The peak to the left of the twin summits, unofficially named "Painter Peak," is 13,387 feet (4,080m) high. The orange-red, thickly embedded quartzite and sandstone rock is from the Precambrian Uinta formation and over a billion years old. Lichens on the rock in

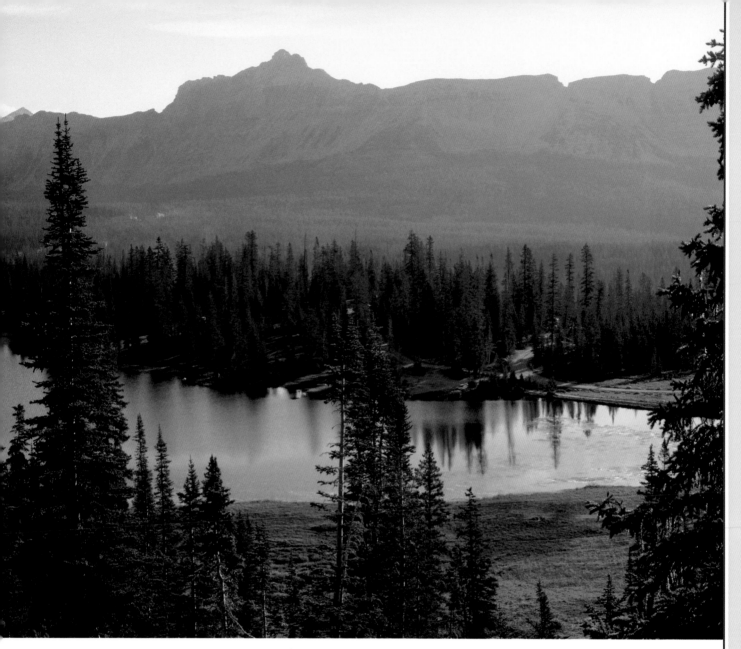

Hayden Peak and Moosehorn Lake

the foreground add color to the scene. Kings Peak was named for Clarence King, the first director of the U.S. Geological Survey.

Mount Emmons, 13,448c feet (4,099m), the fourth-highest peak in the state, is seen at left showing the sunburst over the top of the peak, with First Chain Lake in the foreground. I might add that the fishing in the High Uinta Wilderness is perhaps the best in the contiguous United States. While I am not a fisherman myself, I hiked into the area with our son, who is a dedicated fisherman.

He seemed to catch a fish on almost every cast he made into any one of the Chain Lakes.

Only at the western end of the Uinta Mountains are the peaks accessible in day trips, with State Route 150 (which is closed in the winter) crossing the range in a north–south direction. Hayden Peak, 12,479 feet (3,804m), is seen here rising above Moosehorn Lake. Be warned that this area is very crowded in the summer, and it is very difficult to find a parking place at the lake on weekends and holidays.

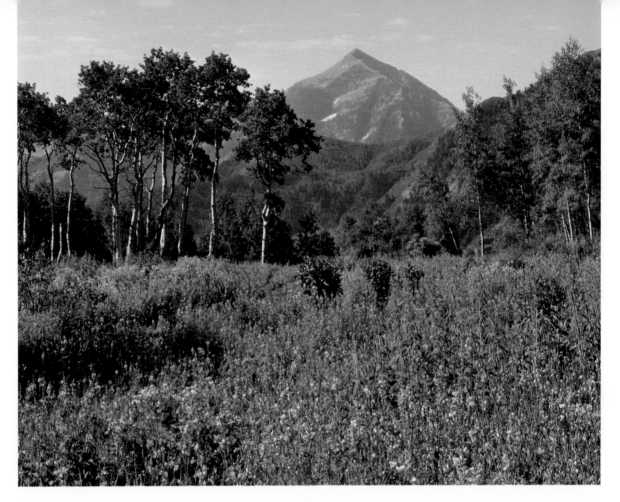

Mount Timpanogos over a field of mountain hollyhock

Wasatch Range

▲▲▲

The Wasatch Range is approximately 160 miles (~250km) long and runs in a north–south orientation from the Idaho border to central Utah. These mountains are considered the western edge of the Rocky Mountains proper, and the western slopes of the Wasatch Range drain into the eastern edge of the Great Basin. Approximately 85 percent of Utah's population lives within 15 miles (24km) of the Wasatch Range, and most of that population lies on the western front of the range.

The origin of the name Wasatch is interesting. According to Ute Indian legend, hunters were in the mountains looking for game when a blizzard came upon them. One of the men became lost, and when he was found he was dead and his penis was frozen

stiff. From then on, the mountains were referred to as Wuhu' seai, meaning "frozen penis."

The best-known and most frequently climbed peak in Utah is Mount Timpanogos, 11,752c feet (3,582m). Trails up the peak are less than an hour's drive from Salt Lake City. "Timp," as locals call it, is a fairly complex peak with several lesser summits, and it is the second-highest peak in the Wasatch Range. The peak rises about 7,000 feet (~2,130m) above the valley floor on the western front. The word "Timpanogos" is the Paiute Indian word for "water on rock" or "river on rock," derived no doubt from the many rivers and cascading waterfalls in these mountains.

In one view taken in the surrounding national forest lands, we see Mount Timpanogos rising in the distance,

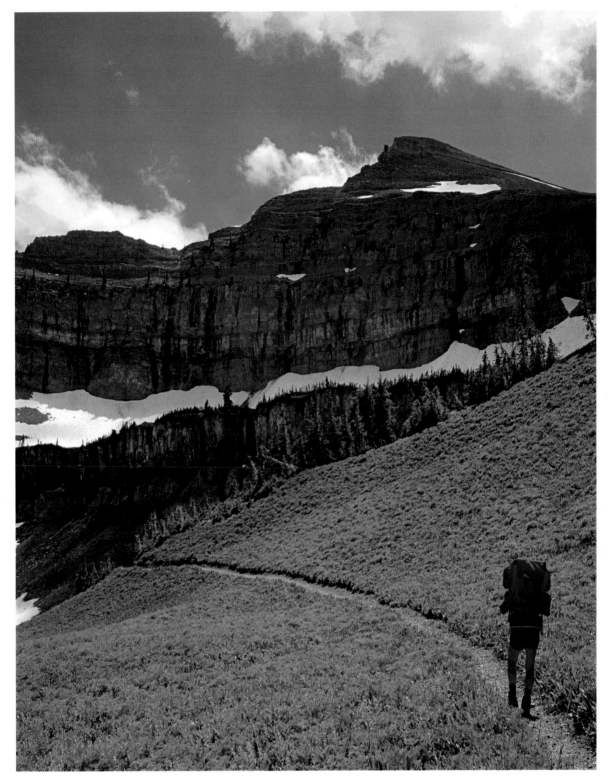

On the trail to Mount Timpanogos

with aspen trees in the mid-foreground, and a field of mountain hollyhock, *Iliamna rivularis*, in the foreground. A second view shows a hiker (in this case me), on the trail to Mount Timpanogos. The picture was taken by a camera with a self-timer mounted on a tripod. A third view, on the next two pages, shows a panoramic view taken at sunset looking south from the summit of the peak. The cities of Provo (barely discernible) and Utah

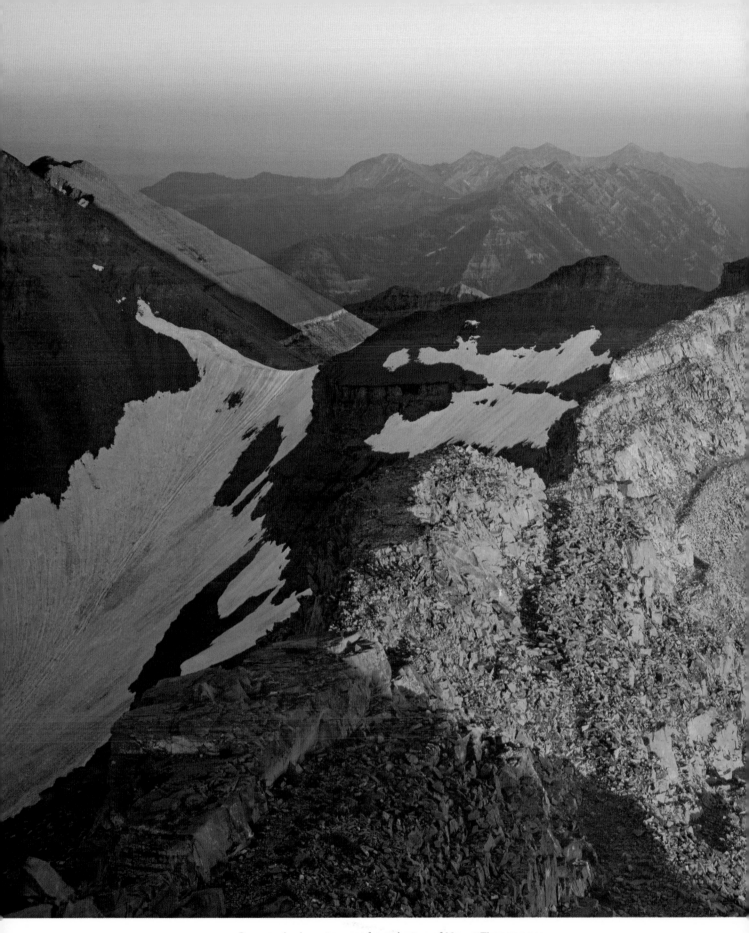
Panoramic view at sunset from the top of Mount Timpanogos

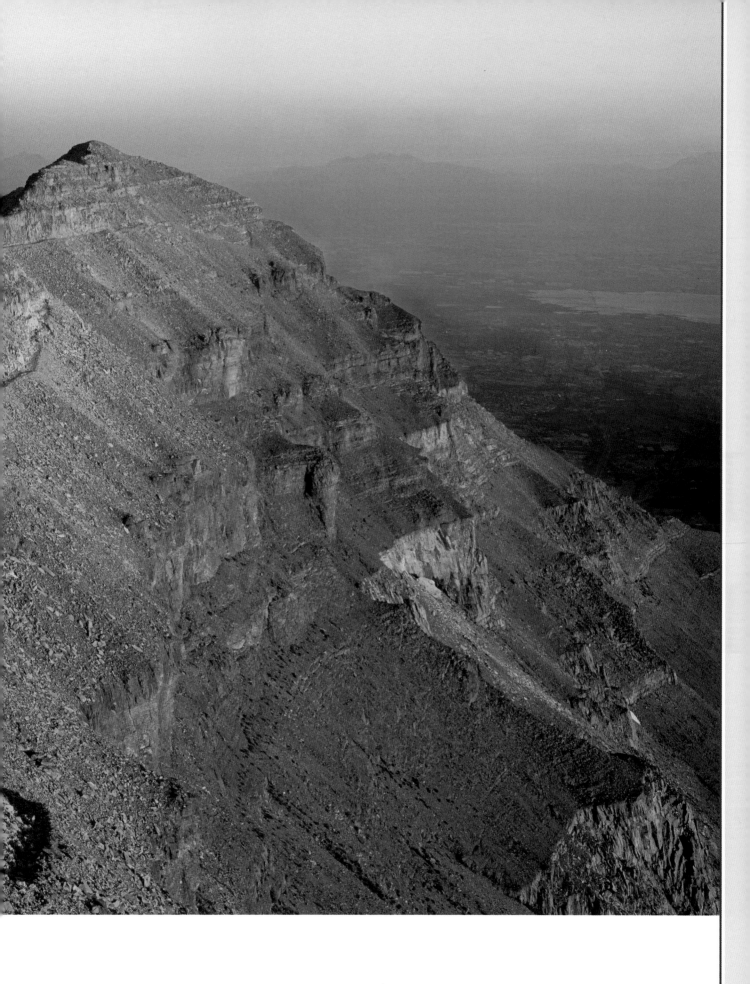

Lake are seen on the right, and part of the Timpanogos Glacier, the only glacier in Utah, is seen at the left. (Some geologists classify this as a rock glacier.) The peak itself is composed of limestone and dolomite and is estimated to be about 300 million years old.

The highest peak in the Wasatch Mountains is Mount Nebo, 11,928 feet (3,636m), in the southern portion of the range, not far from Nephi. The Nebo Loop Scenic Byway forms part of a loop, along with Interstate 15, around Mount Nebo and its three major summits. This mountain is named for the Biblical Mount Nebo in the present-day country of Jordan, where the Hebrew prophet Moses was given a view of the Promised Land that the Hebrews believed God

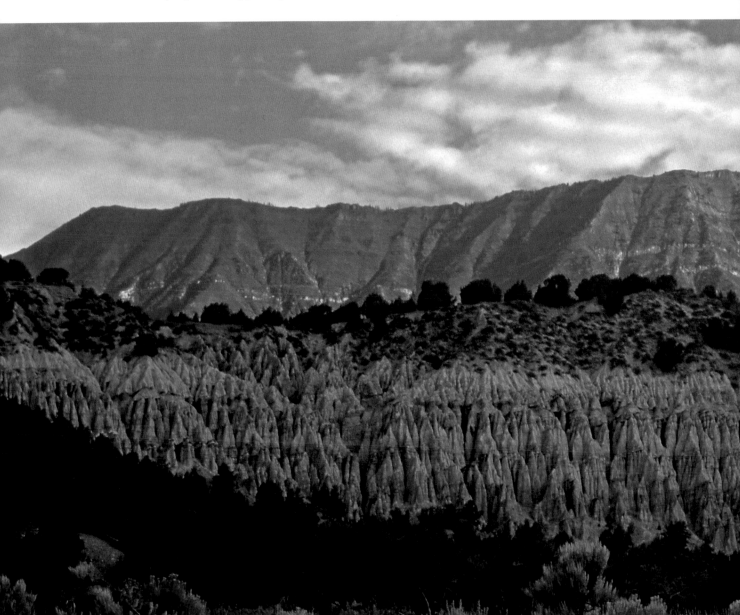

Eroded badlands and the south end of Mount Nebo

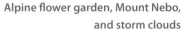

Alpine flower garden, Mount Nebo,
and storm clouds

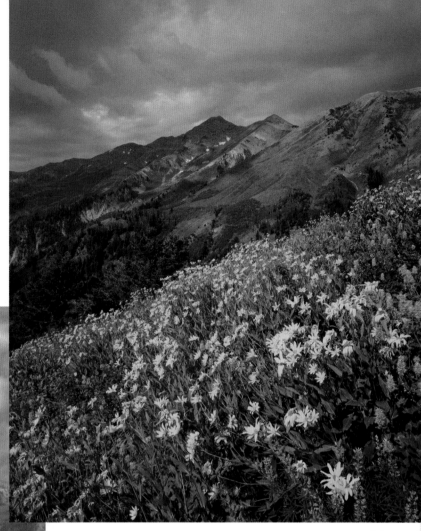

was planning to give to them. According to tradition, Moses was buried on that Mount Nebo. It is said that Native Americans once built signal fires on the summit of Utah's Mount Nebo.

Three major summits comprise Mount Nebo. It was thought that the southern summit was the highest until the 1970s when a new survey was done, which showed the north summit to be the highest. In one view here we see the southern end of Mount Nebo, with eroded badlands (below Mud Spring Hollow, not visible in this view) in the foreground. A second view shows the higher north summit of Mount Nebo, with an alpine garden of wildflowers in the foreground and storm clouds brewing over the peak.

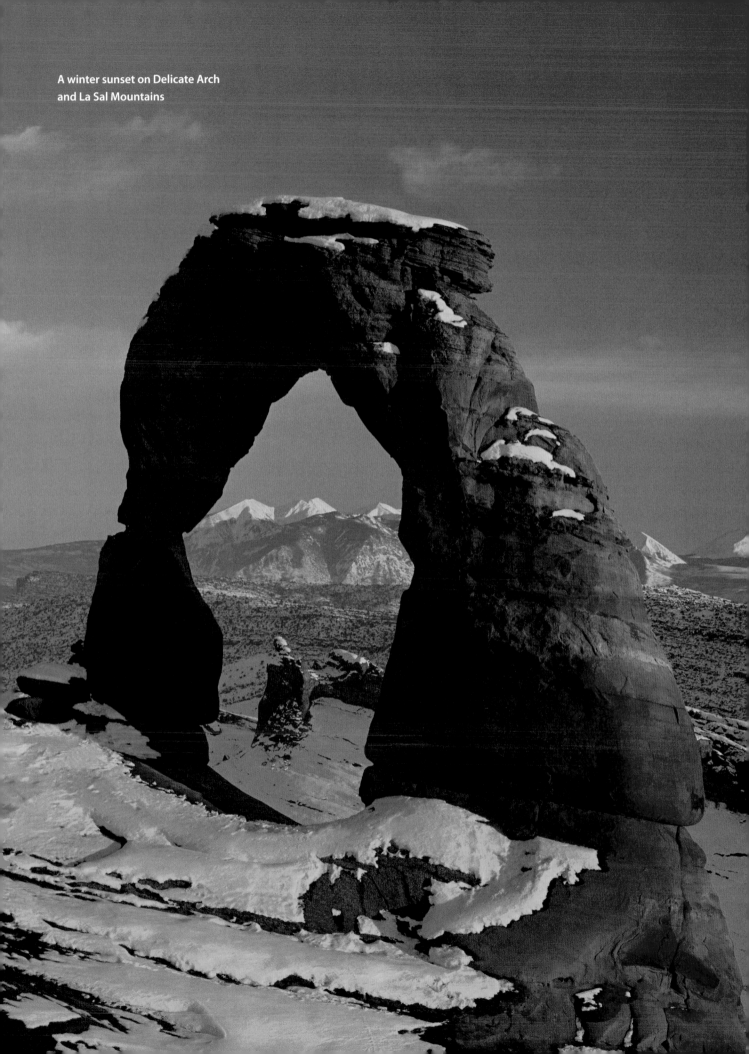

A winter sunset on Delicate Arch
and La Sal Mountains

La Sal Mountains

▲▲▲

While not as well-known as the more popular mountain ranges in Utah, the La Sal Mountains nevertheless are the second-highest mountain range in the state. Some 20 miles (32km) in length and near the Colorado border, these mountains are most often seen by visitors to Arches and Canyonlands National Parks, since the La Sal peaks rise in the distance above Colorado Plateau lands. These peaks rise, in fact, some 8,500 feet (~2,600m) above the surrounding desert, giving them a high visibility.

These mountains were originally named by an early Spanish explorer and missionary, who called them Sierra de la Sal, or mountains of salt. The name derives from the fact that the early explorer didn't believe that there was snow on these mountains, and concluded that the white material he was seeing must be salt.

The view seen here shows these peaks, the highest of which is Mount Peale, 12,726c feet (3,879m), framed by Delicate Arch in Arches National Park, in the winter at sunset.

Titan Tower

▲▲▲

Located some 22 miles northeast of Moab near State Route 28, the Fisher Towers form one of the most incredible group of desert towers on this planet. Anyone who has hiked in or climbed in this area is awestruck by the view of these fantastic, almost unworldly, rock formations. The Titan is the highest of these at about 900 feet (~275m) high and is the highest freestanding tower in the United States. These towers also provide some extremely difficult climbing. The first ascent of the Titan, made in 1962,

was the subject of an article in the November 1962 *National Geographic* magazine. In the article climber Huntley Ingalls described the summit as "a strange, awesomely isolated place, a flat, rough area of bare orange sandstone…."

The towers are composed of Cutler sandstone on the sides, capped with the more erosion-resistant Moenkopi sandstone formation. While the rock is fairly good by sandstone standards, all the formations are covered with a mudlike cake that has to be stripped

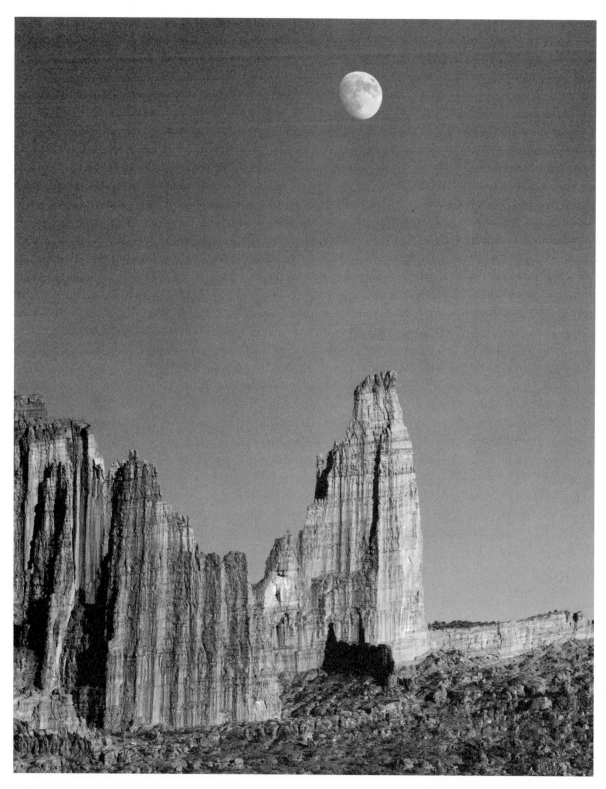

Moon over the Titan

away to find purchase for handholds or protective hardware. This makes any new routes done in this area a very dirty affair!

"Moon over the Titan" shows a real moon, not the fake enormous moon that is often superimposed into scenic postcards of mountains.

Tushar Mountains

▲▲▲

Despite the fact that the Tushar Mountains (from the Paiute word "T'shar" meaning "white") are the third-highest mountain range in Utah, even many Utahns are unfamiliar with this range. The highest peak, Delano Peak, 12,174c feet (3,711m), is higher than any peak in the well-known Wasatch Range, which is in sight of over 80 percent of the population of Utah.

Many maps do not even show the name of the Tushar Range, which borders the eastern edge of the Great Basin and extends about 30 miles (48km) in a north–south orientation in the southwestern part of the state east of Beaver. The high peaks formed 22 million to 32 million years ago in a calamitous volcanic explosion that blew off the top of a massive peak that may have been the highest peak in the Rocky Mountains at that time.

The highest drivable track in Utah, designated the Paiute ATV Trail (also drivable by four-wheel vehicle), reaches about 11,500 feet (~3,500m). This track was originally put in as a result of mining activity in the area, and more or less followed an old Paiute Indian trail. This beautiful area is being considered for wilderness status, and the proposal would eliminate use of this trail by any vehicle.

One of the outstanding features of the Tushar high country is the large number of mountain goats, *Oreamnos americanus*, that inhabit the area. In the view of Delano Peak seen here, taken from the highest point

Mountain goats on Delano Peak

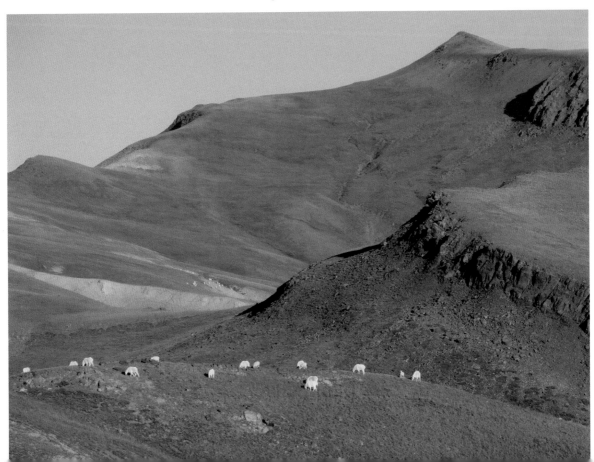

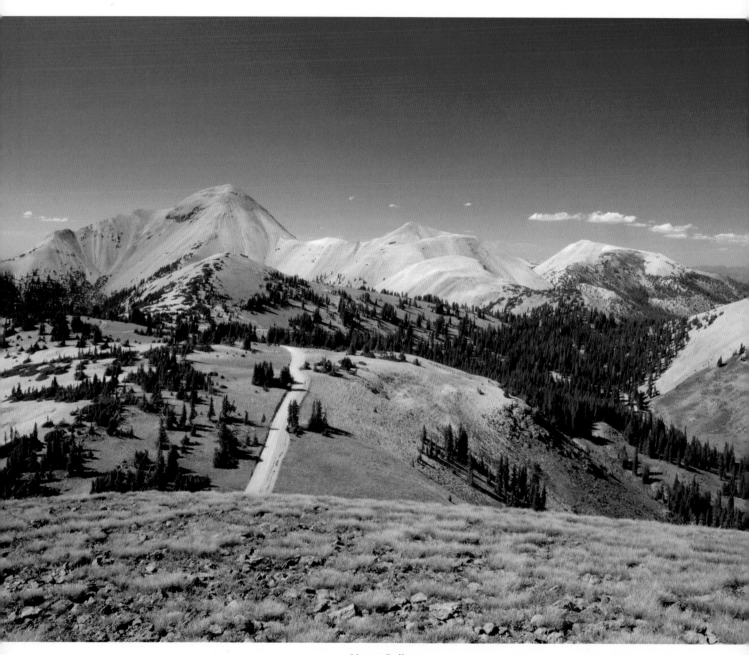

Mount Belknap

on the Paiute ATV Trail, there are about fifteen mountain goats in the foreground and an equal or greater number visible in the distance.

A second view taken nearby shows the rich volcanic colors on Mount Belknap, 12,137c feet (3,699m), the second-highest peak in the Tushar Range. The Paiute ATV Trail can be seen in the middle foreground.

House Range

▲▲▲

The highest and largest cliff to be found in the Great Basin is found on the western face of Notch Peak, 9,658c feet (2,944m), in the House Range of western Utah. This peak has been called the desert equivalent of Yosemite's El Capitan. The vertical rise above the floor of Tule Valley is some 5,000 feet (~1,525m), with the upper portion of the cliff facing north (in the shade) a sheer 2,200 feet (~670m) in height.

This range, with limestone as its major component, formed some 500 million years ago as sediments built up on an ancient sea floor. For that reason, this range is also a major hunting ground for Cambrian fossils. Many trilobites are found here, and part of the range is encompassed in the Notch Peak Wilderness Study Area. Ancient bristlecone pine trees also grow on the upper portion of the House Range. Notch Peak is named for its distinctive profile when viewed from the east or west, caused by the block (with the shaded north face) that forms a sharp profile.

West side of Notch Peak seen above the Tule Valley

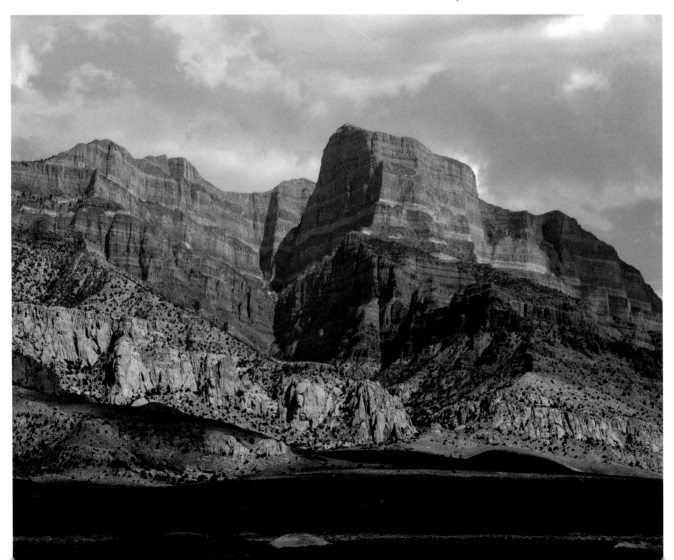

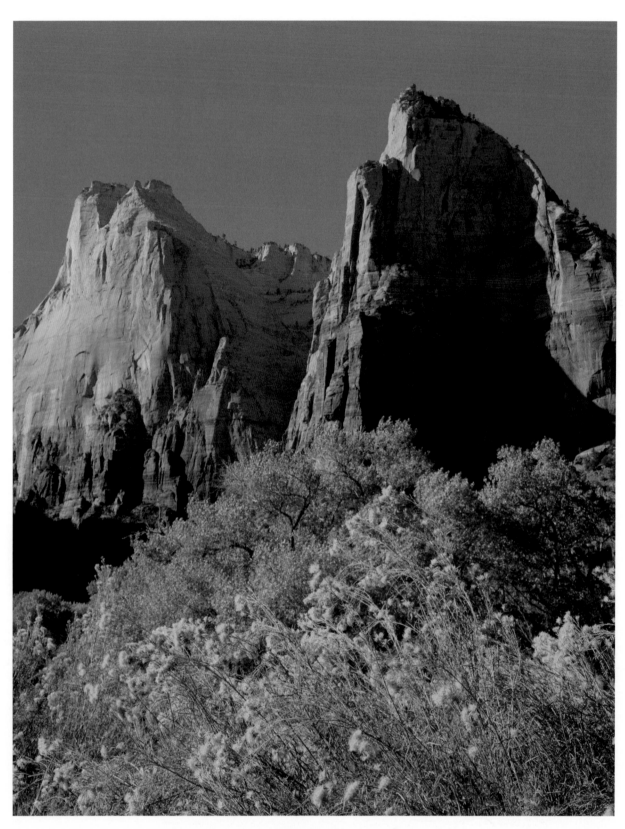

Abraham (left) and Isaac (right) in the Court of the Patriarchs

Zion National Park

The peaks and cliffs of Zion National Park are in a class by themselves. Words fail to adequately describe this area of the United States where the southwestern end of the Colorado Plateau meets the Mojave Desert. My personal description is that it is "Yosemite Valley in Technicolor, with walls that match in size and sheerness those of Yosemite."

In 1909 President William Howard Taft gave federal protection to a portion of this area, under the name of Mukuntuweap National Monument. Zion was given its name by Mormon pioneers in 1918; the same year, the unwieldy name that Taft had given to the area was changed to Zion, which means "Place of Refuge" in Hebrew.

Two of the peaks in the Court of the Patriarchs are shown here, with rabbit brush, *Chrysothamnus nauseosus*, in the foreground. On the left is Abraham, 6,990 feet (2,131m), and on the right is Isaac, 6,831 feet (2,082m). The southwest face of the first (in the sun), which is more than 2,000 feet (610m) in height, is one of the most difficult climbs in Zion National Park. In 1916 these two peaks were named by a Methodist minister who gave religious names to the monoliths he viewed. A third patriarch, Jacob, is out of view to the right.

The largest and highest facade of sandstone in North America, perhaps the world, is shown in this panoramic view into the amphitheater of the Towers of the

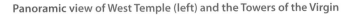

Panoramic view of West Temple (left) and the Towers of the Virgin

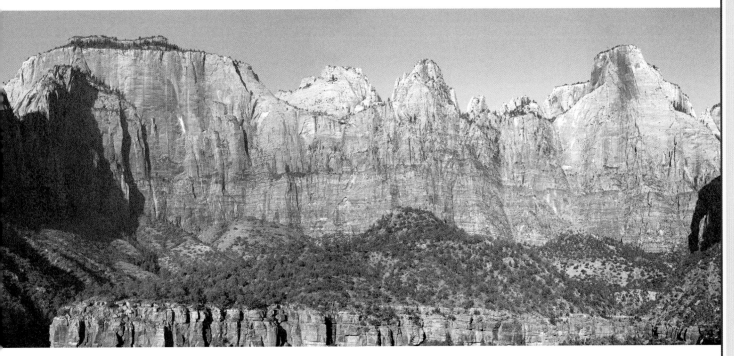

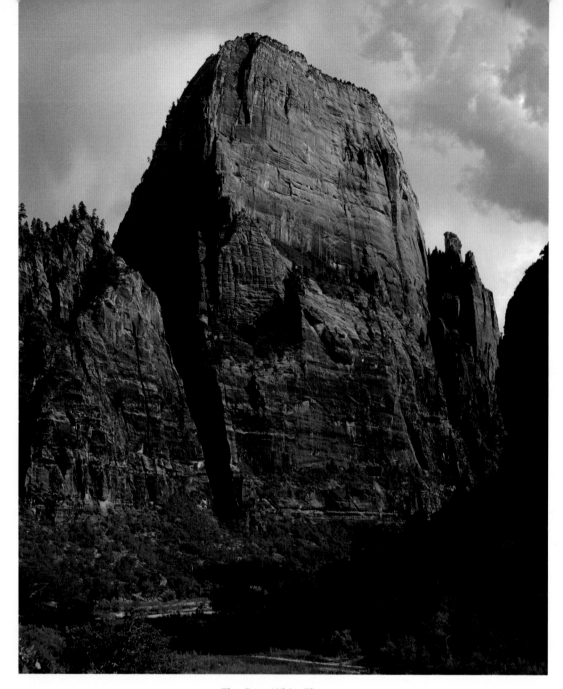

The Great White Throne

Virgin. On the left is West Temple, 7,810 feet (2,380m), and immediately to the right, in a lighter shade of sandstone, is Sundial, 7,590 feet (2,313m).

On the right side, the peak with the dark stain below the summit is Altar of Sacrifice, 7,505 feet (2,288m). The view shown here may be seen near the south entrance to Zion National Park near the Zion Human History Museum. West Temple is 3,800 feet (~1,160m) above the viewer from this view point.

One of the great rock formations in North America, and a centerpiece of Zion National Park, is the Great White Throne, 6,744 feet (2,056m). This monolith rises approximately 2,400 feet (~730m) above the Virgin River in Zion Canyon. This view appeared on an 8 cent U.S. postage stamp in 1934, as one stamp in a commemorative series on U.S. national parks. The road into Zion Canyon (which is closed to passenger cars except during the winter months) passes right beneath this

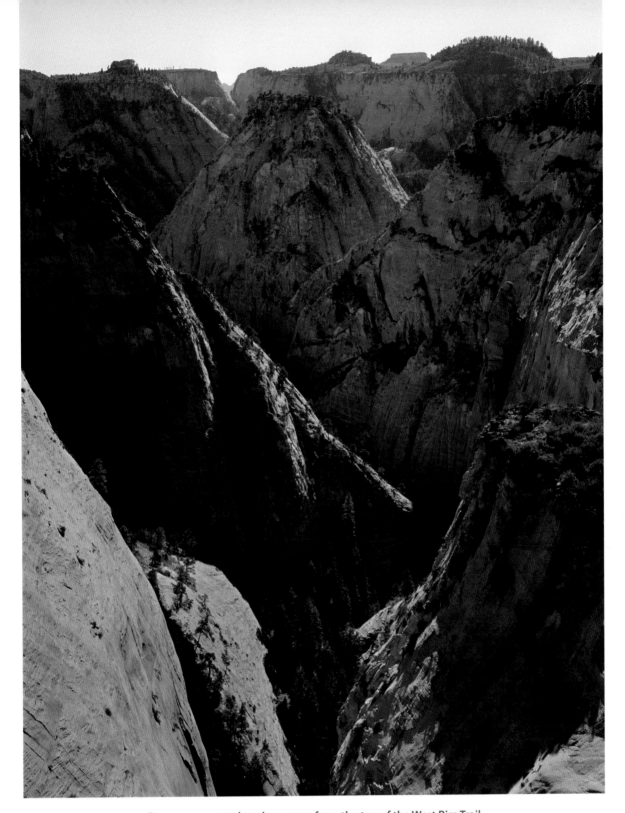

Deep canyons and peaks as seen from the top of the West Rim Trail

great monolith. In Christian belief, the Great White Throne is the seat of the Last Judgment before God. The formation is composed of Navajo sandstone, found in abundance in the southwestern United States.

The view of deep canyons and high cliff faces that presents itself from the top of the West Rim Trail in Zion National Park gives a good idea of the convoluted nature of the landscape of this canyon country.

Utah Peaks and Locations Featured

Abraham [312419] .. 37.2430N/112.9787W

Altar of Sacrifice ... 37.2257N/113.0198W
[212419 and 212422 panorama]

Mount Belknap [D12216] 38.4193N/112.4125W

Delano Peak [D12219] ... 38.3692N/112.3714W

Mount Emmons [212N10] 40.7116N/110.3038W

Great White Throne [312480] 37.2609N/112.9412W

Hayden Peak [212N05] ... 40.7356N/110.8441W

Isaac [312419] ... 37.2448N/112.9731W

Kings Peak [212N16] .. 40.7763N/110.3730W

Mount Nebo [M-12201 & 212202] 39.8218N/111.7603W

Notch Peak [212106] ... 39.1432N/113.4094W

Painter Peak [212N16] ... 40.7530N/110.3590W

Mount Peale [212702] ... 38.4384N/109.2291W

South Kings Peak [212N16] 40.7659N/110.3778W

Sundial [212419 and 212422 panorama] 37.2155N/113.0243W

Mount Timpanogos [212M08] & [212M18] 40.3908N/111.6460W
& [212M14 and 212M15 panorama]

Titan Tower [612751] .. 38.7182N/109.2834W

West Rim Trail, Zion Nat. Park, approx. 37.296 N/112.989 W
view from top [312452]

West Temple [212419 and 212422 panorama] 37.2108N/113.0207W

The numbers in brackets are the author's file numbers for the images.

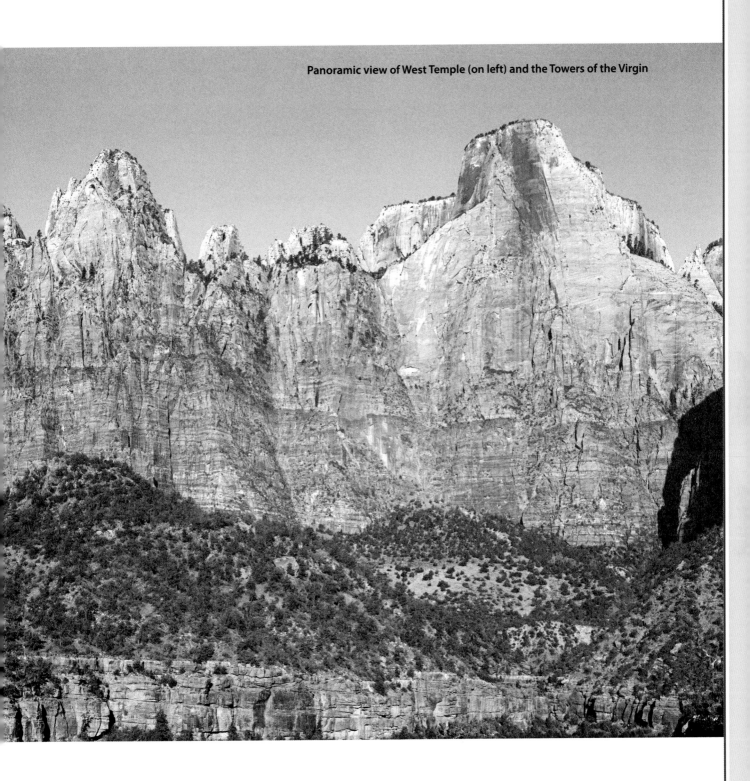

Panoramic view of West Temple (on left) and the Towers of the Virgin

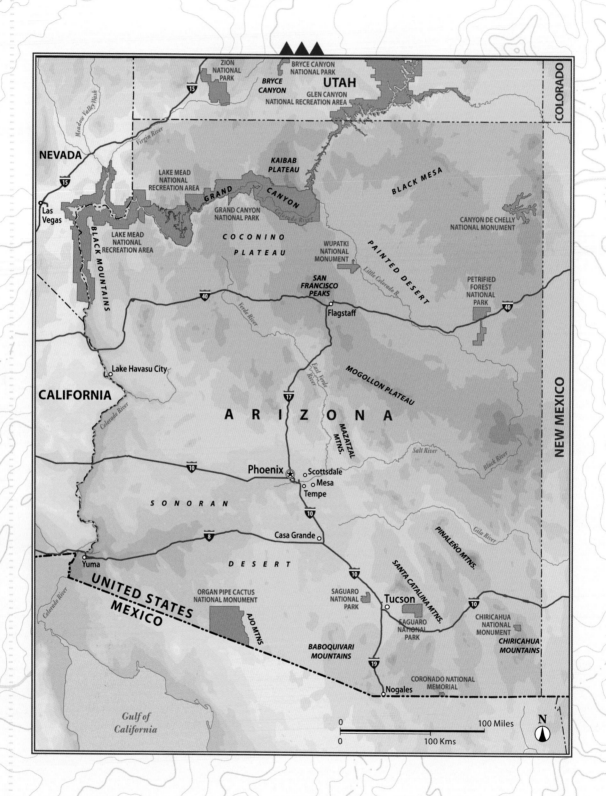

NEVADA

UTAH

COLORADO

CALIFORNIA

NEW MEXICO

ZION NATIONAL PARK

BRYCE CANYON NATIONAL PARK

BRYCE CANYON

GLEN CANYON NATIONAL RECREATION AREA

Meadow Valley Wash

Virgin River

KAIBAB PLATEAU

BLACK MESA

LAKE MEAD NATIONAL RECREATION AREA

GRAND CANYON

CANYON DE CHELLY NATIONAL MONUMENT

Las Vegas

BLACK MOUNTAINS

LAKE MEAD NATIONAL RECREATION AREA

GRAND CANYON NATIONAL PARK

Colorado River

COCONINO PLATEAU

WUPATKI NATIONAL MONUMENT

PAINTED DESERT

Little Colorado R.

PETRIFIED FOREST NATIONAL PARK

SAN FRANCISCO PEAKS

Verde River

Flagstaff

Lake Havasu City

MOGOLLON PLATEAU

East Verde River

A R I Z O N A

Colorado River

Salt River

MAZATZAL MTNS.

Black River

Phoenix

Scottsdale

Mesa

Tempe

S O N O R A N

PINALEÑO MTNS.

Gila River

Casa Grande

D E S E R T

Yuma

SANTA CATALINA MTNS.

Colorado River

ORGAN PIPE CACTUS NATIONAL MONUMENT

SAGUARO NATIONAL PARK

Tucson

CHIRICAHUA NATIONAL MONUMENT

UNITED STATES

MEXICO

AJO MTNS

SAGUARO NATIONAL PARK

CHIRICAHUA MOUNTAINS

BABOQUIVARI MOUNTAINS

CORONADO NATIONAL MEMORIAL

Nogales

Gulf of California

0 100 Miles

0 100 Kms

N

ARIZONA

San Francisco Peaks

▲▲▲

The San Francisco Peaks, often referred to as San Francisco Mountain, are part of the San Francisco Volcanic Field, an area some 50 miles (80km) in width, encompassing some 1,800 square miles (~4,660 sq km) and extending from Williams in the west to somewhat east of Flagstaff. In its six-million-year history, the San Francisco Volcanic Field has produced more than 600 volcanoes.

The earliest eruptions were in the west, near Williams, and the area of eruptions proceeded eastward, with the most recent eruption in 1064 at what is now called Sunset Crater, in Sunset Crater National Monument to the north of Flagstaff. This eruption must have been witnessed by the Native American inhabitants of the pueblos in the nearby Wupatki National Monument. There will no doubt be eruptions from this volcanic field in the future, but this could be anytime from tomorrow to thousands of years from now. These peaks have religious significance to thirteen local American Indian tribes, and the peaks form the Navajo "sacred mountain of the west," called Dook'o'oosliid.

The highest peak in the group is Humphreys Peak, 12,637c feet (3,852m), which is also the highest peak in the state. It is estimated that San Francisco Mountain, a stratovolcano, was once 16,000 to 20,000 feet (~4,875m to 6,100m) high, and an explosion, similar to the one that occurred on Mount St. Helens in 1980, blew out its side, leaving the individual peaks we see now. The San Francisco Peaks received their name from Spanish friars in the seventeenth century, well before the advent of the famous California city of the same name.

Humphreys Peak was named around 1870 for General Andrew A. Humphreys, a U.S. Army officer who was a Union general during the Civil War. This peak is

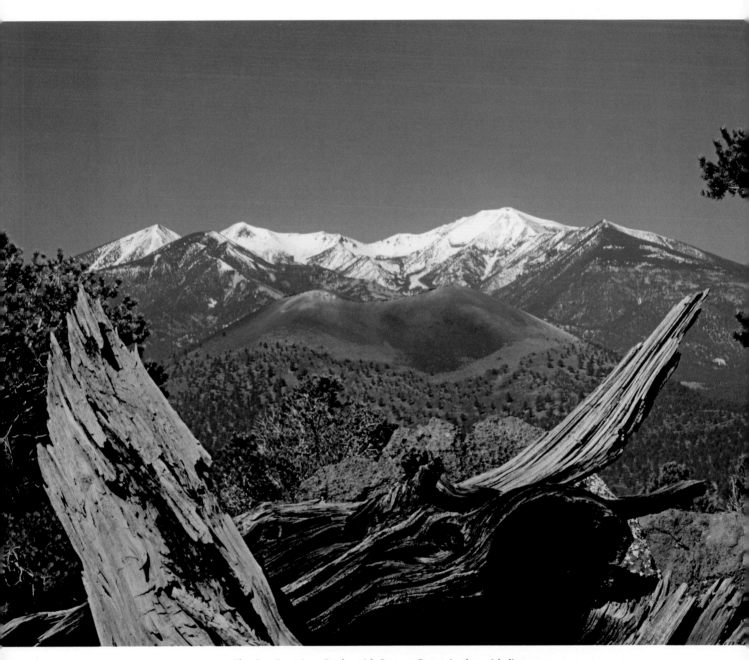

The San Francisco Peaks with Sunset Crater in the mid-distance

not to be confused with the Mount Humphreys in the Sierra Nevada, California, named for the same man.

In the view of the San Francisco Peaks, in the center we see Sunset Crater, 8,042c feet (2,451m), a cinder cone and site of the last eruption in the volcanic field. In the 1920s a film company wanted to simulate volcanic eruptions by exploding tons of dynamite on the top of the cinder cone. Fortunately, this would-be environmental disaster was stopped in its tracks, vetoed by the local authorities. Currently, climbs of this cinder cone are prohibited to protect the fragile plant community there.

While many people think of Arizona as mostly desert, the environment on the upper slopes of the San Francisco Peaks is definitely alpine, and contains the only tundra to be found in the state. Extremely high winds scour the summits of these peaks in the winter. This view, taken from the summit of Humphreys Peak in February, shows Agassiz Peak, 12,360c feet (3,767m), the second-highest peak in the state.

There is a rare and federally protected plant on Agassiz Peak, the San Francisco Peaks groundsel, *Senecio franciscanus*, a dwarf alpine species of the sunflower family. As a result, all ascents of Arizona's second-highest peak are prohibited except during winter when the ground is covered by snow. Violators are subject to a $500 fine, and rangers patrol the area, especially on weekends in the summer.

Winter view of Agassiz Peak as seen from the top of Mount Humphreys

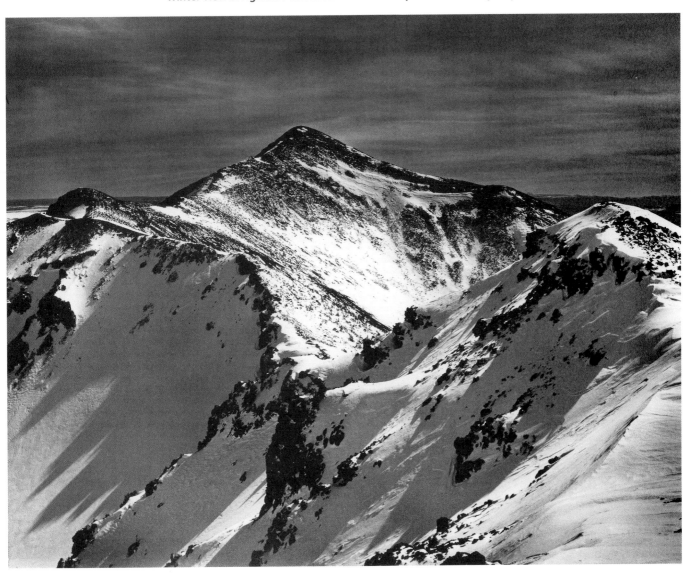

Agassiz Peak was named after the famed Swiss naturalist, Jean Louis Rodolphe Agassiz (1807–73), who is considered the father of glaciology. Despite his many contributions to this field, he believed in Creationism and was a dedicated opponent of Darwin. He said in 1867, "I trust to outlive this mania." A second winter view shows windswept snow and ice at the summit of Humphreys Peak.

Windswept snow and ice at the summit of Mount Humphreys

Mazatzal Mountains

▲ ▲▲

When heading northeast from Phoenix on State Route 87, your attention is increasingly drawn to Four Peaks, which appear ahead of you. The highest of the Four Peaks, in the Four Peaks Wilderness of the Mazatzal Mountains, is Browns Peak, 7,659c feet (2,335m), which is the only named peak of the group. It is the northern-most of the Four Peaks, and appears on the left in this view. The other three peaks are within 150 feet (~45m) of the altitude of Browns Peak.

These peaks rise over 6,000 feet (~1,825m) from

The Four Peaks in the Four Peaks Wilderness rising above the Sonoran Desert

Hedgehog cactus in bloom and the Mazatzal Mountains

the Sonoran Desert near Phoenix, which adds to their prominence. Stately saguaro cacti, *Cereus gigantea*, add depth to this scene. In Aztec language, mazatzal means "an area inhabited by deer," but no one seems sure how this name from an ancient culture in Mexico wound up here.

One of the great pleasures of exploring Arizona's mountain landscape in the spring is the combination of the desert in bloom with the mountains as a backdrop. In this scene in the Mazatzal Mountains, taken along the Apache Trail (State Route 88) between Apache and Canyon Lakes, we see Simpson's hedgehog cactus, *Pediocactus simpsonii*, in bloom with the mountains rising in the background.

Ajo Range

▲▲▲

Located on the border between Organ Pipe Cactus National Monument and the Tohono O'odham Indian Reservation (the tribe formerly known as the Papago), the Ajo Range contains one of the "lushest" desert environments found in North America. Despite blistering hot temperatures in the summer, this area does receive some rainfall in both winter and in summer, the latter season's rain often coming in the form of cloudbursts.

Desert in bloom in Alamo Canyon, Ajo Mountains

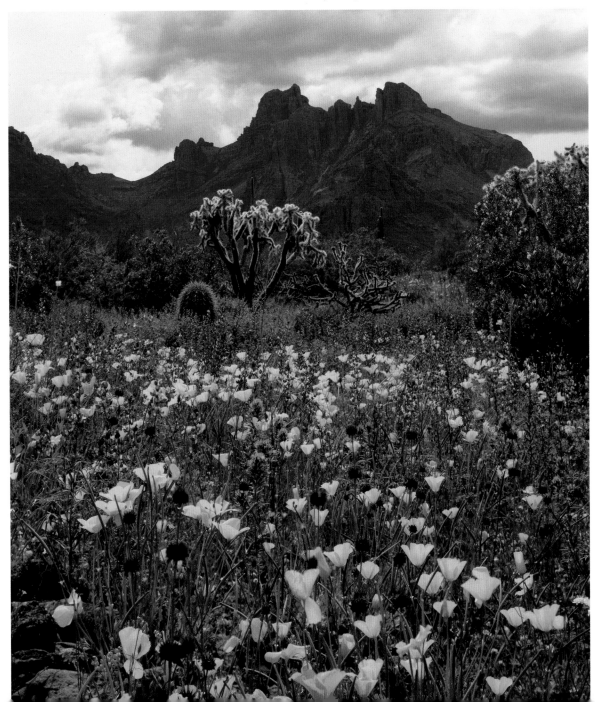

The result is a plethora of desert plant species that boggles the imagination.

Springtime in wet years provides a riot of blooming plants such as those seen on the previous page in Alamo Canyon with unnamed peaks in the Ajo Range as a backdrop. In the foreground there are Mexican gold poppies, *Eschscholtzia mexicana*. Intermixed with the poppies are the common owl's clover (purple) and lupine (blue). The Ajo Mountains are of volcanic origin.

It is an unfortunate fact that, because of the increase in illegal border crossings into the United States from Mexico, portions of the Organ Pipe National Monument where you used to be able to drive are now closed for security reasons. One of the most notable examples is part of the Puerto Blanco Drive, where the rare senita cactus can be viewed. A popular park ranger, Kris Eggle, was shot and killed by drug runners in this area in 2002.

Baboquivari Mountains

▲▲▲

The distinctive profile of Baboquivari Peak, 7,734 feet (2,357m), in the Baboquivari Peak Wilderness area of the Baboquivari Mountains, sets it apart from all the other peaks in the area. This peak, the highest in these mountains, is about 50 miles (80km) southwest of Tucson and straddles the eastern boundary of the Tohono O'odham Indian Reservation. This mountain requires technical climbing skills to reach the summit, and is an impressive sight no matter what direction it is viewed from.

Baboquivari is the sacred mountain of the Tohono O'odham god and creator, I'itoi, who resides here. This view, with chaparral-covered hills in the foreground, is from the Kitt Peak National Observatory, to the north of the peak.

Baboquivari Peak as seen from Kitt Peak

Santa Catalina Mountains

▲▲▲

Mount Lemmon, 9,157 feet (2,791m), is the highest peak in the Santa Catalina Mountains, just northeast of Tucson. It is the site of a ski area (the southernmost in the continental United States) and the Steward Observatory complex (run by the University of Arizona), the latter of which occupies the top of the mountain. More interesting, at least to climbers, is the fact that there are hundreds of rock formations in the area, with over a thousand routes, all on fairly good rock. This is the major rock-climbing center in the state of Arizona.

Goosehead Rock is one such formation that attracts climbers; it is located right next to the Sky Island Scenic Byway in Coronado National Forest, which leads to the top of Mount Lemmon. The rock is located about 15 miles (24km) up the highway from the start of the Sky Island Byway and is visible from the road. Goosehead Rock is bigger than it looks, with climbing routes from 40 feet to 90 feet (12m to 27m) high, including one that goes right over the beak of the rock.

Goosehead Rock on Mount Lemmon

Pinaleño Mountains

▲▲▲

The Pinaleño Mountains in the southeastern part of Arizona contain the highest mountain in the southern part of the state: Mount Graham, at 10,724c feet (3,269m). These mountains have more vertical relief than any other range in the state. Mount Graham rises over 7,800 feet (~2,375m) above nearby Safford (from where the view seen here was taken) to the northeast.

It is also said that these mountains have the highest diversity of habitats of any mountain range in North America. These mountains form a "sky island," that is they are completely surrounded by Sonoran-Chihuahuan desert valleys, isolating all plant and animal species in these mountains. Evolving separately on this sky island, the Mount Graham red squirrel was placed on the federal endangered species list in 1987.

Mount Graham as seen from near Safford

Desert floor viewed from Swift Trail Parkway on Mount Graham

Mount Graham is also the site of the Mount Graham International Observatory maintained by the University of Arizona. The LBT, or Large Binocular Telescope, which saw first light in 2006, is the most advanced of its type in the world. Also located here is the Vatican Advanced Technology Telescope. (Yes, the Vatican as in Vatican City, Rome, Italy, seat of Pope Benedict XVI!)

State Route 366, the Swift Trail Parkway in Coronado National Forest, crosses the crest of the Pinaleño Mountains. A second view shows the desert, many thousands of feet below, as seen from this parkway. A fire caused by lightning—the Nuttall-Gibson Complex fire—burned over 30,000 acres (~12,150 hectares) in June 2004.

Chiricahua Mountains

▲▲▲

Similar to a number of other mountain ranges in southern Arizona and New Mexico, the Chiricahua Mountains form a "sky island." The highest peak is Chiricahua Peak, 9,759 feet (2,975m), but the peak itself is not that interesting. The highest point of the peak is on a long, broad forested ridge in Coronado National Forest. One of the more interesting and rugged peaks in these mountains is Sanders Peak, 8,763 feet (2,671m). This view is from the northeast, in the Cave Creek Valley.

Sanders Peak as seen from Cave Creek Canyon

These mountains are famous for the strange spires, turrets, battlements, and other fascinating rock formations to be found in Chiricahua National Monument and parts of Coronado National Forest. Almost all the formations are composed of tuff, the material ejected from volcanic explosions and spread over the area millions of years ago, welded into rock, and then eroded and shaped by the elements and movements in the earth's crust.

The scope of these rock formations defies the imagination, and the four views shown here are just a sampling of what can be found in the area. The balanced rock seen here is one of many to be found in Chiricahua National Monument. The Totem Pole, also

Balanced Rock near Massai Point, Chiricahua National Monument

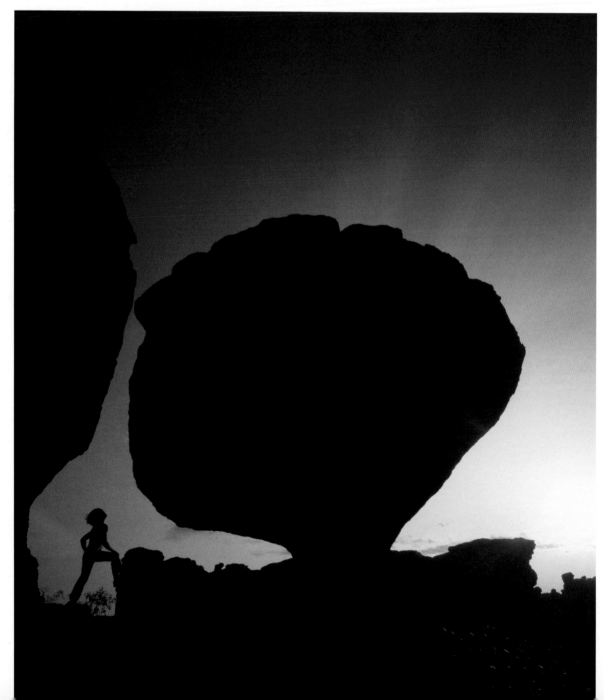

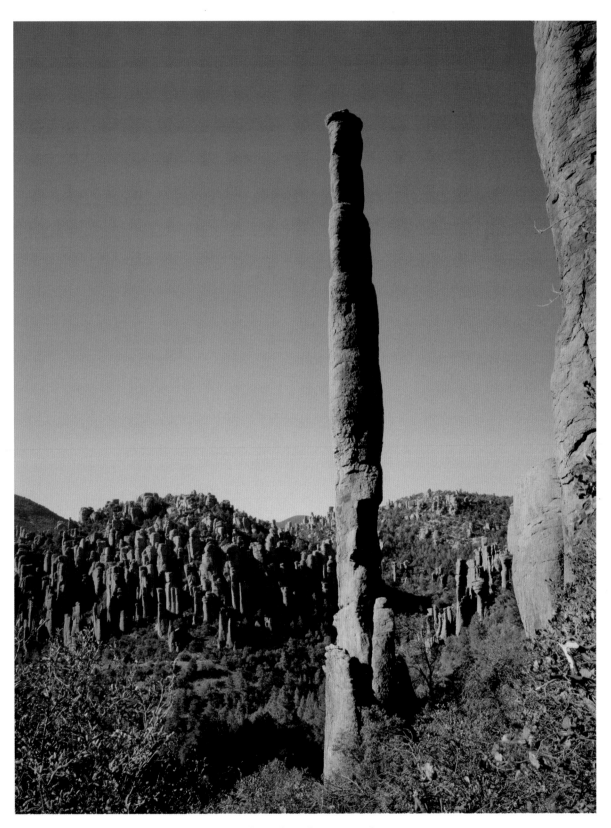

The Totem Pole in Chiricahua National Monument

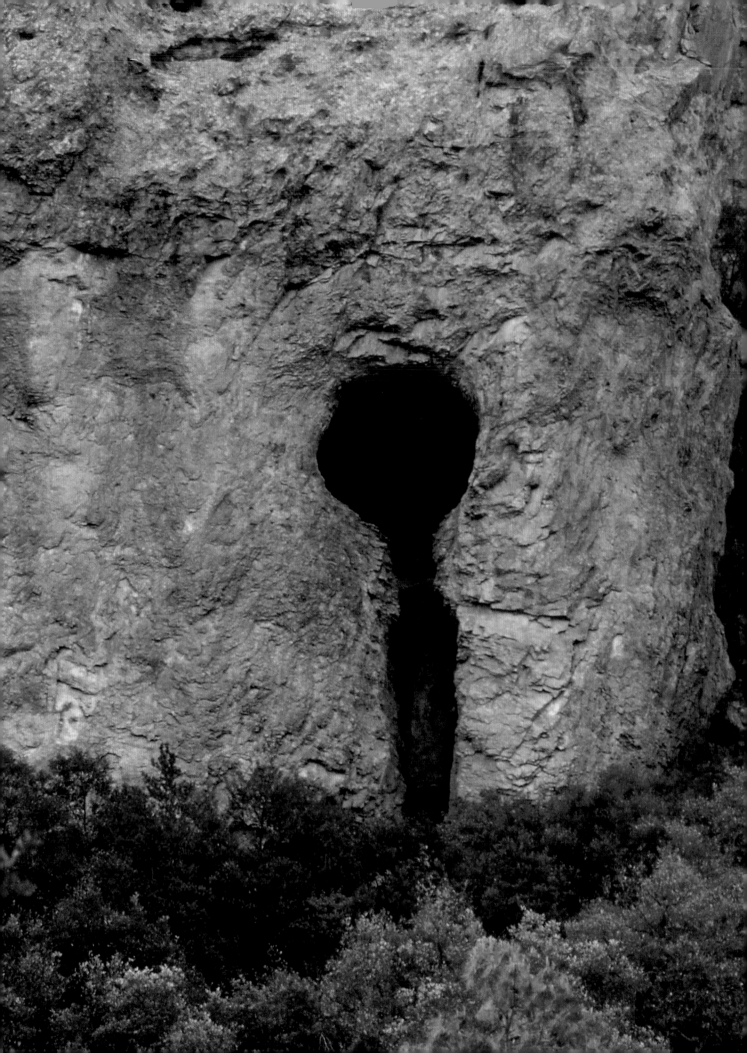

found in the monument, is 137 feet (42m) high and at its narrowest is less than a yard (0.9m) wide. (This Totem Pole is not to be confused with the more famous Totem Pole in Monument Valley Navajo Tribal Park, on the border between Arizona and Utah.) Due to the fragile nature of these rock formations, rock climbing is prohibited within Chiricahua National Monument.

The views of Skull Eyes Rock, on the following two pages, and the Keyhole are from above the south fork of Cave Creek in Coronado National Forest. The Keyhole is approximately 35 feet (~11m) high, and about 14 feet (~4m) wide at the top and 5 feet (~1.5m) wide at the bottom.

The Chiricahua Mountains derive their name from the Chiricahua Apache Indians who inhabited the area. For more than twenty-five years in the nineteenth century, Cochise and Geronimo, famous warriors, led a valiant yet vain attempt to defend their territory and retain their way of life. It ended with the final surrender of Geronimo in 1886. By that time, most of the Apaches had been sent to the north, to the current site of the San Carlos Indian Reservation. Geronimo himself (born in 1829) was never to return to his native land; he was exiled to Florida, and later died in Oklahoma in 1909.

The Keyhole above the South Fork of Cave Creek, Coronado National Forest

Arizona Peaks and Locations Featured

The numbers in brackets are the author's file numbers for the images.

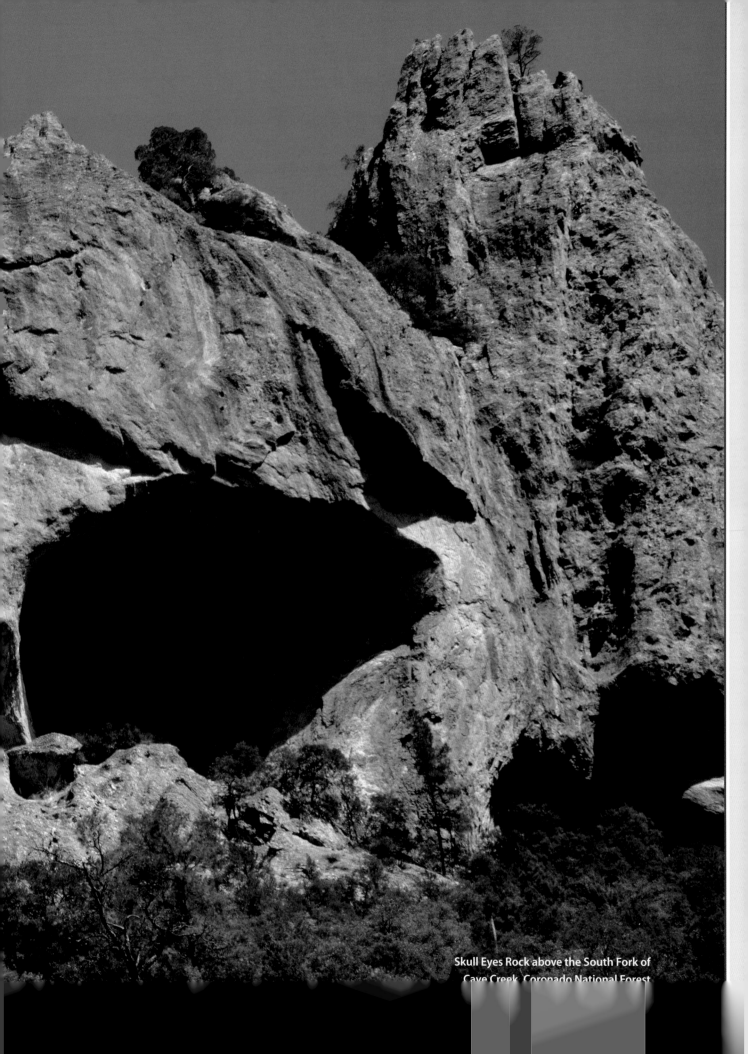

Skull Eyes Rock above the South Fork of
Cave Creek, Coronado National Forest

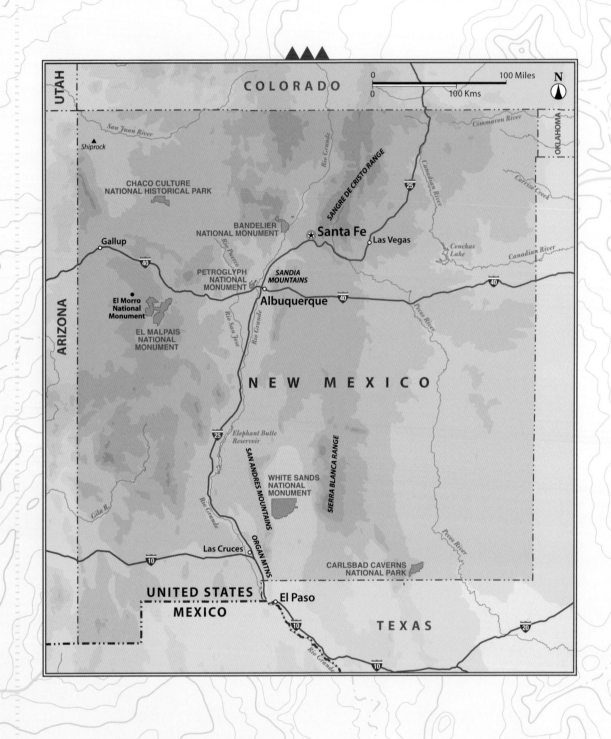

NEW MEXICO

Shiprock

▲▲▲

Shiprock, 7,178 feet (2,188m), a New Mexico landmark in the northwest corner of the state, rises about 1,700 feet (518m) above the surrounding desert. This peak attained world fame in 1939 when the first ascent was made; the climb was at that time considered the most technically difficult ever accomplished in North America. Shiprock is the remains of a volcanic neck (volcanic plug), the central feeder pipe of a larger volcanic landform, which—having been composed of softer rock—has since eroded away completely, leaving only the plug, which was composed of harder, more durable rock.

Shiprock, located on the Navajo Indian Reservation, is considered by the Navajos to be sacred, and it is a main character in their folklore. It is called Tse Bi Dahi (also seen in literature as Tse Bitai) meaning "the winged rock." This name comes from an ancient folk myth that tells how the Shiprock was once a great bird that transported the ancestral people of the Navajos to their lands in what is now northwestern New Mexico.

In this myth the Navajo ancestors had crossed a narrow sea far to the northwest (the Bering Strait?) and were fleeing from a warlike tribe. Tribal shamans prayed to the Great Spirit for help. Suddenly the ground rose from beneath their feet to become an enormous bird, which flew south for an entire day and night, finally settling at the place where Shiprock is now located.

It is widely believed that climbing Shiprock is prohibited by the Navajos, due to a 1970 climbing accident

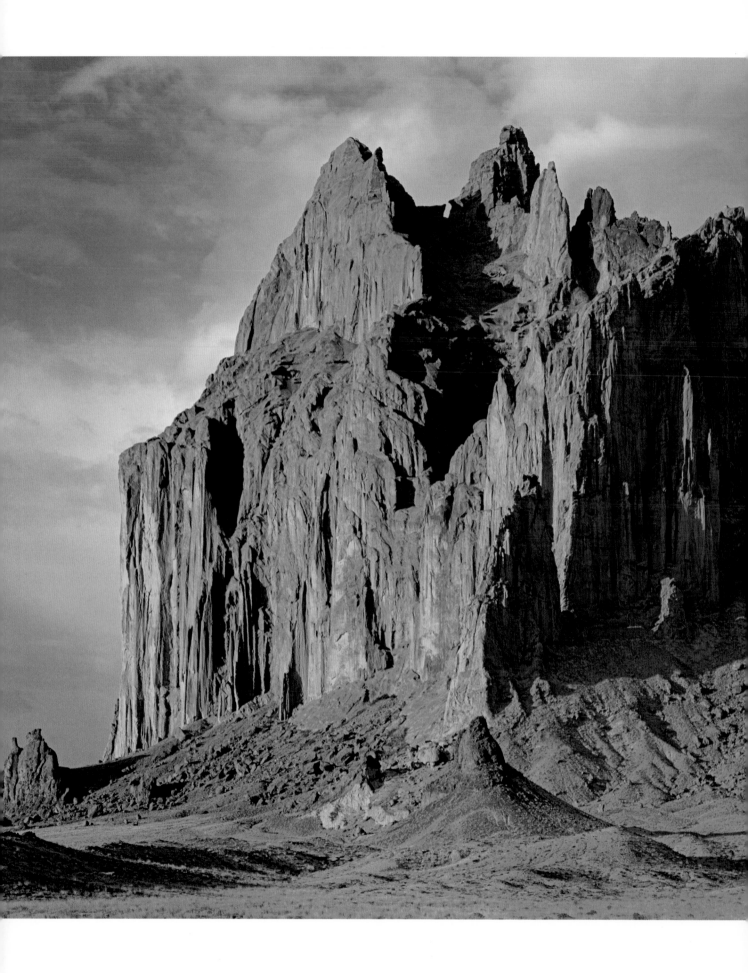

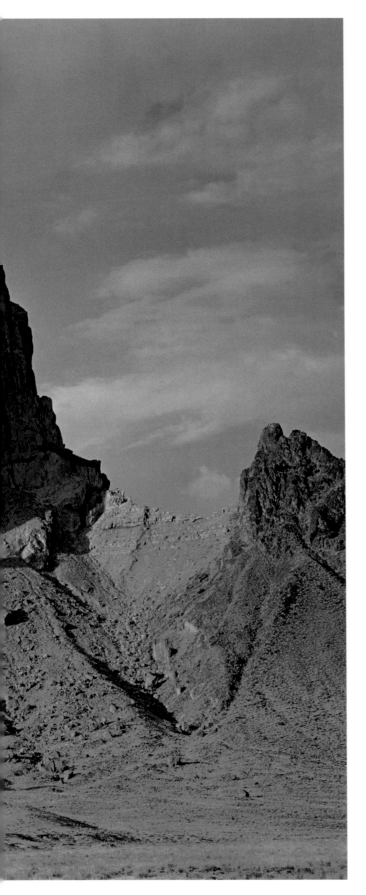

Shiprock

on the rock that required a hazardous rescue. Unlike some Navajo lands where climbing is prohibited, this is not the case with Shiprock. Interested climbers, however, need to get permission from a local Navajo land-use permit holder. Inquiries in the town of Shiprock, located somewhat to the northeast of the formation, would yield the necessary information as to the person to contact.

The geological formation called Shiprock is 15 miles (24km) southwest of the town of Shiprock and is best viewed by traveling south on U.S. Highway 491 (numbered US 666 on earlier maps) and then west on Red Rock Road, near where this picture was taken. *Note*: The route number was changed in 2003 due to association of the number 666 with the "number of the beast" or the Antichrist in Revelation 13:18 in the New Testament.

Wheeler Peak as seen from near Bull of the Woods Trail

Sangre de Cristo Range

▲▲▲

The New Mexico portion of the Sangre de Cristo Range, in the north-central part of the state, stretches about 100 miles (160km) in a north–south orientation from the Colorado border to a little south of Santa Fe. The Colorado portion of the Sangre de Cristo Range continues north of the New Mexico border for another 115 miles (~185km). "Sangre de Cristo" means "blood of Christ" in Spanish.

The Sangre de Cristo Range contains nine major summits of 14,000 feet (4,267m) or more, but a careful inspection of the map shows that the summits reaching this elevation stop only some 8 miles (13km) north of the New Mexico border at Culebra Peak, 14,047 feet (4,281m). Some New Mexico climbers (and/or some residents) might say "It's not fair! Colorado has all the fourteeners in the Rocky Mountains!"

At 13,167c feet (4,013m), Wheeler Peak, located in the Wheeler Peak Wilderness in Carson National Forest, is the highest peak in the state. This Wheeler Peak is not to be confused with the Wheeler Peak in Great Basin

Clouds over Hermit Peak

National Park in Nevada, which has a surprisingly similar elevation—13,065c feet (3,982m). To make things even more confusing, both these peaks were named after Army Major George Montague Wheeler, who was the leader of the Wheeler Survey, a party of surveyors and naturalists in the late nineteenth century that explored the area now occupied by seven western states.

Truchas Peak, 13,108c feet (3,995m), south of Wheeler Peak, was at one time considered the highest peak in New Mexico until a 1948 survey established Wheeler Peak as the highest summit. In the view seen here from near the Bull of the Woods Trail over colorful rocks in the foreground, we are looking towards the Wheeler Peak complex where there are three "thirteeners" clustered together in a half-mile area.

Anchoring the very southern end of the main chain of the Rocky Mountains and the Sangre de Cristo

Range is Hermit Peak, 10,267c feet (3,129m), located in the Pecos Wilderness in Santa Fe National Forest. The marked difference in the generally published altitude of 10,212 feet and the current corrected altitude is due to the fact that the lower altitude was based on a station situated below the actual summit. In the view seen here, taken from the east on a summer morning, clouds are starting to build up for the usual afternoon thunderstorms.

Hermit Peak was called El Cerro del Tecolote (the Hill of the Owl) by early Spanish settlers. From 1863 to 1867 this mountain was the home of Juan Maria Agostini, an Italian penitent who lived there as a hermit, carving crucifixes, religious emblems, and giving blessings in exchange for food. Leaving the area, Agostini moved to the Organ Mountains in southern New Mexico, where Native Americans killed him in 1869.

Sunrise on El Morro

El Morro

▲▲▲

Located southeast of Gallup in western New Mexico lies El Morro ("morro" means "headland" or "bluff" in Spanish), in El Morro National Monument. At an elevation of 7,200 feet (2,195m) near the Continental Divide in the Zuñi Mountains, El Morro is a massive mesa point of sandstone rising about 200 feet (~60m) above the valley floor. El Morro, named by Spanish conquistadors, is steeped in history.

Two years before the founding of Jamestown and fifteen years before the Pilgrims landed at Plymouth Rock, the first Spanish inscription was made by Don Juan de Oñate in April 1605. The inscription, shown here, has been enhanced either by archaeologists or national park service personnel to make it easier to read. Early travelers inscribed more names and messages on the rock, giving El Morro its other name: Inscription Rock.

Long before the early Spanish explorers explored the area, the Zuñi Indians had pueblos in the area, including one on top of El Morro, and they left their own petroglyphs on the rock. Space prohibits inclusion of the details of conflict in the area between Native Americans and Spaniards, and then Mexicans and Anglo-Americans, which lasted some 250 years altogether.

The Oñate Inscription, 1605, on El Morro

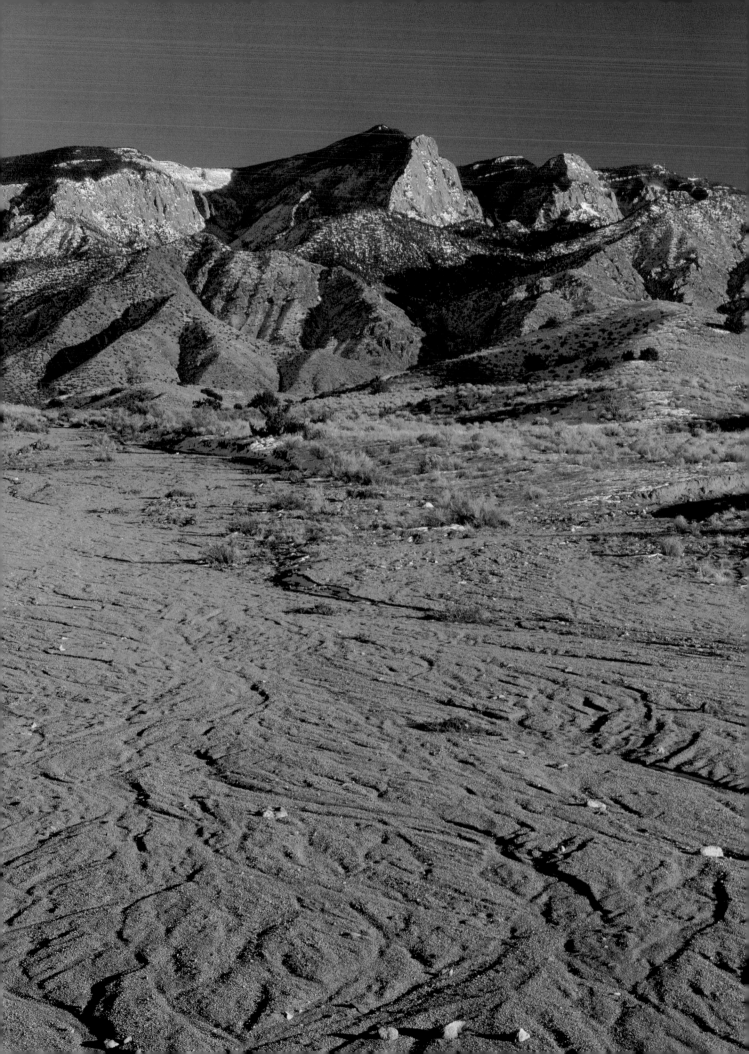

Sandia Mountains

▲▲▲

The Sandia Mountains rise over 5,000 feet (~1,500m) from the desert floor in the Rio Grande Valley to the highest point, Sandia Crest, 10,678 feet (3,255m), which appears on the right in this view. It doesn't appear to be the high point, but that is only because of perspective.

The Sandia Mountains are very prominent when seen from Albuquerque and from Interstate 25, which runs north from the city. The view seen here was taken near I-25 along the western base of the Sandia Mountains. The Shield is the triangular formation seen in the upper center of this view, and the Needle is the rock formation to the right of it. These granite outcroppings offer the best longer rock-climbing routes to be found in central New Mexico. Another view near Sandia Crest shows me next to an igloo winter campsite. This upper portion of the Sandia Mountains is in Cibola National Forest.

The photographer/author next to an igloo camp on Sandia Crest

Sandia Crest as seen from the desert floor in Rio Grande Valley

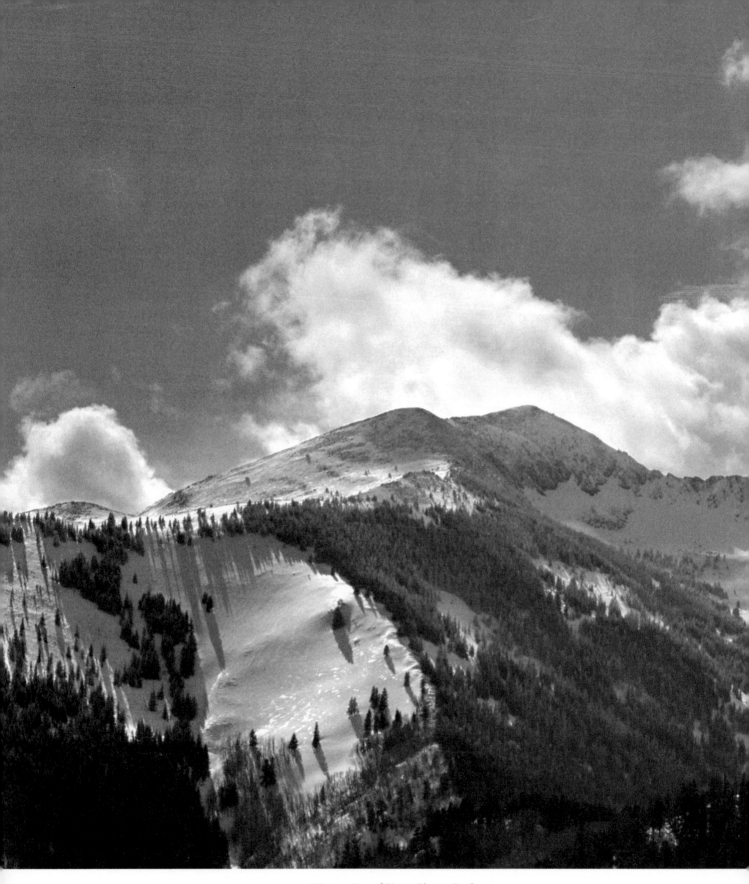
Winter view of Sierra Blanca Peak

Sierra Blanca Range

▲ ▲ ▲

Sierra Blanca Peak in southern New Mexico, the high point in the Sierra Blanca Range at 11,981c feet (3,652m), has the distinction of being the highest most southerly peak in the contiguous United States. That is, to find any higher peaks farther south, one has to go into Mexico. This peak also has an almost 8,000 feet (~2,440m) vertical rise above the adjacent Tularosa Basin to the west, and was glaciated during the Ice Age.

Calling the peak Sierra Blanca Peak is somewhat repetitious when you realize that in Spanish, Sierra Blanca itself means White Mountain, but that is how this peak is labeled on USGS topographic maps. The peak itself is located in the Mescalero Apache Indian Reservation, although the approach to hike up the peak is located in Lincoln National Forest. The view seen here is from the east and shows a glacial cirque immediately below the summit, extending to the right.

There seems to be considerable confusion among mapmakers regarding this peak. On one AAA road map dated 2006, I saw two separate summits listed on the map: Sierra Blanca Peak at 11,973 feet and Sierra Blanca at 12,003 feet. A 2006 Rand McNally Atlas lists only Sierra Blanca at 12,003. This confusion comes about because one station marker at the summit is stamped 12,003 feet. Later calculations gave the 11,973 feet elevation, and the National Geodetic Survey updated elevation calculation—11,981 feet—is given at the start of this paragraph. Despite what your map may tell you, there is only one peak with the name Sierra Blanca.

San Andres Mountains

▲▲▲

The San Andres Mountains extend some 75 miles (~120km) from the Sierra Oscura ("Dark Mountains") on the north to San Agustin Pass on the south, with the Organ Mountains to the south of the pass. These mountains are on the eastern edge of the rift valley of the Rio Grande and are contained almost wholly within the White Sands Missile Range, which extends eastward from these mountains.

The view shown here is of the San Andres Mountains as seen from White Sands National Monument, the one area of public access within the much larger missile range. These white sands form the largest area of gypsum dunes in the world. Being white, they take on whatever color the lighting may be, in this case the warmer colors of early morning. This eastern front of the San Andres Mountains is composed of limestone and rises in a fault block over 4,000 feet (~1,220m) in a single sweep. A rare flood in White Sands National Monument created this opportunity for a reflection picture.

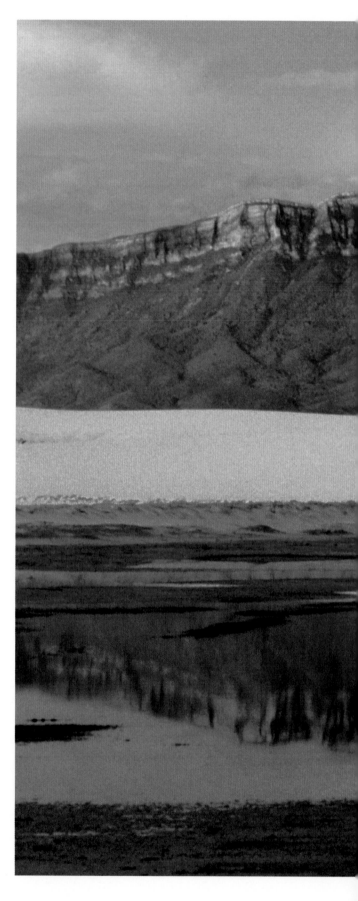

Eastern front of the San Andres Mountains as seen from White Sands National Monument

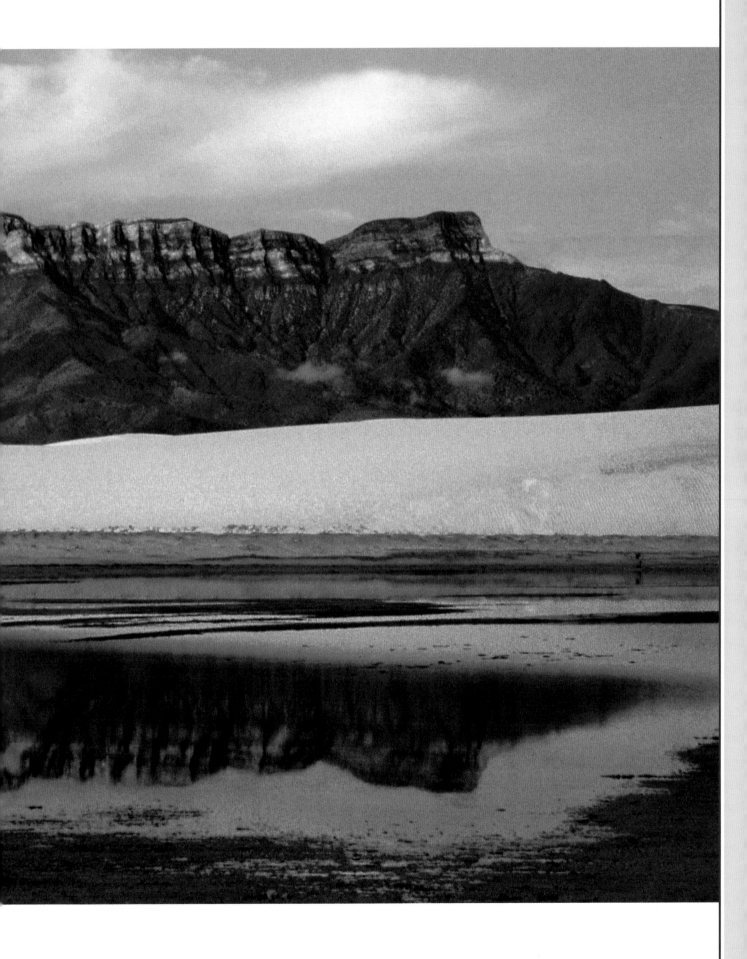

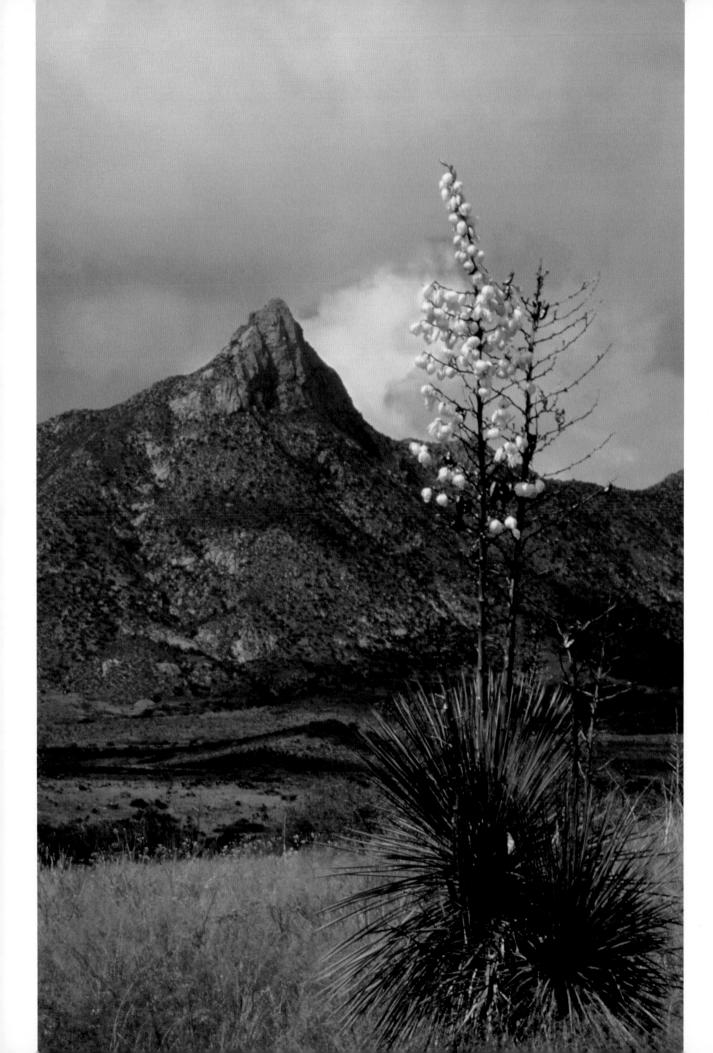

**Flowering yucca plant (New Mexico state flower)
and San Agustin Peak**

San Agustin Peak, 7,030 feet (2,143m) stands guard over San Agustin Pass at the very southern end of the San Andres Mountains. The USGS topographic map shows a relatively small area labeled San Agustin Mountains, but this is, in fact, a subrange of the San Andres Mountains. This striking peak is best viewed when heading west on U.S. Highways 70 and 82 as you are approaching San Agustin Pass. The peak, and the pass, are approximately 25 miles (40km) northeast of Las Cruces. Seen in the foreground is a flowering yucca plant, the New Mexico state flower. There are several species of yucca, the most stately of which are *Yucca elata* and *Yucca glauca*, but it was never stated which one was intended when the yucca was made the state flower in 1927, so either one may be considered the state flower. The species seen here is the *Yucca glauca*.

Organ Mountains

▲▲▲

Rising over 5,000 feet (~1,500m) above the surrounding desert, the Organ Mountains present a panoply of spires unmatched elsewhere in the state of New Mexico or the Rocky Mountains. Composed of igneous rock (intrusive granite and extrusive rhyolite), these crags, not surprisingly, received their name due to their similarity in appearance to the pipes in a church organ. The highest peak in these mountains is Organ Needle, which is the farthest right peak seen in this panorama on the next two pages.

I have seen at least three published altitudes for this peak, ranging from 8,980 to 9,012 feet (2,737m to 2,747m). There is no survey station on the peak, and the USGS topographical map does not give an elevation, so an accurate elevation determination awaits in the future. These peaks dominate the view to the east of Las Cruces, and the views heading east on US 70 from Las Cruces are stunning.

Hiking and climbing in these mountains presents a special desert challenge. Bob Michael, Brown Bear Mountaineering Club, Boulder, Colorado, described the problems encountered: "The Organs are surely the brushiest desert peaks I have ever experienced. With the sole exception of the jumping-type chollas, every conceivable variety of stabbing, slashing, sticking, clawing, and jabbing vegetable is right at home there."

New Mexico Peaks and Locations Featured

El Morro (Inscription Rock)35.0411N/108.3501W
[214403] & [214407]

Hermit Peak [M-14203]...................................35.7445N/105.4153W

Organ Needle [214878].................................32.3451N/106.5620W

San Agustin Peak [M-14805]32.4387N/106.5631W

San Andres Mountains [M-14804].................Various

Sandia Crest [214503].....................................35.2101N/106.4495W
& [214507]

Shiprock [214151] ..36.6876N/108.8365W

Sierra Blanca Peak [214820].........................33.3743N/105.8088W

Wheeler Peak [214257]..................................36.5568N/105.4169W

The numbers in brackets are the author's file numbers for the images.

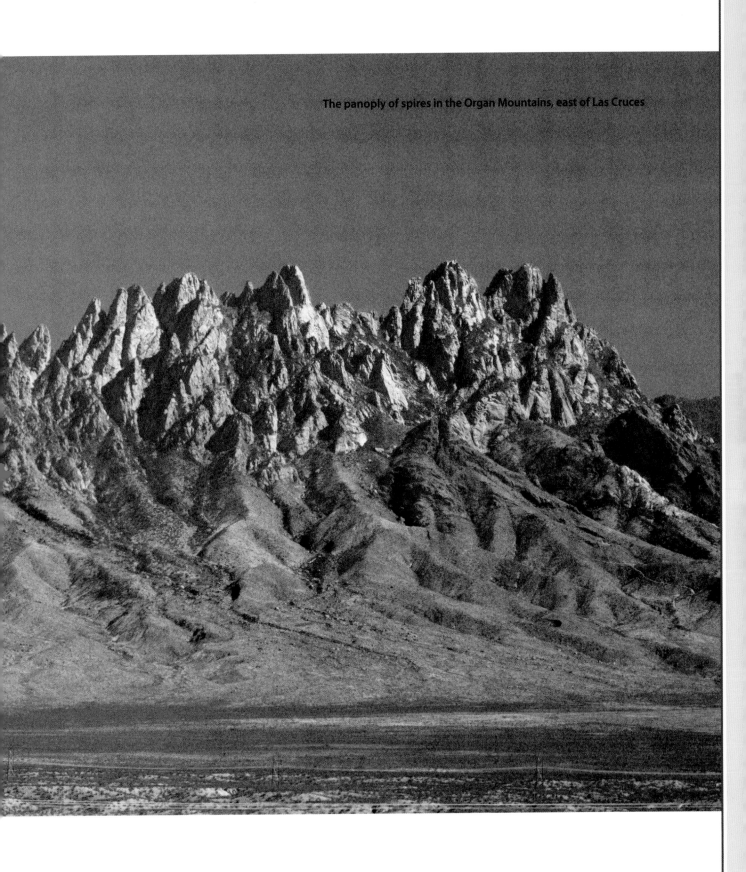

The panoply of spires in the Organ Mountains, east of Las Cruces

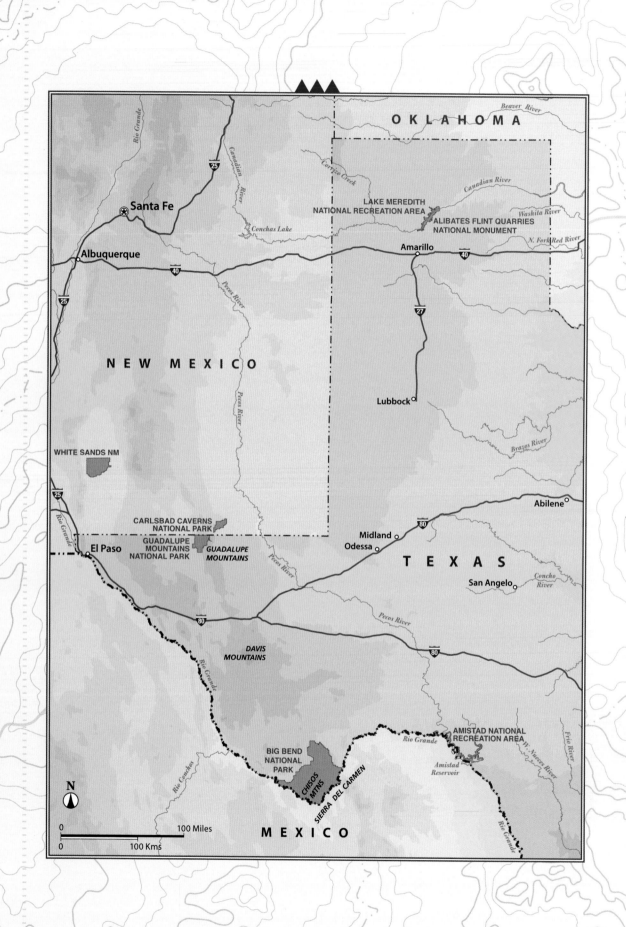

TEXAS

Guadalupe Mountains

▲▲▲

Mountains in Texas? Yes, and while lower than their neighbors to the north in New Mexico, they are no less spectacular. El Capitan, 8,085 feet (2,464m), may be less well-known than the *other* El Capitan in Yosemite Valley, California, but it is the signature peak for Texas and the Guadalupe Mountains, in Guadalupe Mountains National Park.

The upper part of the southeast face, seen in this view, is a 1,000-foot (~305m) sheer limestone cliff. These bluffs form part of the largest exposed ancient fossil reef in the world, having been the floor of a shallow sea almost 300 million years ago. This fossil reef rises over 4,000 feet (~1,200m) from the desert salt flats, below where the picture on the next page was taken. Heavy winter rains, which do not occur every year, had produced a profusion of desert wildflowers. A ridge connects El Capitan with Guadalupe Peak, 8,751c feet (2,667m), the highest peak both in this range and in the state of Texas.

A note of caution: Mountain lions frequent the Guadalupe Mountains, and warnings are posted at the start of the Guadalupe Mountain Trail.

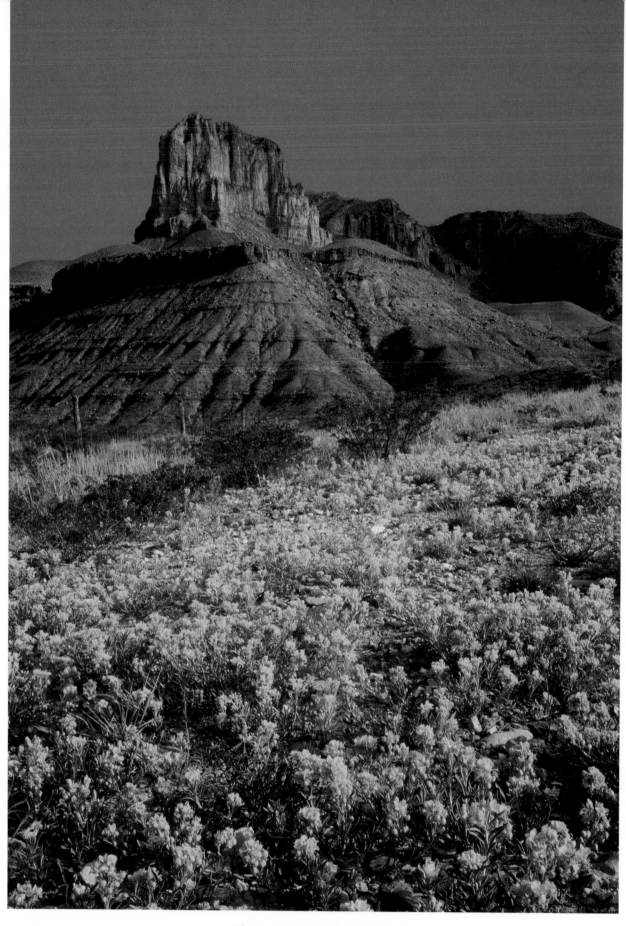

El Capitan on Guadalupe Peak

Cane cholla cactus and Sawtooth Mountain

Davis Mountains

▲ ▲▲

The Davis Mountains are the largest mountain range in Texas, in terms of area, that lies wholly within the state. This range forms a "sky island," surrounded by low desert on all sides, and contains some species unique to this range of mountains. The Davis Mountains are located roughly halfway between the Guadalupe Mountains and the mountains of Big Bend National Park.

The view here shows Sawtooth Mountain, 7,686 feet (2,343m), the third-highest peak in the Davis Mountains, seen from the northeast near a formation called The Rockpile. The peak rises about 1,700 feet (~520m) above The Rockpile, and in the foreground is cane cholla cactus, *Opuntia imbricata*. What appears to be yellow flowers on the cactus is actually the fruit. The columns seen on Sawtooth Mountain were originally igneous intrusions that did not reach the surface; subsequent weathering away of the overlying rock exposed the mountain.

There is considerable history associated with the Davis Mountains. They were named for Jefferson Davis, the secretary of war under Franklin Pierce, and later the president of the Confederate States of America. As secretary of war for the United States, he ordered construction of the Fort Davis Army Post to protect the San Antonio–El Paso Trail. Settlements in this area were close to the fort, but protection ceased during the Civil War, when the fort was not maintained.

After the Civil War the fort was once again maintained, but conflict between the Mescalero Apaches and area settlers continued until about 1880. In 1941 engineers of the State Department of Highways and Public Transportation discovered the name Christopher (Kit) Carson carved on a huge boulder at The Rockpile, with the date of December 25, 1839. The Rockpile is also called Point of Rocks.

Northeast face of Casa Grande Peak

Chisos Mountains and the Adjacent Sierra del Carmen

▲▲▲

The Chisos Mountains, located in Big Bend National Park, have the distinction of (1) being the most southerly mountain range in the contiguous United States, and (2) being the only mountain range contained wholly within a national park. This range occupies a relatively small area, about 40 square miles (~104 sq km), but there is nothing small about Casa Grande ("Big House" in Spanish) Peak, 7,325 feet (2,233m). This is the signature peak of this range, and of Big Bend National Park. It rises above the campground in Chisos Basin, and when hiking in the area, you have to strain your head backwards to view the entire peak. The rock ramparts of the northeast face can be seen in this dramatic profile. These cliffs are of igneous origin, composed of somewhat unstable rhyolite.

The Big Bend of the Rio Grande River in Texas marks the point where the great American cordillera crosses into Mexico, on its way through Central America, and down through the Andes Mountains, ending at the Tierra del Fuego in Peru and Argentina, at the southern tip of South America. This is a dramatic transition point, as can be seen in the accompanying photograph on the next two pages. The limestone palisades of the Sierra del Carmen (there are no accurate elevations available) in the Mexican State of Coahuila rise above the waters of the Rio Grande River, as seen from the American side in Big Bend National Park.

The highest peak seen is known as El Pico, or Pico Cerda. The former means "peak or snout or beak" in Spanish; the latter might be translated as "pig snout," which it somewhat resembles. These rugged mountains hold the first officially recognized wilderness area in Mexico—the El Carmen Wilderness Area, created in 2005.

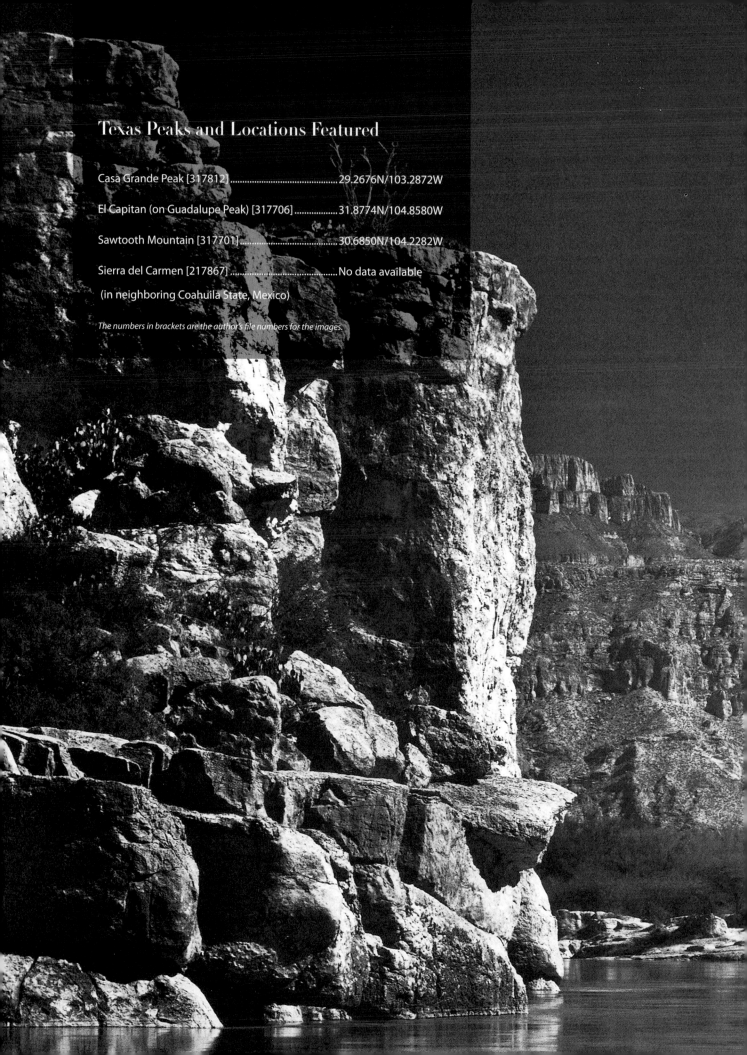

Texas Peaks and Locations Featured

Casa Grande Peak [317812] ...29.2676N/103.2872W

El Capitan (on Guadalupe Peak) [317706]31.8774N/104.8580W

Sawtooth Mountain [317701] ..30.6850N/104.2282W

Sierra del Carmen [217867] ...No data available
 (in neighboring Coahuila State, Mexico)

The numbers in brackets are the author's file numbers for the images.

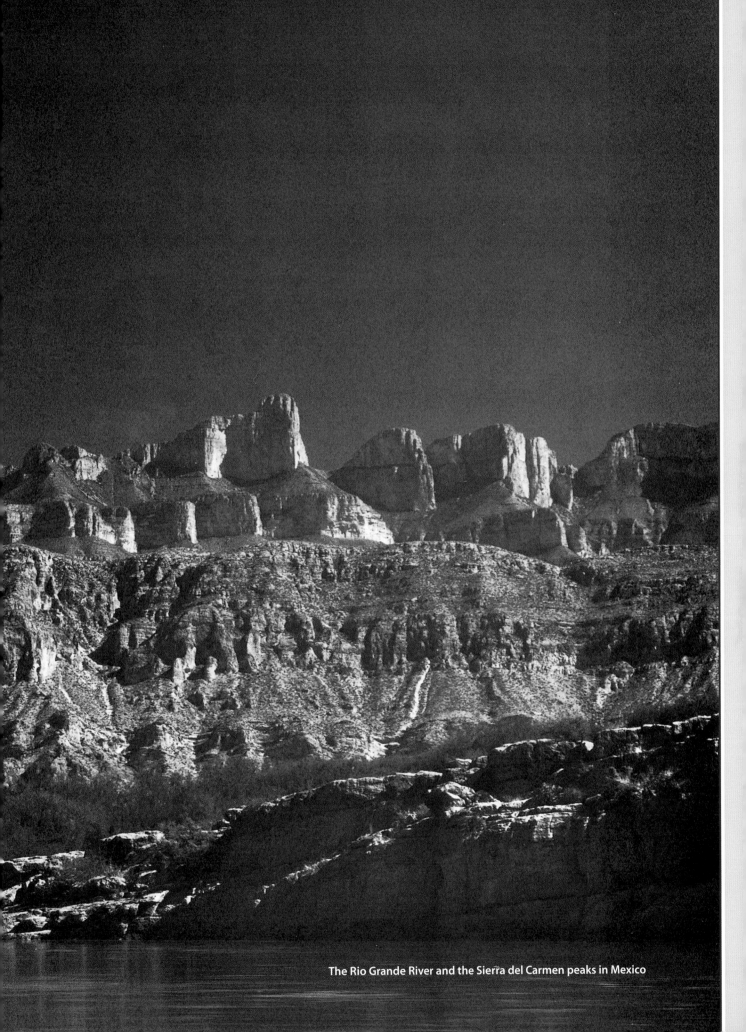

The Rio Grande River and the Sierra del Carmen peaks in Mexico

INDEX

▲▲▲